HISTORIC PHOTOS OF
FLORIDA
GHOST TOWNS

TEXT AND CAPTIONS BY STEVE RAJTAR

TURNER
PUBLISHING COMPANY

In 1916, two Harvard University chemical engineers testing the beaches along Florida's east coast found useful minerals at this location. This photo from around 1927 shows the Buckman and Prichard Incorporated ilmenite mill located in Mineral City, founded in St. Johns County in 1916. After extraction of the ilmenite (titanium ore), the tailings would then be worked for the extraction of rutile, zircon, monazite, and silicate. During World War II, the federal government took over the area and used the minerals in the production of munitions. The area is now an upscale tourist resort with a focus on golf, known as Ponte Vedra Beach. The mining company, National Lead Company, created the area's first golf courses for recreation of its employees.

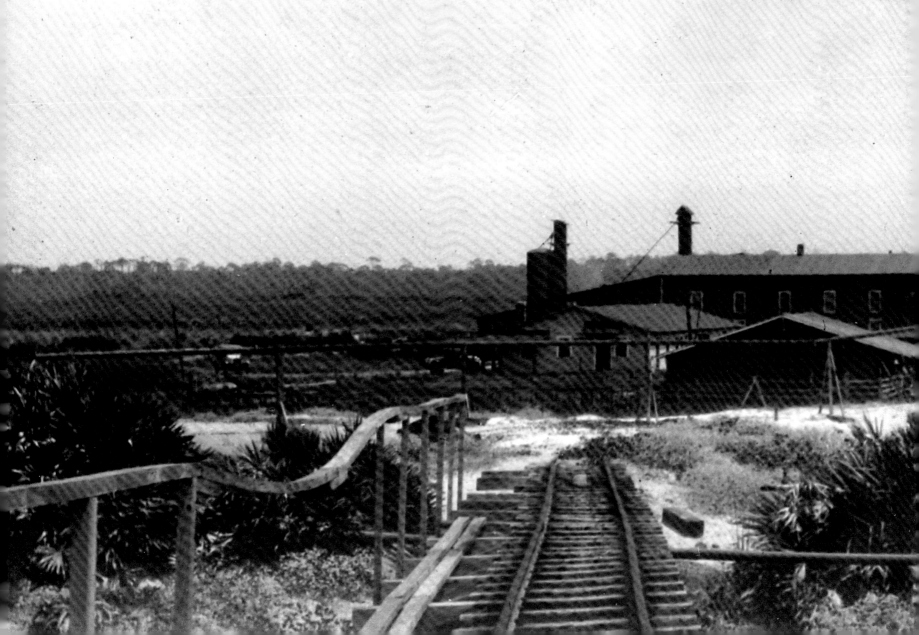

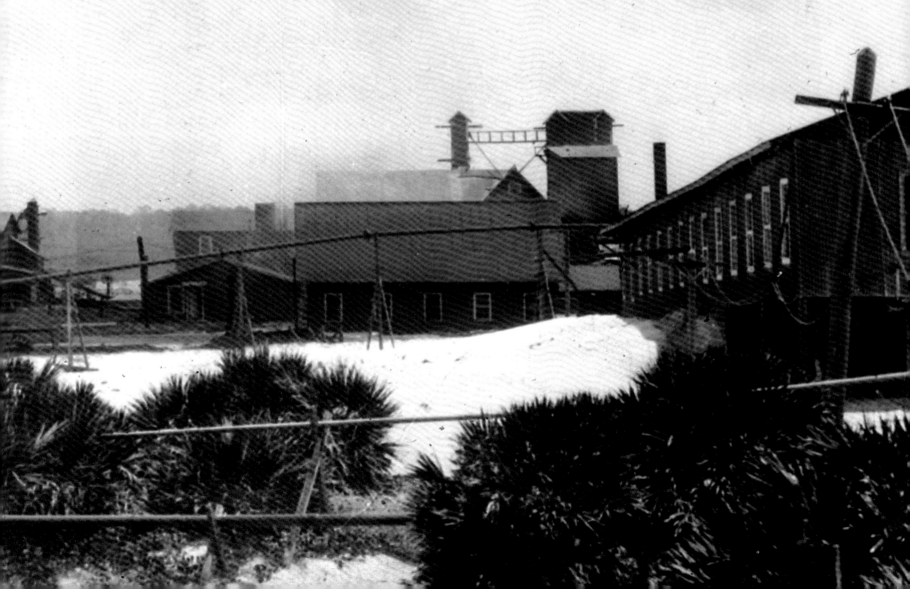

HISTORIC PHOTOS OF
FLORIDA
GHOST TOWNS

Turner Publishing Company
200 4th Avenue North • Suite 950
Nashville, Tennessee 37219
(615) 255-2665

www.turnerpublishing.com

Historic Photos of Florida Ghost Towns

Library of Congress Control Number: 2009933002

ISBN: 978-1-59652-552-8

Printed in China

10 11 12 13 14 15 16 17—0 9 8 7 6 5 4 3 2 1

Contents

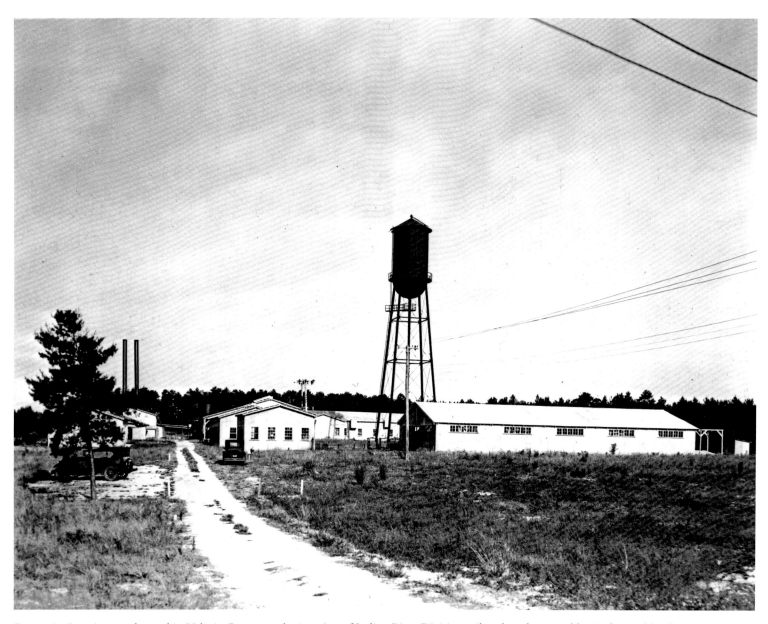

Enterprise Junction was located in Volusia County at the junction of Indian River Division railroad tracks owned by Luther Caldwell and Elijah Watson. Today it is found approximately at the intersection of Benson Junction Road and Shell Road, southwest of DeBary. In 1925, the Ox Brush Fibre Company moved there from Sanford, where it had operated since 1884. For a time, it was the country's largest manufacturer of brushes, making them from palmetto fibers. In addition to the manufacturing plant, the company had 17 houses for its employees, a post office named Benson Junction, and stores. The business closed down during the 1970s.

Acknowledgments

This volume, *Historic Photos of Florida Ghost Towns,* is the result of the cooperation and efforts of many individuals and organizations. It is with great thanks that we acknowledge the valuable contribution of the Florida State Archives, and the many photographers and collectors who have shared their images of the state by donating them to the Florida Photographic Collection.

We would also like to thank those who seek out the communities that no longer exist, providing valuable resources for historians, genealogists, and those who just want to see how our predecessors lived. In particular, we would like to recognize the contributions of Jim Pike, Mike Woodfin, and all of the other contributors to GhostTowns.com.

With the exception of touching up imperfections that have accrued with the passage of time and cropping where necessary, no changes have been made to the photographs. The focus and clarity of many photographs is limited to the technology and the ability of the photographer at the time they were taken.

PREFACE

When most people think of a ghost town, they conjure up an image of a dusty group of dilapidated wooden buildings in the Old West. Tumbleweeds roll down the street. Hinged doors of a saloon flap noisily in the wind. Broken windows, empty wooden sidewalks, and perhaps a drifter on horseback passing through complete what Hollywood has led us to believe is a ghost town.

Although such an abandoned area would certainly fit anyone's definition of a ghost town, many other scenarios also qualify. Various criteria for identifying these towns have been developed over the years, and to better understand the scope of this work, it is necessary to know the criteria used in selecting the Florida ghost towns from the large number of settlements that existed, but are no more.

The town must have had a reason to exist as a community. Often, it was established to support a single company or a single industry, or perhaps a group of farms located near one another. It may have sprung up as a shipping point along a waterway or railroad line, or may have started as a camp for workers laying track or building a bridge. In some cases, towns originated as military forts or as supporting residences, stores, and businesses just outside their gates.

After establishment, the town must have had a period of growth. It may have been a rapid boom period or a gradual increase in population, but in any event, there must have been growth. If the town could not attract people to work in the local industry, operate stores, pastor churches, or provide the services needed in any viable community, it wasn't really a town to begin with.

The next important phase needed for a town to evolve into a ghost town, of course, is a decrease in population. It must be a substantial decrease in that there must be too few left to maintain a real sense of community. It may be the result of an obvious event such as a hurricane or massacre or epidemic. It may be a consequence of something identifiable but less immediate, such as the gradual departure of residents following a factory or mine closing, the rerouting of a railroad, or competition with another nearby town that was better at attracting residents. It may also be less obvious, with people leaving for other destinations for a variety of reasons, or no specific reason at all.

Finally, the formerly thriving town should not be there anymore, whether the site now has ruins of buildings, nothing at all recognizable as a human residence, or is a modern city bearing no resemblance to the former town. Basically, if there used

to be a town there, and it's no longer there, it's a ghost town. If its history is documented in words and pictures, it may be one included in this volume.

Unlike the movie ghost towns of the Old West, those in Florida rarely have wooden sidewalks, swinging saloon doors, or anything else constructed of wood. It doesn't take long in Florida for unmaintained wooden structures to disappear: they are ravaged by termites, carried away by winds and floods, and reduced to ashes by frequent fires. Rather than being preserved by a dry climate as in cowboy movies, abandoned wooden towns in Florida quickly revert to palmettos and pines. Therefore, unless the abandonment of a town is fairly recent, what survives at Florida ghost town sites is generally made of other material, such as stone foundations, brick walls, or marble gravestones. Wood will be no more than a memory, with the possible exception of that treated with creosote or other chemical preservatives.

There are many reasons a town loses its population and its raison d'être. Often, an area settled to support a single company or a single industry will pass into memory not long after that company or activity ceases. In several instances, when a company closed, it not only terminated the town but also gave its residents deadlines by which they would be required to purchase and move their homes, or else demolition crews would eliminate them. Similarly, the decline of plantations as viable crop producers took away the necessity for nearby supporting settlements.

Railroads and governments have played major roles in creating ghost towns. Where a train track is placed, or where it is moved to, bears strongly on where a successful town can lie. When a government dissolves a town's charter, or acquires the land on which it sits for a public purpose, the town will often quickly disappear.

Other ways of rapidly converting a thriving settlement into a ghost town include fires, floods, hurricanes, and epidemics. More often, however, a town merely fades away over a period of time without a single drastic event. Perhaps the town loses its will to exist because its crops lose their demand, other regions of the state become more popular, or for no easily definable reason.

The final category covered herein is that the old town has lost out to another. Some examples arise from economic competition with another, with the stronger one winding up with the residents and businesses of both. Others are merely absorbed by nearby towns, and what used to be a distinct historical town is transformed into a mere neighborhood within the city limits of another, which grew amoeba-like and swallowed up its surroundings and made them parts of itself.

Merely because a place is called a ghost town does not mean that there are no living residents. On the contrary, someone may be reading this at their home in one of the ghost towns described in this book. It's not the absence of people that qualifies an area to be called a ghost town. It is instead the drastic change from what the town used to be when it thrived to what it is today. In essence, it's a completely different town than it was. Florida has hundreds or thousands of such ghost towns, fascinating those who strive to imagine what used to be.

—*Steve Rajtar*

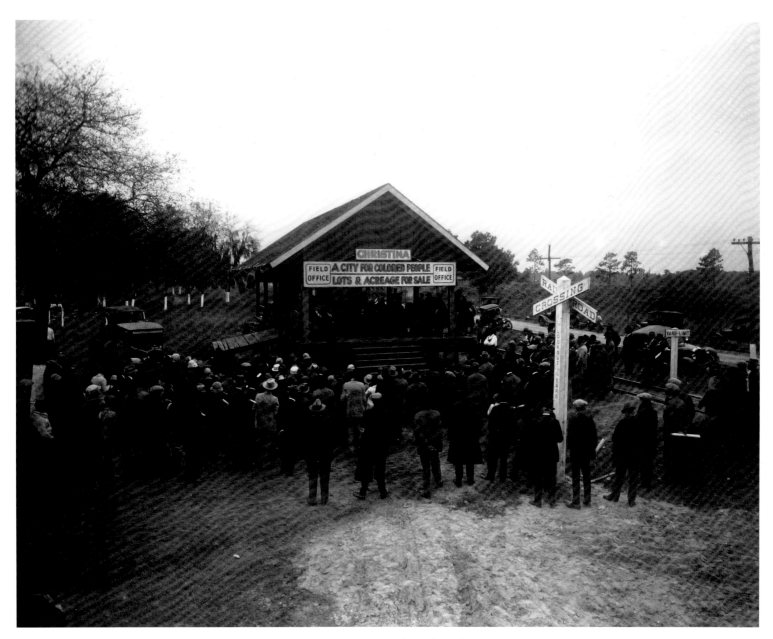

Christina was a small town along the west side of the railroad tracks, across from the Polk County phosphate mines. It originated out of the Land Pebble Phosphate Company operation near the D. M. Pipkin homestead. Its post office remained open from 1908 until 1918, when mail service was moved to Lakeland. Initially a town for black laborers, it still has its name on Christina Lake, Christina Drive, and Christina Park Road, east of the railroad tracks. The few homes remaining west of the tracks are in an area of greater Lakeland labeled on some maps as Tancrede. The town was first named Medulla Mine by C. G. Memminger, who later renamed it for his only daughter. It was gone by the early 1930s. This 1925 photo depicts the railroad station south of the intersection of Harden Boulevard and Ewell Road (CR 540A).

COMPANY CLOSINGS

A common scenario for creating a ghost town goes like this. A company arrives in the area and sets up a business to exploit the local natural resources. It may be a lumber company that creates a town to support a sawmill business, an oil-drilling venture, or a phosphate company that constructs a mining and mineral extraction operation. At some point, the lumber will all have been cut, or the drilling will have been abandoned, or the mine will have been exhausted, or the need for whatever was being produced will have diminished.

At that point, the company often closes for good or moves on to another area and sets up a new factory and perhaps another settlement. The former company town, with no company to support and be supported by, often quickly fades away. The businesses close, the residents move to other places where they can find work, and the former town becomes abandoned.

Another version of the story is that the company remains open, but the company town is eliminated. Employees then need to find new homes to commute from if they wish to remain with the same company. Some may remain in the area but turn to farming, fishing, or another means of making a living.

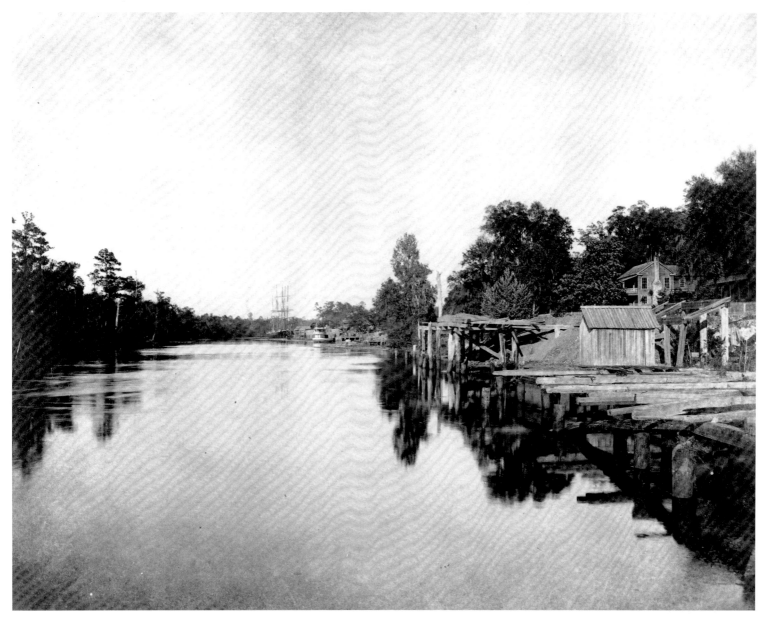

This is a nineteenth-century view of the St. Marys River crossing at King's Ferry, known in the late eighteenth century as Mills Ferry after it was visited by naturalist William Bartram. It was called Whitehouse beginning in 1792 and Drummond's Ferry in 1817. In the 1870s, following a downturn in river traffic as a result of the Civil War, the J. Mizell and Brothers Lumber Company purchased an 1850s sawmill in King's Ferry and built a larger one in 1881. Thereafter, outgoing shipments of lumber increased. Local crops included cotton, indigo, corn, and rice. In 1896, the *Nassau County Star* newspaper began publication in King's Ferry, then moved to Crandall. The local lumber industry decreased tremendously by 1905, the Mizell mill closed seven years later, and the last post office closed in 1926.

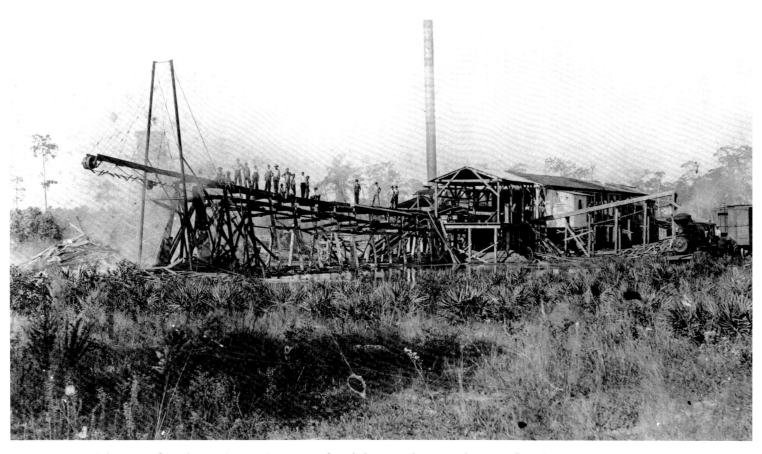

The town of Bamboo in Sumter County was founded in 1883 by B. E. Chapman of South Carolina. It had its own post office from 1884 until 1890, when it moved to Orange Home. After the Big Freeze of 1894-95, Bamboo's population decreased to 30, but it really transformed from a thriving town to a ghost town after its sawmill and post office closed down. Depicted in this photo is the Goethe sawmill that operated there, not far from the intersection of today's SR (State Route) 44 and CR (County Route) 468.

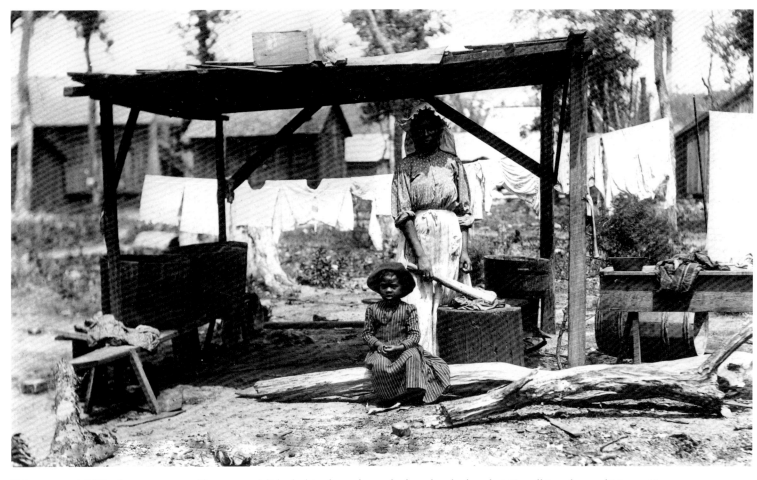

Taken around 1890, the year a post office was established, this photo shows the laundry shed at the Warnell Lumber and Veneer Company. The Sumter County company town of Warnell was hurt when the lumber company moved to Plant City in 1898. On September 10 that same year, the town's post office closed.

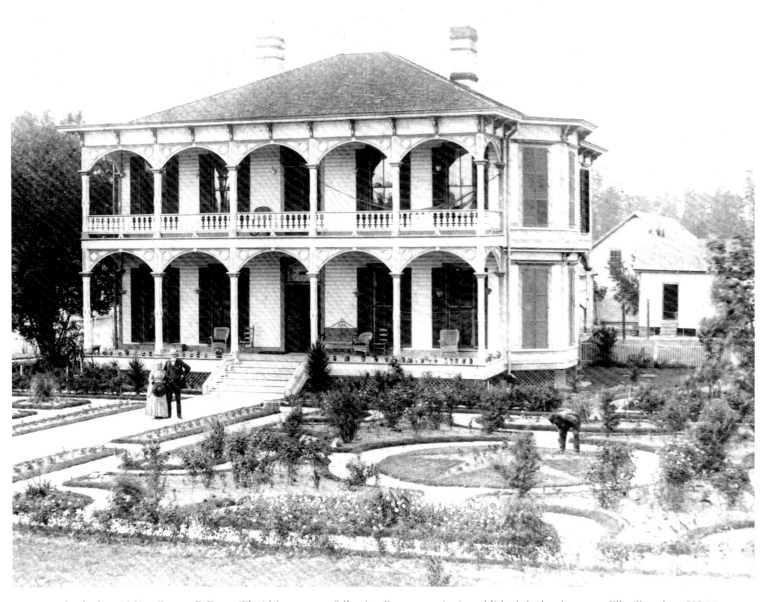

In the late 1860s, George F. Drew (Florida's governor following Reconstruction) established the lumber town Ellaville, where US 90 crosses the Suwannee River. He named it after one of his slaves. The Suwannee County town, which reached a population of 700 in 1895, began its decline in the early 1900s when most of the nearby lumber had been cut. In 1942, the post office was dissolved, and its building was moved to Madison, with the village of Falmouth handling its mail service beginning the next year. The old post office building was officially presented to the Madison County Garden Club and made a county historical site in 1972. All that remains are a few gravestones and ruins of the Drew mansion, which burned down around 1970.

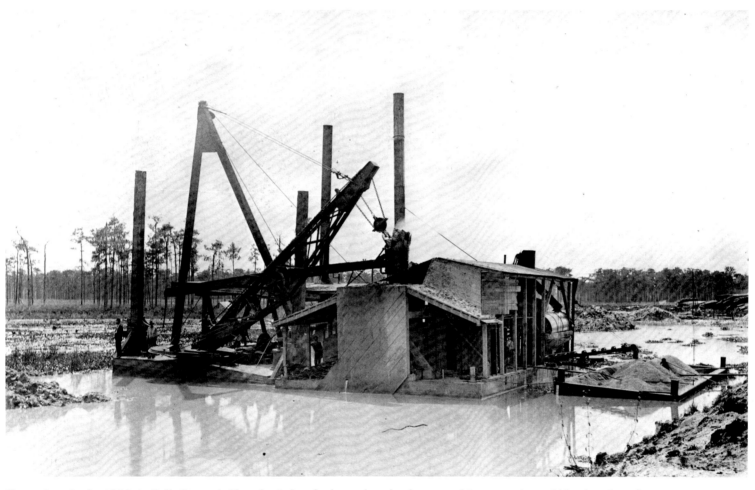

Shown here in the 1890s in Polk County's Phosphoria is a dredge and washer barge used in processing pebble phosphate for shipment. The short-lived post office was established on October 28, 1891, and closed on May 15, 1908. Thereafter, mail for the area was handled in Bartow.

In 1905, the Pembroke Mine and its company town in Polk County were purchased by a French company and changed hands several more times over the years. During the 1940s, the town experienced growth due to increased phosphate mining. One of the earliest buildings still remaining is the mine laboratory, erected in 1906. Pembroke was granted a post office five years later. The combination post office and commissary still stands but was abandoned long ago. All that is left with the name of a once active community is a road sign. The mine is shown here as it appeared in its construction stage.

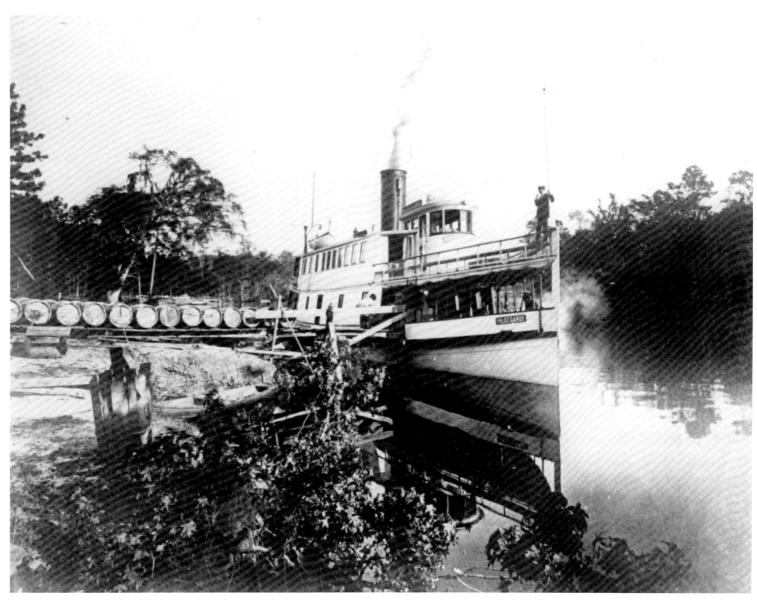

Along the St. Marys River in Nassau County, a home was built during the 1790s at a location known as Sandag and Sandy Bluff. In 1803, it was acquired by Burroughs Higginbotham. His heirs still had the property in 1827, and around that time Enrique Gilbert obtained land there to establish a brickyard. Around the business of making clay bricks, including those used to construct Fort Clinch in Fernandina Beach, grew the settlement of Brickyard, which had a post office in the mid-1870s. The brick-making business ceased by 1881, and Brickyard began its decline. However, the docks continued to be used to ship naval stores hauled from the town of Lessie. Shown here in 1906 is the steamship *Hildegarde* loading barrels of resin at the Brickyard docks.

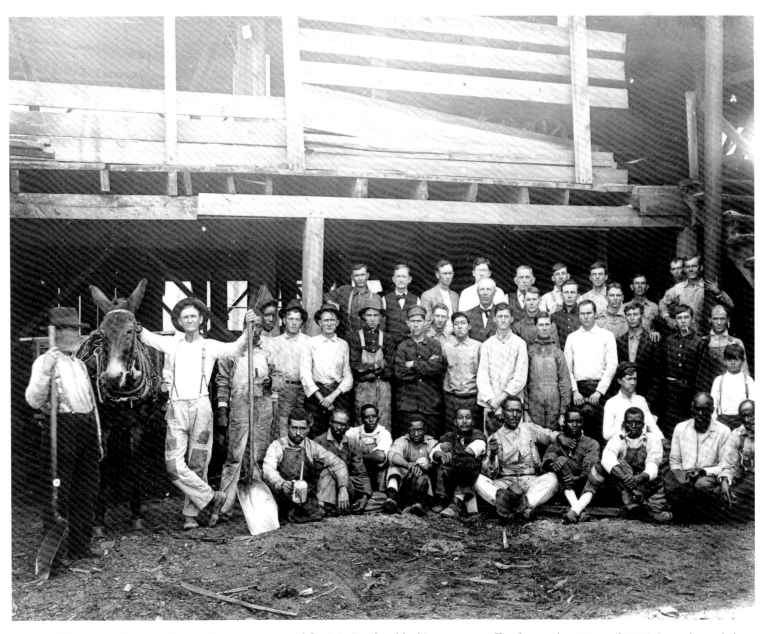

The town of Boyd in Marion County was named for J. B. Boyd and had its own post office from only 1891 until 1895. It was located along the Norfolk Southern Railroad track where CR 140 (Boyd Road) crosses it just west of US 221. This photo from around 1910 shows the employees of the Weaver Loughridge Lumber Company sawmill located in Boyd.

Lessie was located seven and a half miles east of Hilliard along Lessie Road, north of CR 108 in Nassau County. Oscar Moore built a turpentine still there during the 1890s and constructed a commissary for his business. Others came to work for him and built homes near his, with their children attending either the Wilder Swamp or Brickyard schools. In a corner of the commissary, a post office opened in 1899 and lasted nine years. Barrels of resin produced in Lessie were shipped out along the St. Marys River from the Brickyard docks, and the turpentine operation eventually switched ownership to J. R. Wilson and James Gross, who both departed in 1912. Later, the property was owned by Dixon and Son until the business shut down and the settlement dispersed. This 1910 photo shows a flowing well in Lessie.

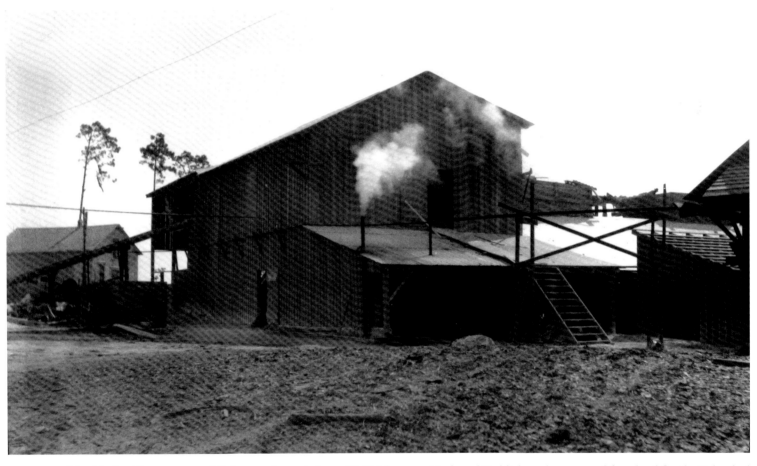

The Marion County town of Zuber was located along CR 25A between Ocala and Reddick, and was named for a local family. Zuber had its own post office for only ten years, from 1907 until 1917, when mail service shifted to Kendrick. Shown here in 1913 is the Florida Lime Company Plant Number 3 in Zuber.

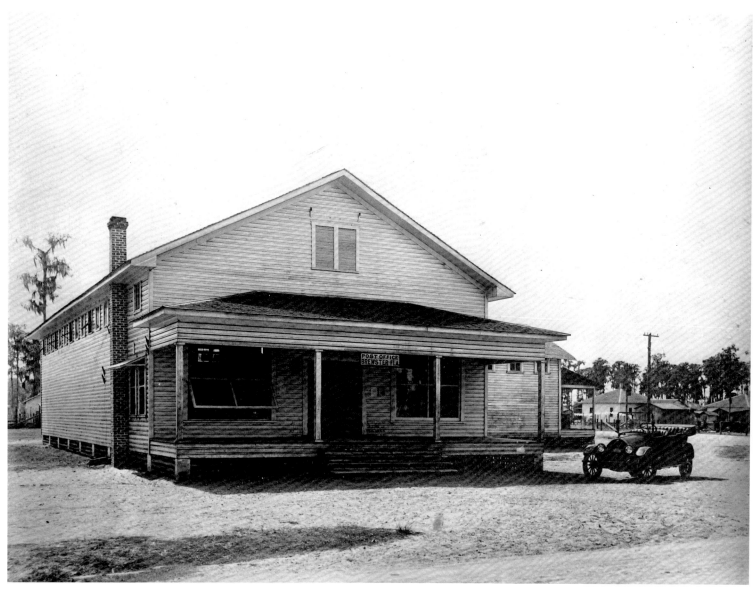

Brewster, established in 1910, was a Polk County company town of the Brewster Phosphate Company. Previously called New Chicora, the town was renamed for Amalgamated Phosphate major stockholder B. H. Brewster, Jr. The first structure was a smokestack, which remains standing today along with remnants of the power plant, phosphate pits, and the Brewster Watering Hole, a beer bar. The village closed in 1962, and residents were offered the opportunity to purchase their homes and move them, which many did to Fort Meade, Bartow, and Bradley Junction. The phosphate plant closed down in the 1970s, and the land was deeded to the state as partial satisfaction of an environmental damage judgment against American Cyanamid Company. Shown is a 1917 photo of the post office and company commissary, located off today's Old SR 37, north of CR 630.

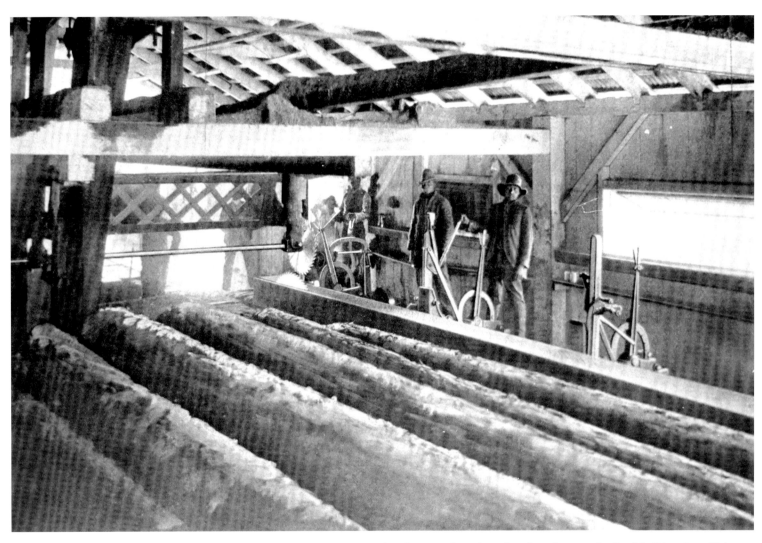

Muscogee was founded by lumbermen in 1857 in Escambia County where the railroad tracks cross the Perdido River into Alabama, just north of CR 184. While the mill was operating, the town's population varied between 300 and 400. This photo taken in the second decade of the twentieth century shows the interior of the Southern States Lumber Company sawmill. About all that remains today of Muscogee is a cemetery. The name Muscogee comes from a city of the same name in Georgia derived from the Creek term for "swamp" or "swamp Indian."

In about 1880, Benjamin Franklin Camp built a home in Alachua County for himself and his bride. The following year, he and his brothers, R. J. and J. S., founded the town of Campville along the nearby Peninsular Railroad tracks. They owned the Campville Brick Company, and many residents were engaged in making bricks or cutting lumber. The Camp brothers also partnered with W. H. Kayton in a plant nursery. By the mid-1880s, Campville had 250 residents, a general merchandise store, grist mill, and cotton gin. The few Campville homes standing today are located near the railroad track along NE 191st Terrace, north of NE 190th Terrace. They were first sold with deed restrictions prohibiting liquor sales on the property. This photo shows an abandoned clay pit in Campville.

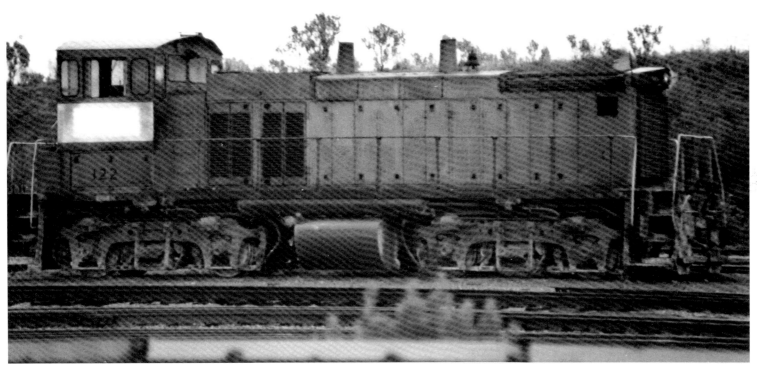

In Polk County along SR 60 between Mulberry and Bartow was another phosphate company town, Ridgewood. Its up to 200 residents worked for the Davison Chemical Company in its phosphate mine and factory. The town was founded by Harry L. Pierce after he left his first phosphate business in the town of Pierce. During the 1950s, the company town disappeared and was phased out the following decade. Although the phosphate mine still exists, the Ridgewood name appears on little more than road signs. Pictured here in the Ridgewood vicinity is the Seminole Phosphate Company engine No. 122.

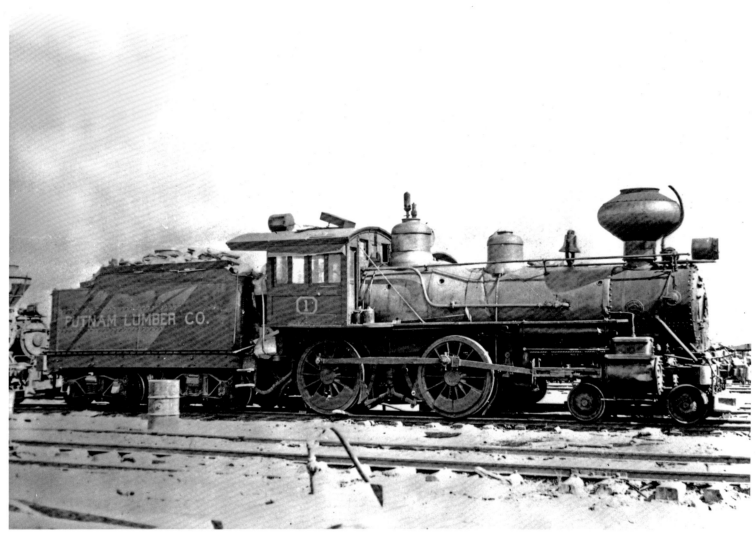

The Dixie County town of Shamrock was situated along Alt US 19/27 about a mile west of Cross City. Shamrock, named for a nearby lumber company's mill, established its post office on March 10, 1928. This photo features an engine built in 1893 by the American Locomotive Company. After 1918, the engine was acquired by the Putnam Lumber Company and operated in Shamrock.

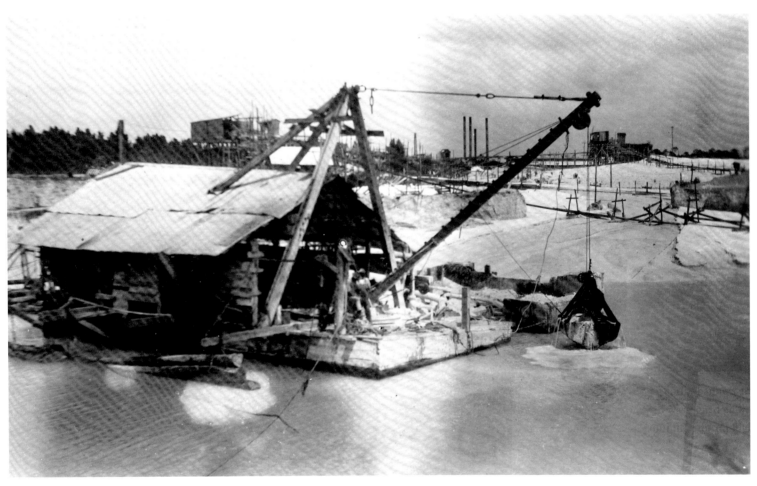

On Keuka Road east of CR 21 in Putnam County was the town of Edgar, which by the mid-1890s boasted of a post office, general store, and many orange groves nearby. Its Oak Grove Sunday School, meeting beneath a brush arbor beginning in 1887, was organized by Brother Isaac Newsome and evolved into the Mount Bethel Missionary Baptist Church. Edgar's post office, after operating from 1894 until 1960, moved to Interlachen. The kaolin pit pictured here was operated by the Edgar Plastic Kaolin Company, formed to exploit the state's largest kaolin deposits used to manufacture perfumes and toiletries. The region's kaolin mining survived the Great Depression and several decades thereafter.

The town of Benotis grew up around the Taylor County soft phosphate plant of the Otis Phosphate Company, pictured here in 1920. Its post office operated from 1917 until 1922. According to local legend, the name comes from the Latin nota bene, meaning "note well."

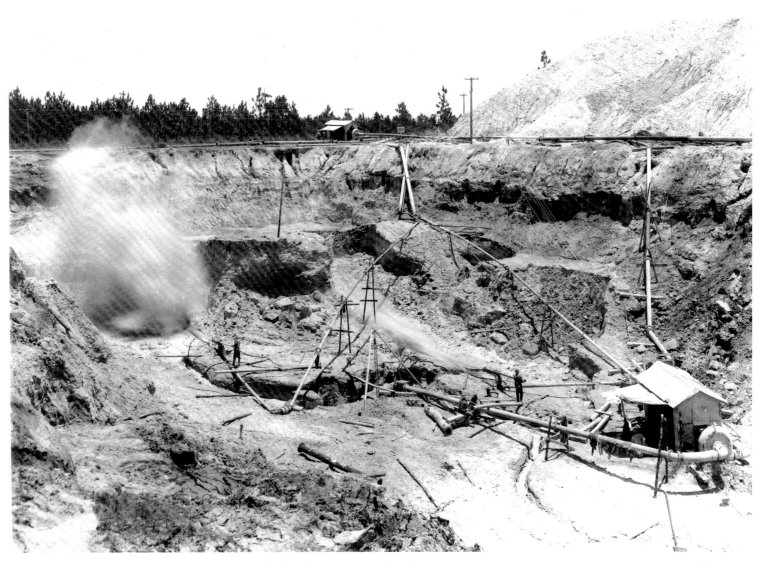

This 1925 photo shows a crew using hydraulic pressure at a phosphate mine in Pauway. It was a company mining town in Polk County that opened its post office on August 13, 1907. That closed only a few years later on May 31, 1912, and mail service to the area was taken over by Lakeland.

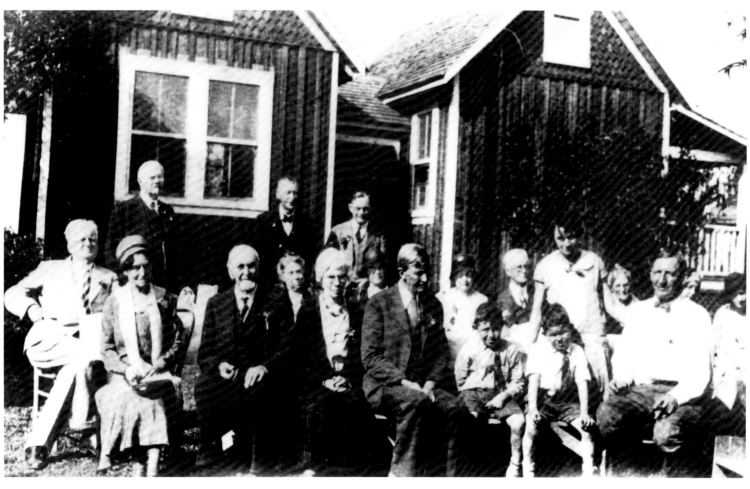

Northwest of Fort Meade in Polk County was Agricola, established by 1907 as a company town of Swift and Company, a food-processing plant and phosphate mine. Residents were served by a school and stores, and all worked for Swift. During the mid-1950s, Swift no longer felt compelled to provide housing for its employees. Agricola residents were offered the opportunity to purchase the homes they had lived in and move them; those that were not relocated were torn down, and Agricola ceased to be a town. The mine was managed in the late 1920s by David M. Wright, seated at far-right wearing a white shirt in front of his Agricola home with a gathering of University of Michigan alumni. The name Agricola comes from the Latin term for "agriculturalist" or "farmer."

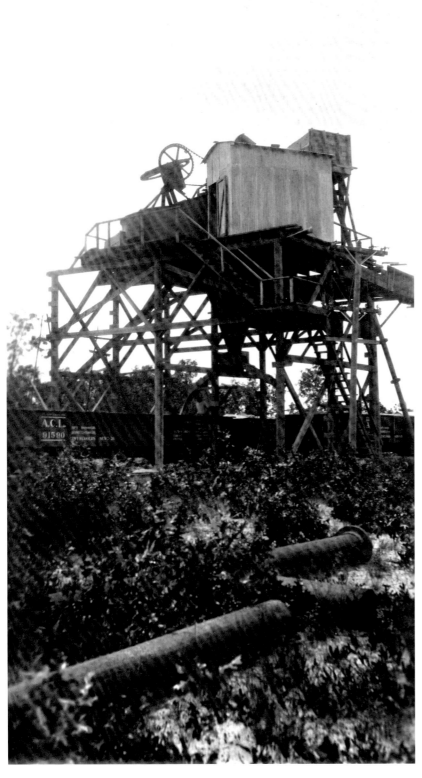

Located in Putnam County along Keuka Road (CR 20A) at the intersection with Strickland Road was the town of Keuka, developed around 1882 by the Keuka Land Company shortly after the Southern Railway laid its tracks nearby. Its population in 1889 was about 200, then dropped to 65 in 1938. It may have been named for an early settler, William L. Keuka, or for New York's Lake Keuka, whose name in the language of the Seneca Indians means "landing place" or "taking canoes out." Many of the earliest settlers were members of the Church of the Brethren who advocated peace, temperance, and simple living. That church died out in Keuka by the late 1930s. Shown here in 1927 was the Diamond Sand Company washing and classifying plant.

Fellowship was located along US 27 at the intersection with CR 464B in western Marion County, and was connected to Ocala by a pony express mail route in the 1880s. Its 1895 population was only 21. Nearby was this oil derrick photographed in 1928, belonging to the Flesher Petroleum Company.

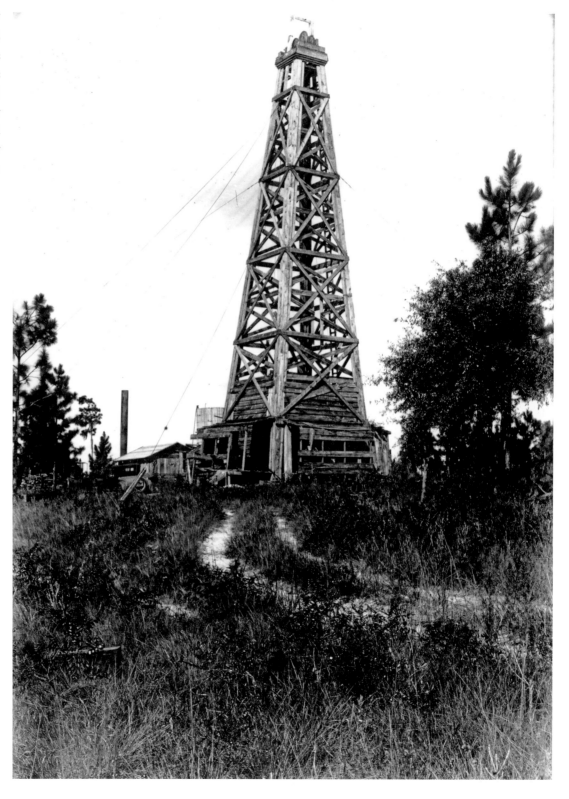

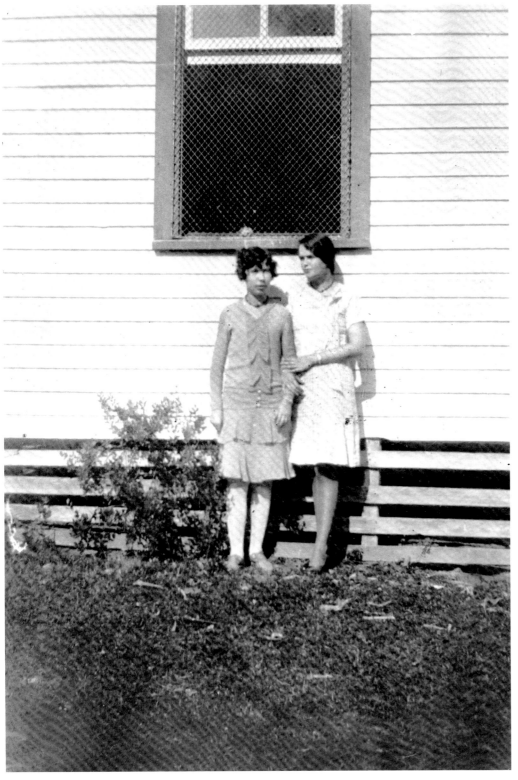

In 1898, a post office named Bailey opened in Calhoun County at the intersection of today's SRs 20 and 73. It was renamed Clarksville in 1905 after the Clarks, a prominent local family. One of the businesses active there was the Calhoun Gas and Oil Company, which had an oil well in Clarksville in the early 1920s. Shown here in a 1929 photo are a pair of Clarksville teachers, Arra Nichols and Lois Kelly.

The town of Bay Harbor was established in the late nineteenth century in Bay County and was an active port because of the operation of a local paper mill. Bay Harbor had a post office from 1914 to 1952. The old post office building on Everitt Avenue was razed in the 1990s, and much of the former townsite was turned into a parking lot for the remaining Panama City Paper Mill. All that is left of the former town is a few homes. Shown here is a well being drilled in 1930 for the Southern Kraft Paper Corporation in Bay Harbor, named for the nearby St. Andrews Bay.

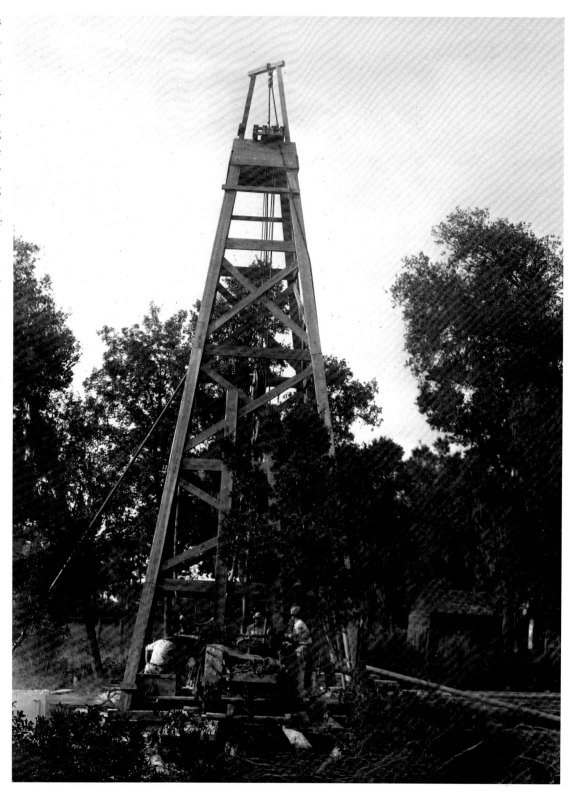

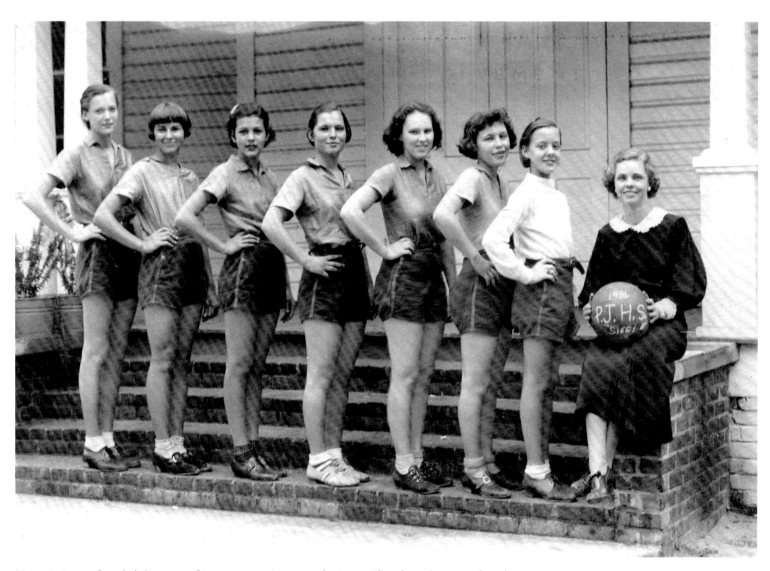

Harry L. Pierce founded the town of Pierce in 1906 to serve the Pierce Phosphate Company, later known as American Agricultural Chemical. It was located at the intersection of Old SR 37 and Pebbledale Road in Polk County. A post office opened with the name of Philippi, then was renamed Pierce in 1907, the same year a school was established. In 1955, the company closed and sold the homes to the employees, who then had to move away. Many wound up in Pinedale, Oak Terrace, and Rolling Hills. This is a group photo of the Pierce Junior High girl's basketball team of 1936.

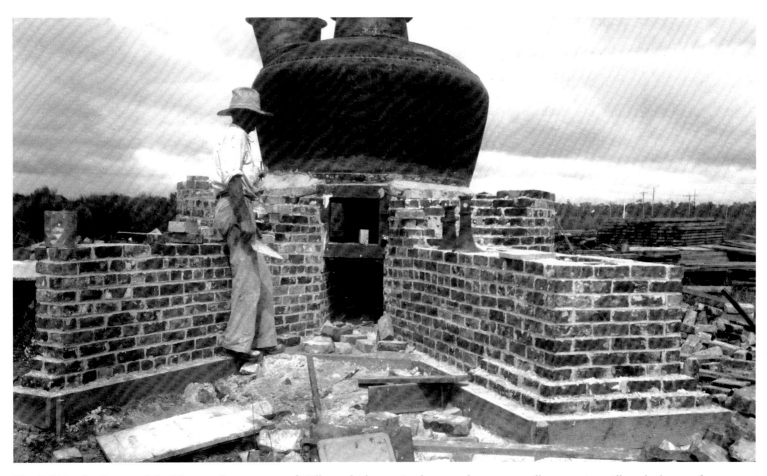

The Robbins family started the Manatee County town of Willow, which contained a general store, sawmill, turpentine still, and a house of ill repute, in addition to the homes of sawmill workers. A post office opened in 1889. The mill closed during the Great Depression, and the turpentine business was moved to Tampa. This 1937 photo shows the government plan turpentine still of F. R. Snowden, located near the Hillsborough County line at the dead end of Willow Road east of US 301.

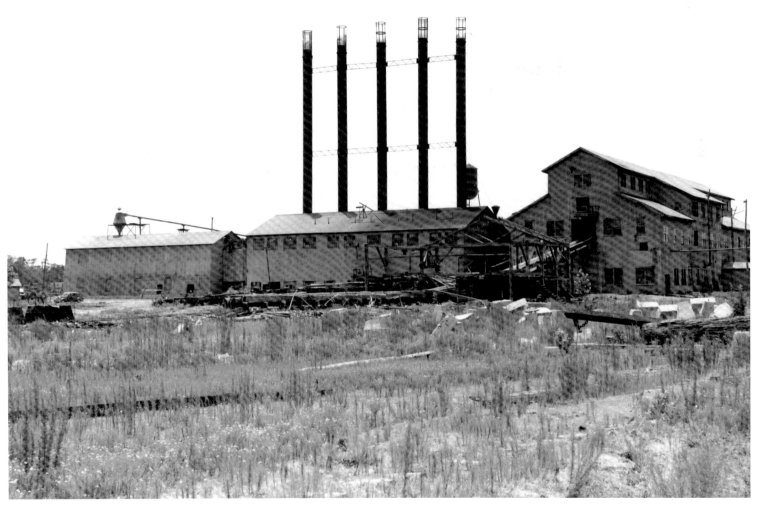

Caryville was first settled in 1845, and one of its early names was Half Moon Bluff. The Pensacola and Atlantic Railroad arrived in 1882, so the town was renamed for R. M. Cary of Pensacola, the secretary of the railroad. In 1903, it was the first town in Washington County to have electricity. Caryville thrived as a lumber town until 1937, when the mill closed. This photo shows the Caryville lumber mill being dismantled. The town was located at the intersection of US 90 (Old Spanish Trail) and CR 279 (Waits Road), just east of the Choctawhatchee River, close to where the Louisville and Nashville Railroad crossed the river. The town had its own school until 1968, and sawmill operations continued into the 1980s. Nearly all of the few remaining homes and other buildings were destroyed by floods in 1990 and 1994.

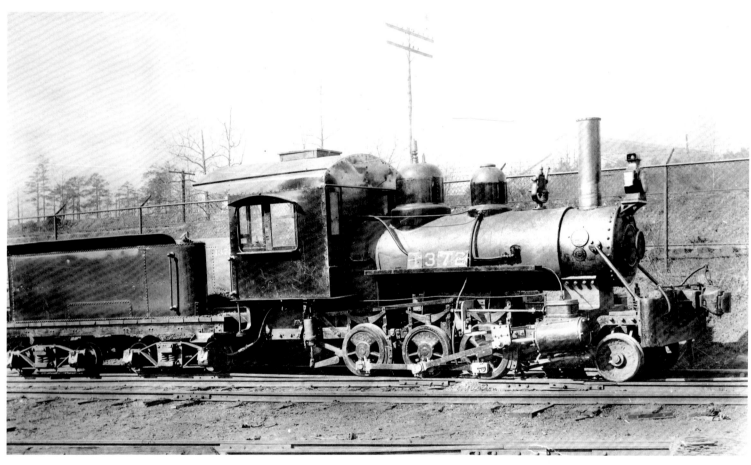

From 1916 to 1918, the Osceola Cypress Company built the town of Bridgend, also known as Osceola, about a mile below Lake Harney. Along the shore was the lumber mill with stores, offices, and residences located across Osceola Road. Trees were cut near Lake Okeechobee and hauled to Bridgend by railroad, which included this engine acquired in 1919. Others cut in Bithlo were also processed in Bridgend. The mill's generator provided electricity for the well-built homes, which featured indoor toilets. Beginning in 1939, the company phased out its Seminole County operation and moved it to Port Everglades, and the town disappeared. All that is left is the ruin of its brick bank vault.

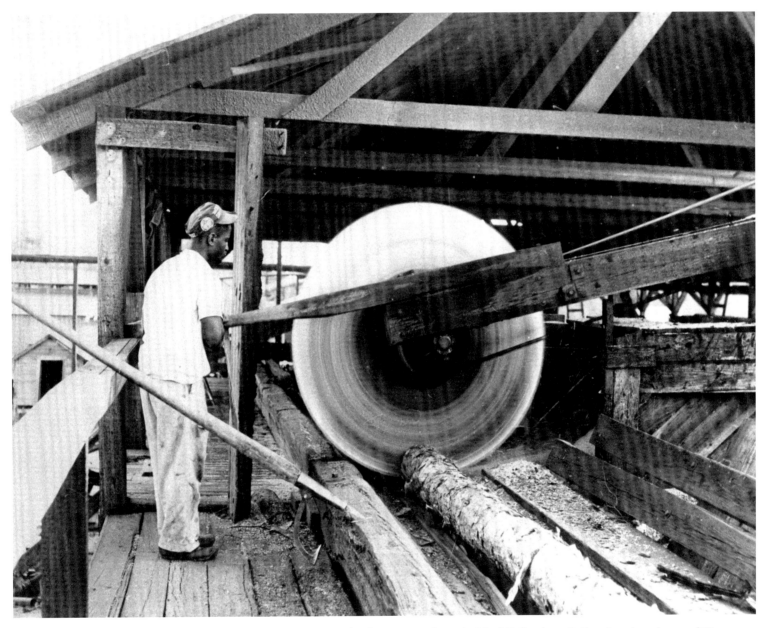

Established in about 1895, Watertown was located in Columbia County along the Norfolk Southern Railroad track and west of Watertown Lake, now part of the east side of Lake City. It is believed to have been named for Watertown, New York. The Watertown Post Office operated from 1890 until 1958 before moving to Lake City. This 1956 photo shows R. Gordan Granger at the deck saw of his Watertown sawmill.

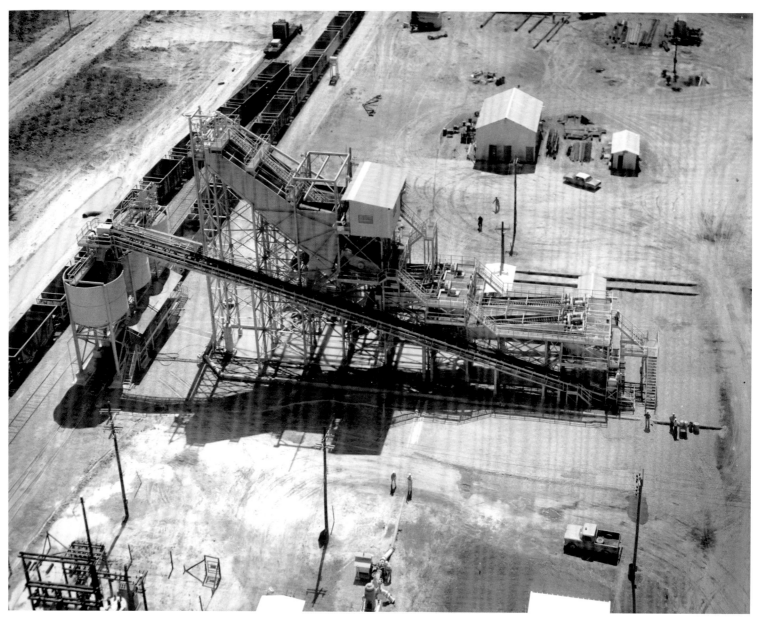

In Polk County a mile south of Mulberry on SR 37 was the company town of Kingsford, named for the Kingsford Mine that was purchased by Prairie Pebble Phosphate in 1903. Its first post office opened in 1893 and operated under the name of Mitchell until the following year, when Major Lewis McClain renamed it Kingsford. It closed in 1906, and mail service was transferred to Mulberry. Shown here in 1962 is the International Minerals and Chemical Corporation plant located at the former townsite.

PLANTATION DECLINES

North Florida in the early years was predominantly agricultural, with cotton and tobacco being the major crops. Plantations were established by wealthy families, often with labor provided by slaves. The number of people needed to cultivate these large areas of land constituted what essentially was a small town, and often the plantations attracted others who acquired land nearby to establish a real town. Many plantations date back to the years when Florida was a U.S. territory, and some survived as viable businesses well into the twentieth century.

One of the earliest well-documented plantations belonged to Dr. Andrew Turnbull, who in the late 1760s partnered with Sir William Duncan to obtain 60,000 acres of Florida land. Turnbull set up a plantation in what is now Volusia County for the growing of indigo, then needed to produce dye. He recruited indentured servants from Minorca and named his plantation New Smyrna after his wife's home region in Turkey.

Turnbull had intended to leave the onerous task of building the plantation to 500 black slaves, but on the trip across the Atlantic in 1768, their ship sank. That left all the work to the 1,403 white colonists who survived the crossing (148 did not), and the climate, mosquitoes, and other problems they encountered made their seven years of indenture seem much worse than what they had signed up for. Furthermore, the overseers at New Smyrna made life unnecessarily difficult, so complaints were sent to the British government. Eventually, the living and working conditions became intolerable, and the colonists walked away to live in St. Augustine, making New Smyrna an instant ghost town.

Whether the particular plantations suffered a relatively quick loss of their labor forces because they freed their slaves or because other workers departed, or because they instead faced a more gradual demise as demand for their crops or their large-scale operation waned, they all headed toward the same fate—becoming ghost towns. Some are remembered with restored buildings, some with ruins, and some only with photographs and memories.

Madison County's Hopewell was located five miles south of Madison on SR 360 at the intersection with Old Saint Augustine Road, a portion of the Bellamy Road constructed in the 1820s to connect St. Augustine with Pensacola. Pictured here in 1897 are Hopewell residents Joseph Austin Lamb, his wife Nancy Ann Farnell Lamb, and their children. In 1905, children in Hopewell attended the local school with P. F. Davis as their teacher.

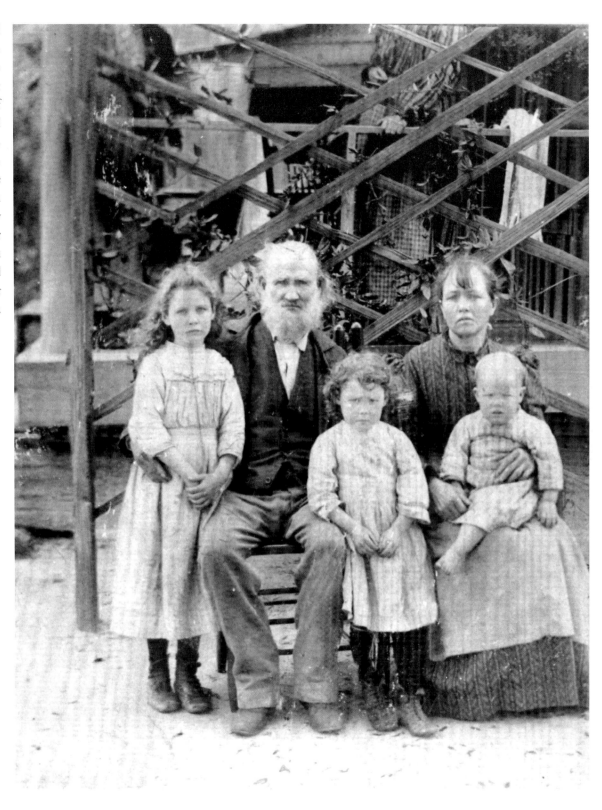

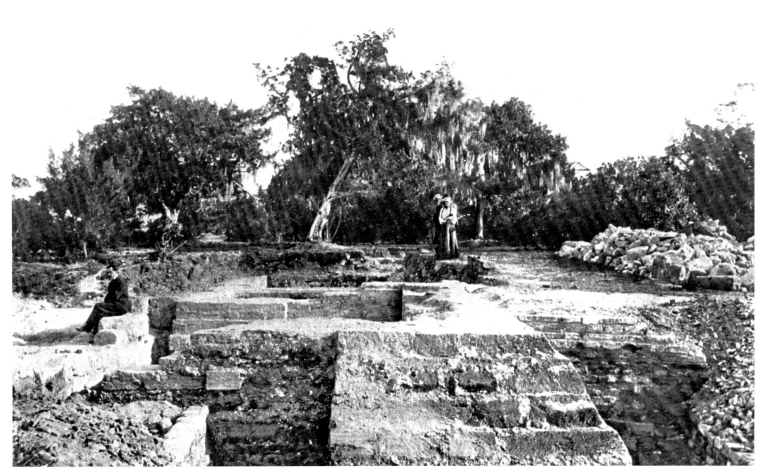

Often thought to be the foundation of the home of Andrew Turnbull, the ruins shown here are now believed to be part of a commercial structure for his colony of New Smyrna, named for the region in Asia Minor where his wife grew up. Built around 1768 atop a large Indian mound, it is sometimes referred to as the Old Fort Ruins and lies within today's city of New Smyrna Beach. New Smyrna ceased to exist on November 9, 1777, when the last resident left the Turnbull property and walked north to St. Augustine to live in the Minorcan Quarter.

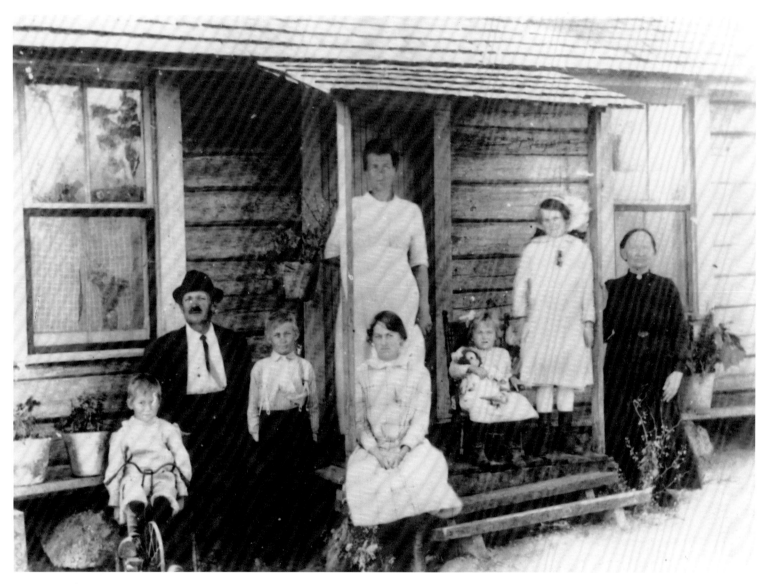

The town of Haile grew up around the plantation of the Haile family, who settled between Cadillac and Kokomo. In 1862, Edward Haile was one of two Alachua County representatives sent to Richmond, Virginia, to impress upon the Confederate government the importance of maintaining an army in Florida to protect its settlers. After the end of the Civil War, Haile partnered with George Savage in owning a dry goods store in Gainesville. This photo shows the John and Wilhelmina Salmi family on their front porch in Haile around 1910. The Haile name is memorialized in the restored plantation and the upscale community called Haile Plantation, begun during the 1970s.

In 1839, Pickene Brooks Bird acquired a plantation near Monticello in Jefferson County and named it Trelawn for the large oak trees growing on its lawn. The Birds became prominent in cotton planting, the nursery industry, business, and politics. They also grew LeConte pears on a 100-acre plot of Trelawn. In a corner of the plantation was the Drifton Post Office, near where the railroad track crosses US 19 south of the intersection with CR 158. In 1895, Drifton had only ten residents. This 1944 photo was taken 12 years before its post office closed and mail service moved to Monticello.

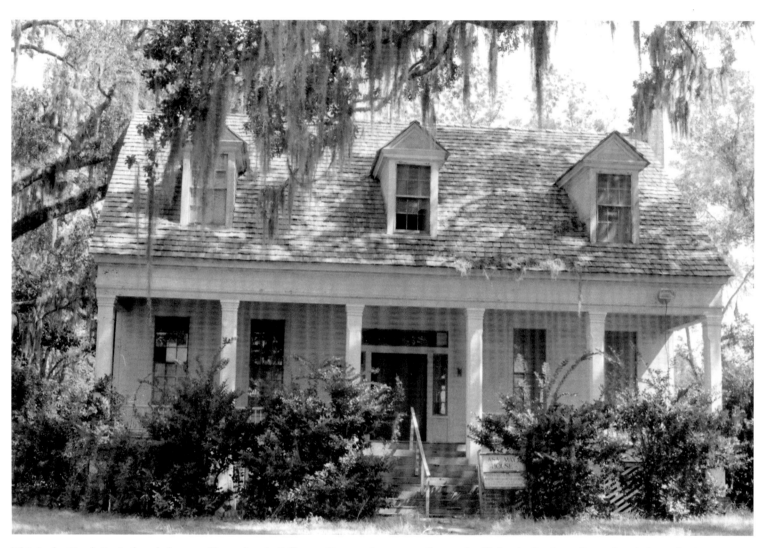

This is the Greek Revival–style home still standing in Jefferson County about ten miles south of Monticello along Capps Road. It was built by slaves in about 1840 as the Rosewood Plantation home of Asa May. The town of Capps was settled nearby and opened a post office in 1899 with James A. Brown as postmaster. It closed in 1928, and mail service was moved to Drifton. The bricks for the home's chimneys and piers were manufactured on the homesite, and the cypress exterior and heart pine interior are still intact and sound.

Blame It on the Railroad

In the opinion of many, the construction of railroad lines was the most important factor in the settlement of Florida. Large portions of the peninsula were located too far inland to be reached by boats, and until the arrival of the railroads, they were essentially inaccessible. Even if settlers could get to them on foot, there was no way to obtain supplies from civilization and no way to transport crops to market.

The railroads changed all that. With major coastal cities connected by numerous tracks crisscrossing the state, inland areas were opened to settlement. Towns sprang up where tracks met at junctions, crossed rivers, or just passed by an area where settlers believed they could make a living. A railroad company's plans to construct tracks meant that at minimum, a camp would be needed for workers, which often evolved into a permanent settlement once the temporary workers moved on.

Sometimes towns would be set up in advance along the expected route of the railroad tracks, only to find out that the right-of-way wound up a mile or more from the town center. Such a discrepancy usually meant that the original townsite would be abandoned or moved, or a new settlement along the tracks would eclipse the first one and perhaps absorb it. For example, the original Apopka town center was moved a mile to the west to take advantage of the opportunities afforded by the arrival of the railroad.

Where two towns in proximity both wanted the railroad, the one chosen by the railroad company would often be the only survivor. A good example of that occurred in Alachua County, where former county seat Newnansville became a ghost town when the railroad tracks were laid a mile and a half away through Alachua, a city still around today.

As one might guess, the abandonment of a railroad often resulted in towns along its former route turning into ghost towns. The success of a railroad could also turn thriving settlements into ghost towns, and that is what happened to St. Francis. It was a busy shipping point for steamboat traffic until the railroad took over as the region's major carrier of goods and crops. Since St. Francis was not on the rail route, it soon disappeared, while other towns near the tracks thrived.

The railroad's decision as to where it would lay its tracks, where it would establish depots, and when it would go out of business had a major impact on the state. Many Florida cities exist today because of the railroads. So do many ghost towns.

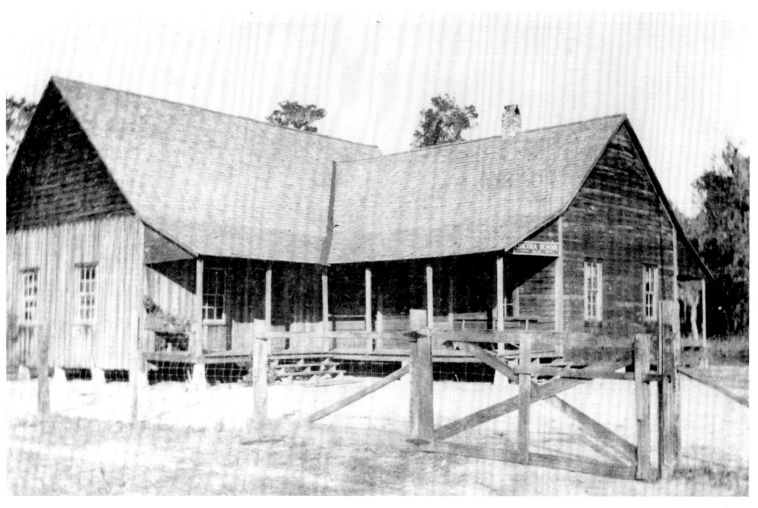

In 1885, the town of Chicora was founded in Polk County, not far from Mulberry. It included the school shown in this photo, a post office that operated until 1920, a blacksmith shop, a general store, and several homes. Early families included the Altmans, Albrittons, Aldermans, and Taylors. When the railroad came through the area, it missed the town by four miles, so the store and post office moved next to the railroad as a settlement named New Chicora. What remains of the original Chicora are the Bethlehem Church Graveyard and the Chicora Graveyard, situated in the front yard of one of the few remaining homes. Chicora may have come from a name given to the coast of South Carolina in 1521, based on Catawba words meaning "Yuchi are there."

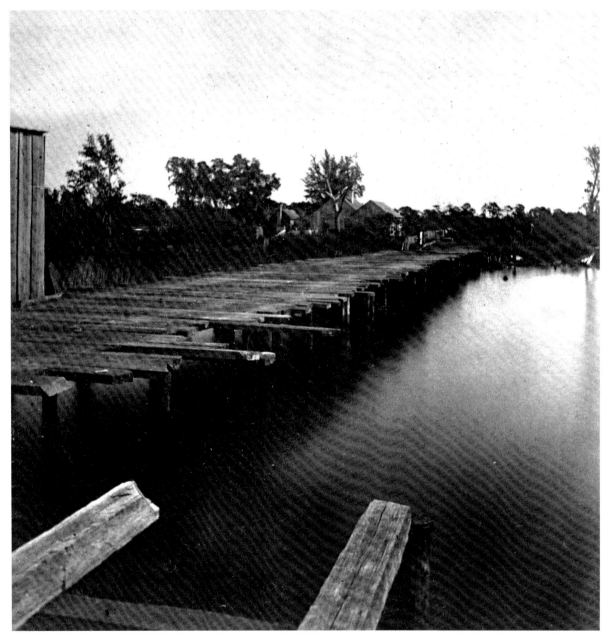

Picolata, Spanish for "broad bluff," was located in St. Johns County on the east bank of the St. Johns River, at the intersection of today's CRs 13 and 208. Originally an Indian settlement, it was replaced by a Spanish fort in 1735, which General James E. Oglethorpe captured in 1740. That fort, and one across the river named St. Francis de Pupa, had been built to protect the Old Spanish Trail that passed nearby. Naturalist William Bartram had an indigo plantation in Picolata in the mid-1760s, and the fort went into disuse in 1769. When nearby Tocoi built a combination mule-drawn and steam railway to transport goods and passengers from the river to St. Augustine, Picolata's commercial importance declined. The fort site is shown here as it appeared before 1900.

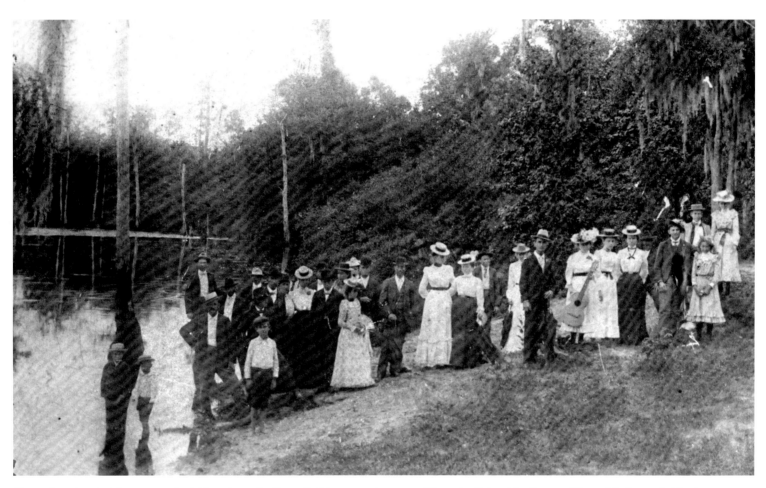

Shown here in 1901 is a group picnicking along the Santa Fe River near the town of Leno in Columbia County. Henry Matier settled in the area around 1850, and the town had a sawmill, two grist mills, six cotton gins, and a cottonseed oil mill. Its early name was Keno, a type of lotto gambling, because the town was a gambling center. In 1876, the first letter of the name was changed with the hope that its reputation would improve. Running nearby was the wire road with the telegraph line, but when the railroad bypassed Leno, the residents moved away. The site was then called Old Leno, and is now within the O'Leno State Park.

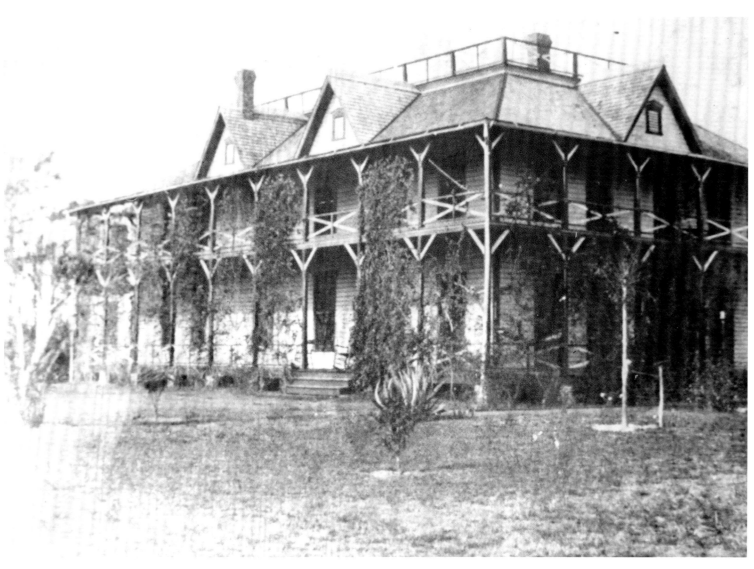

Located on a high shell bluff and originally called Old Town, St. Francis existed to serve steamboat traffic along the St. Johns River beginning in the 1880s, and opened a post office on March 15, 1888. However, the railroad from Jacksonville arrived in the region in 1886 and shifted the flow of freight away from steamboats, resulting in an economic decline for the town. Nevertheless, the newspaper *Florida Facts* began publication there in 1890. The post office closed on October 15, 1909, the same year the St. Francis Hotel shown here burned down. The townsite, located north of Crow's Bluff in Lake County, is now part of the Ocala National Forest.

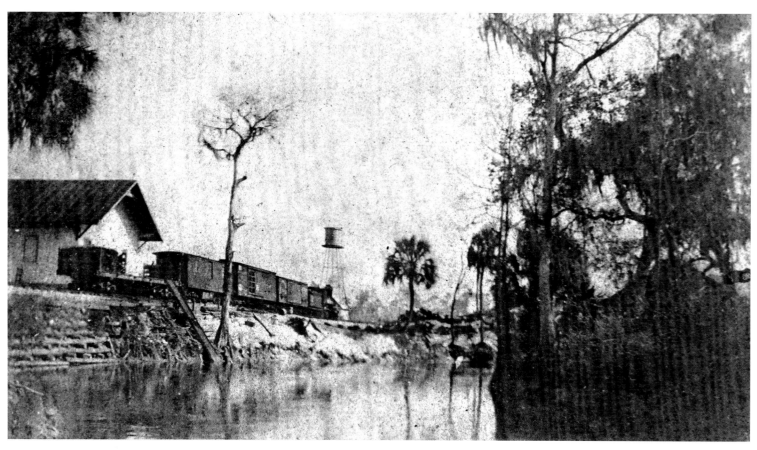

An important Citrus County port for shipping along the Gulf of Mexico, Port Inglis was located on Chamber's Island at the mouth of the Withlacoochee River. The port and the mainland city were named for Captain John L. Inglis, who ran a string of barges in the Gulf of Mexico. In 1889, John C. Dunn of Ocala began buying up land around Dunnellon to develop phosphate mines. John Inglis joined in that venture and became the president of the Dunnellon Phosphate Company. The Port Inglis Terminal Company set up the port and dredged the Withlacoochee River mouth to facilitate phosphate export. That lasted until World War I, when shipments ceased, the railroad was abandoned, and the shipping town, including a school, hotel, and church, died out. The Port Inglis railroad depot is pictured here during the second decade of the twentieth century.

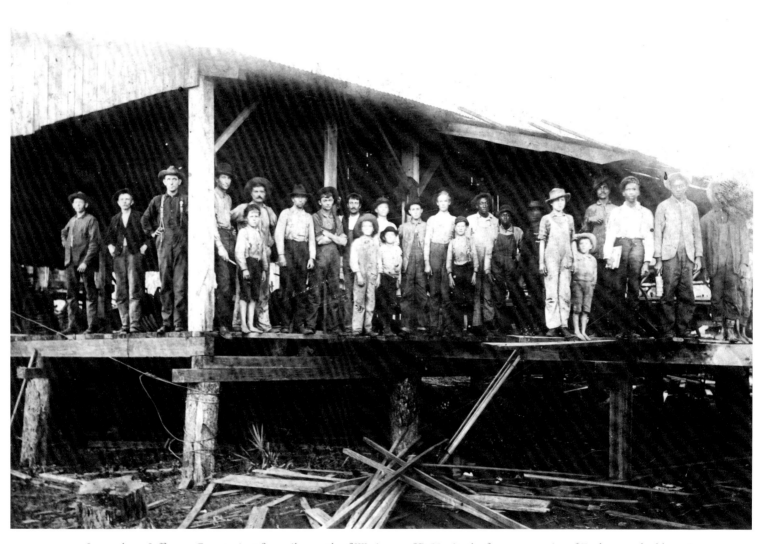

In southern Jefferson County, just five miles south of Wacissa on SR 59, sits the former townsite of Fanlew, reached by going a quarter mile to the west on a graded road to Fanlew Road. First known as Delph in 1904, it served as a railway distribution center for the Florida Central Railroad, which completed a 47-mile stretch of track in 1908 connecting Fanlew to Thomasville, Georgia. The town later served the Atlantic Coast Line Railroad, which acquired the Florida Central in 1914. Probably named for an Atlantic Coast Line superintendent, Fanlew shipped out timber and naval stores. Here sometime after 1910, the sawmill employees pose for their picture.

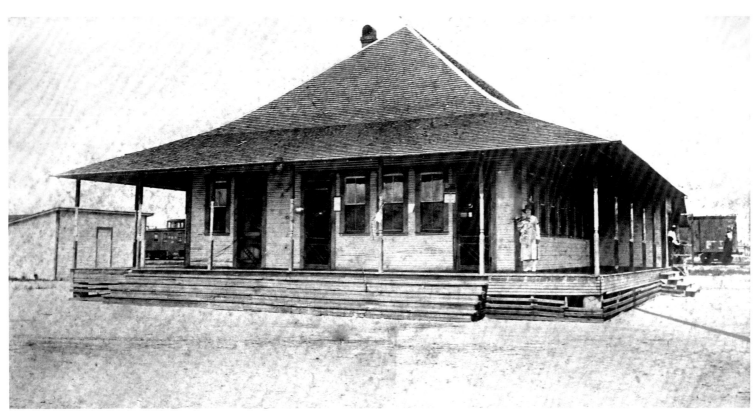

Munson was located in Santa Rosa County at the intersection of SR 4 and Munson Highway (CR 191). In 1913, it was named for Captain Charles M. Munson, general manager of the Bagdad Land and Lumber Company. That same year, the post office opened and operated until 1954, when it shifted to Milton. Shown here in 1914 is the Florida and Alabama Railroad company store and headquarters in Munson.

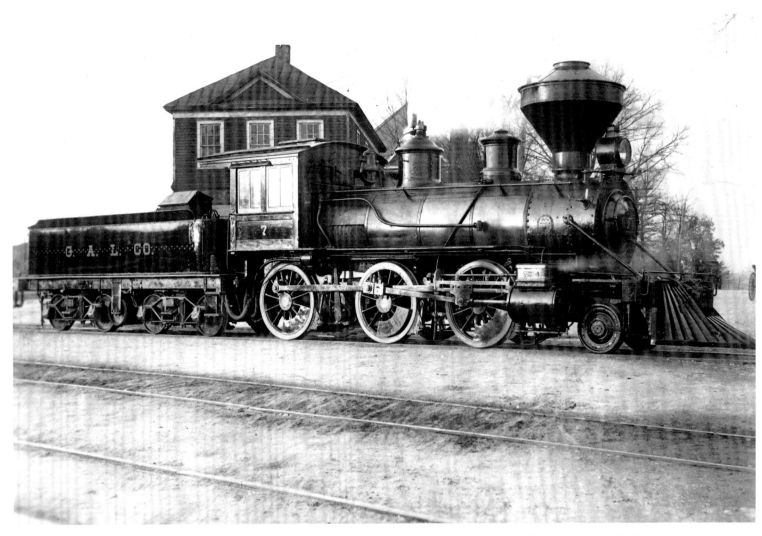

Located in Escambia County along Perdido Bay and SR 298, west of Pensacola, was Millview, a town with 406 residents in 1895. Its strongest sawmill days preceded the Civil War. Millview's post office, which opened in 1872, closed in 1935, and mail service was taken over by Pensacola. This 1915 photo shows an engine of the German American Lumber Company while it was stopped in Millview.

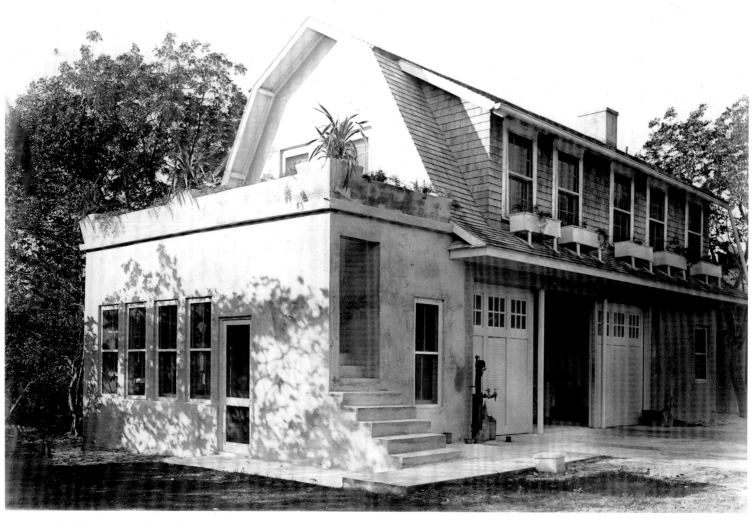

In 1883, Dr. William Cutler bought a former Indian hunting ground and 1838 Seminole Indian War battle site and started growing pineapples, tomatoes, and other fruit. By the end of the following year, the settlement of Cutler (near the intersection of today's SW 168th St. and Old Cutler Rd.) reached a population of 75 and had its own post office. It featured the Richmond Cottage hotel, a school, two stores, and two wharves. However, when the railroad bypassed it in 1903, the town began to decline. In 1915, the property now in Miami-Dade County was acquired by Charles Deering, who incorporated the Richmond Cottage into his home, available today for tours. Pictured here in 1919 is the garage and laundry of the Charles Deering estate.

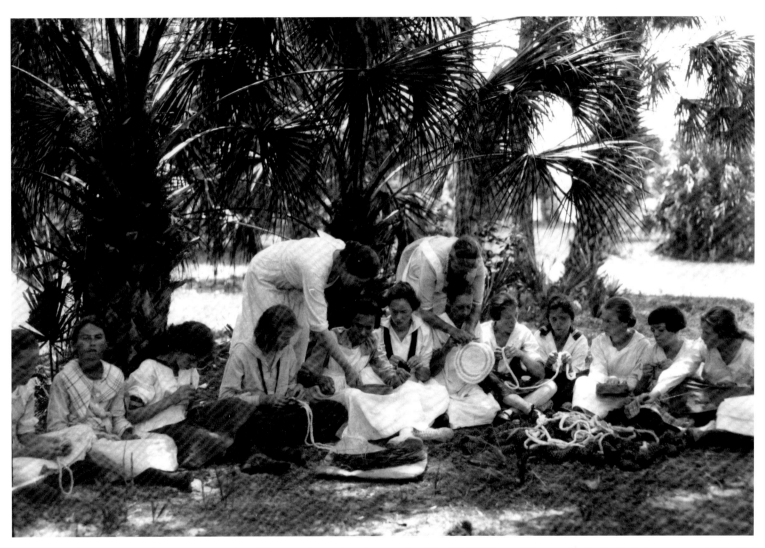

The Hernando County community of Bayport, located at the mouth of the Weeki Wachee River at the Gulf of Mexico, was established in 1842 by Major John D. Parsons as a supply and cotton port. It was important during the Civil War's Union blockade of the larger ports; as a small port, it was left alone and continued to receive shipments. When the blockaders realized that, Bayport became a site of skirmishes with the Confederate Home Guard. Afterward, Bayport was Hernando County's main port for shipping lumber and crops. When the railroad came to Brooksville in 1885, Bayport's importance declined. It had a post office from 1854 until 1955, when it moved to Brooksville. The Agricultural Experiment Station of the University of Florida operated a camp there, shown here in operation during 1921.

47

The Newnansville post office, established in 1826 along the cross-state Bellamy Road, was called Dell's Post Office for brothers James and Simeon Dell who first settled there in 1812-14. It was renamed in 1828 after a War of 1812 hero, Daniel Newnan, a volunteer soldier from Georgia. Newnansville's main products were cotton, corn, and citrus. The town's growth was hurt when the Alachua County seat moved to Gainesville in 1854, and its being bypassed by the Savannah, Florida and Western Railroad in 1884 signaled its eventual demise. It was further hurt by a citrus-ruining freeze in 1886. The population dipped to 152 in 1895 before essentially disappearing. This is a photo of the Eli Futch home built by 1861.

Government Involvement

Several times in Florida's history, towns have been purposely eliminated by the state or federal government. Often, that resulted from closing a fort that had been established to protect the residents from Indians, and without the fort, the adjacent settlement no longer had a reason to exist. Sometimes, the eventual evolution of the area into a ghost town would take many years, but its triggering can be traced to the fort closing.

Rarely, the Florida legislature has revoked a town's charter to punish it, as when the citizens of Boulougne went too far in using their municipal power to operate a speed trap. More often, governments have intentionally eliminated towns for a public purpose, such as the establishment of Everglades National Park, which reduced Flamingo from a viable town to merely the name of a public campsite.

Florida's biggest elimination of towns by government acquisition of land occurred on Merritt Island, east of mainland Brevard County. On the pages that follow are images of the former towns of Allenhurst, Orsino, and Wilson. Other towns eliminated at the same time, with nearly all their buildings either torn down or moved away, included Canaveral Harbor, Chester Shoals, Clifton, Eldora, Happy Creek, Haulover Heights, Heath, Indian River Shores, Mortonhurst, Nathan, Shiloh, Sorroquez, and Wisconsin Village. In their place now is the huge Kennedy Space Center, on portions of which can still be found remnants of roads that once connected over a dozen small towns.

One major Florida construction project that has been planned, started, and stopped several times is the Cross Florida Barge Canal, intended to provide a shortcut for water traffic going from one coast to the other. During the early 1930s, Camp Roosevelt was established to house workers arriving to construct a central section of the canal. After a couple of years, when it was essentially a separate town, the canal project was stopped, and Camp Roosevelt became an educational facility and later a part of residential Ocala. The town of Eureka was hit hard twice by project cancellations, beginning with a decision in the 1920s not to build a dam and hydroelectric plant in the vicinity. It hung on until the 1970s when, with federal termination of the canal project, the elimination of a proposed adjacent recreational area resulted in Eureka turning into a ghost town.

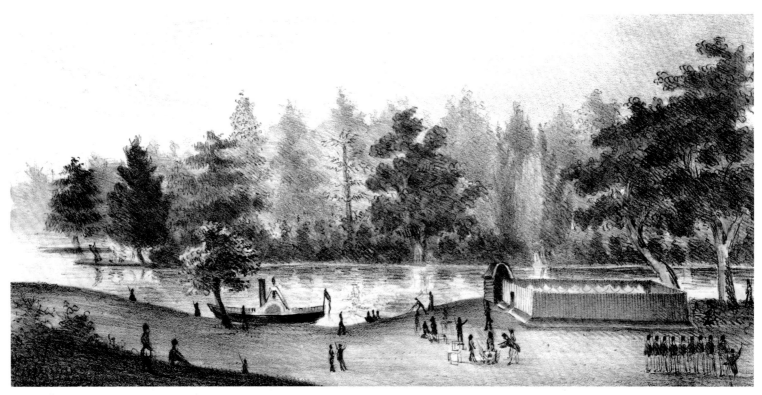

Along the east side of the St. Johns River was Fort Barnwell, also known as Fort Columbia, Fort Call, and Camp Volusia. It served as the Mosquito County seat from 1824 until 1843 and is now part of Volusia County. Nearby were the William Bartram Trail and the Volusia Military Cemetery. This lithograph printed in 1837 shows activity at the fort during the Second Seminole War. E. E. Ropes of Massachusetts purchased the log landing, constructed a log home on it, and served as the postmaster of the town, then named Volusia, from 1868 until 1870. He also served in 1874 as the first worshipful master of Volusia Lodge No. 77, the county's oldest Masonic lodge. The wooden toll bridge, which crossed the St. Johns from Volusia on one side to Astor on the other, was moved to Barberville for its preservation.

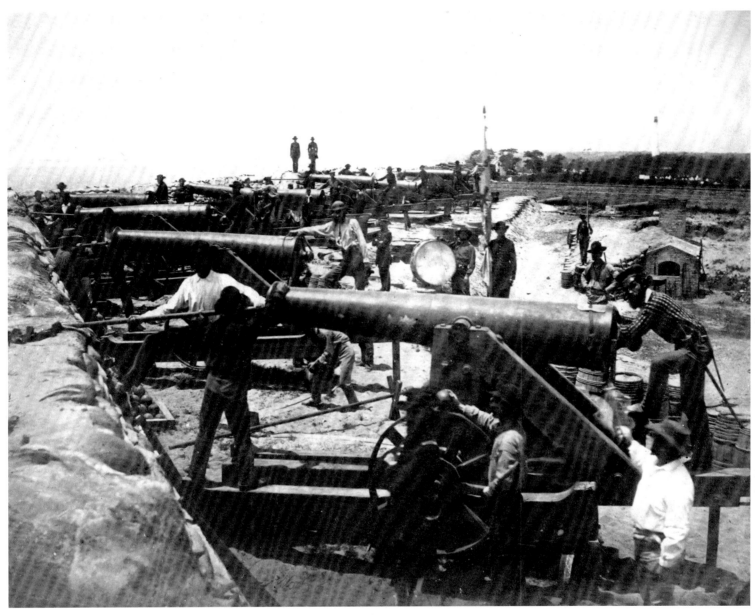

Warrington was situated in Escambia County north of Bayou Grande, just southwest of today's Pensacola Country Club. It was founded in the 1840s during the construction of the Pensacola Navy Yard and was named for U.S. Navy Commodore Lewis Warrington, who supervised the Navy Yard construction in 1825, then served as its first commandant for a year. Warrington had a population of 1301 in 1895. The town was moved away in 1929 to New Warrington, a site along Bayou Grande, to make room for government property expansion. The old site is now part of Pensacola. This 1861 photo shows Columbiad guns at the Confederate water battery.

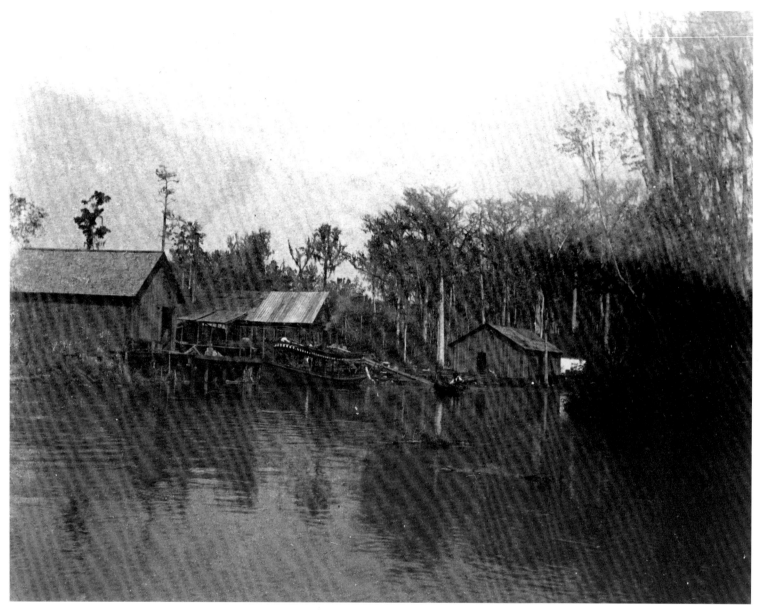

Near the Oklawaha River in Marion County, along CR 316 east of Fort McCoy, was the town of Eureka, from the Greek term meaning "I have found it." Its post office operated from 1873 until 1955, then moved to Citra. Pictured here in 1892 is a steamboat taking on wood as fuel at the Eureka landing. The section passing by Eureka was the narrowest part of the Oklawaha River, Cypress Gate, and it determined the maximum width of the steamboats constructed especially for that river. Near Eureka, a large hydroelectric dam and power plant was planned during the 1920s, but the advent of the Great Depression killed the project before construction began. In the 1970s, federal termination of the Cross Florida Barge Canal project and the proposed recreational facility in Eureka killed the town's chances of making a comeback.

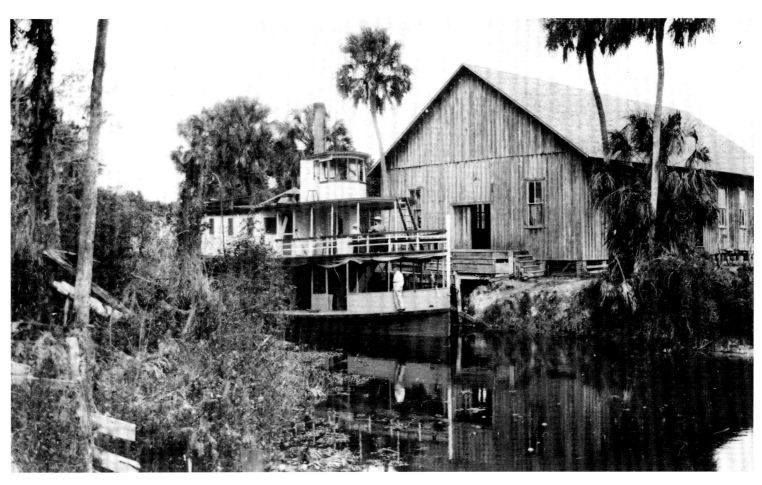

Located on the east bank of the Caloosahatchee River off CR 78A, west of Labelle in Hendry County, was a fort established in 1838 during the Second Seminole War. It was named for the landowner, Pierre Denaud, and Fort Denaud initially was made up of a blockhouse surrounded by tents. In 1855, additions included a hospital, prison, guardhouse, sutler's store, stables, and barracks. A farming community grew up around it. The fort was abandoned in 1858, and most of the settlers moved away. Shown here in the 1890s are the Duval Warehouse and the steamboat *Poinsettia* at the river landing that had previously served the fort and settlement.

Allenhurst was a sports fishing town situated at Haulover Canal, just north of Dummit Cove in Brevard County. As the settlement of Haulover, it was established by Captain D. Dummit in 1852. It was renamed for ferryboat operator Commodore J. H. Allen who, with his friends, established a hunting club in the town around 1910. The last residents' property was purchased by NASA, and the homes were demolished to make room for the Kennedy Space Center. The boat shown in this photo taken not long after 1900 was owned by the James Heddon and Sons Fishing Tackle Company of Dowagiac, Michigan. Its representatives cruised the Atlantic Coast and rivers of Florida, including this area adjacent to Allenhurst, to experiment with their lures and other fishing tackle.

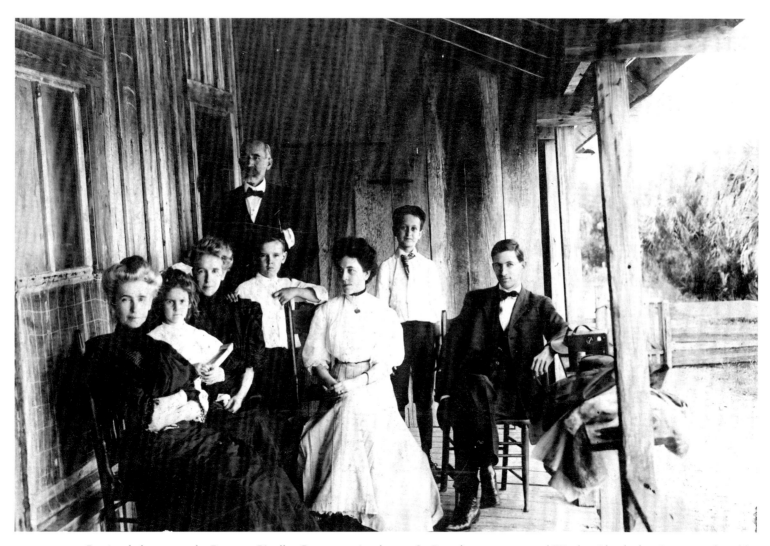

Previously known as the Bayou, a Pinellas County peninsula near St. Petersburg was renamed Weedon Island when it was purchased by Leslie Washington Weedon, Sr., in 1898. It was a retreat for the wealthy and those hiding from the law. During the 1920s, the Sky Harbor Airport was constructed there, and Pitcairn Aviation planes connected with Miami, New York, and Washington, D.C. In the late 1980s, the state purchased the property and turned it into a wildlife preserve, but airport remnants can still be found there. This is a 1907 portrait of the Weedon family on the porch of their caretaker's home.

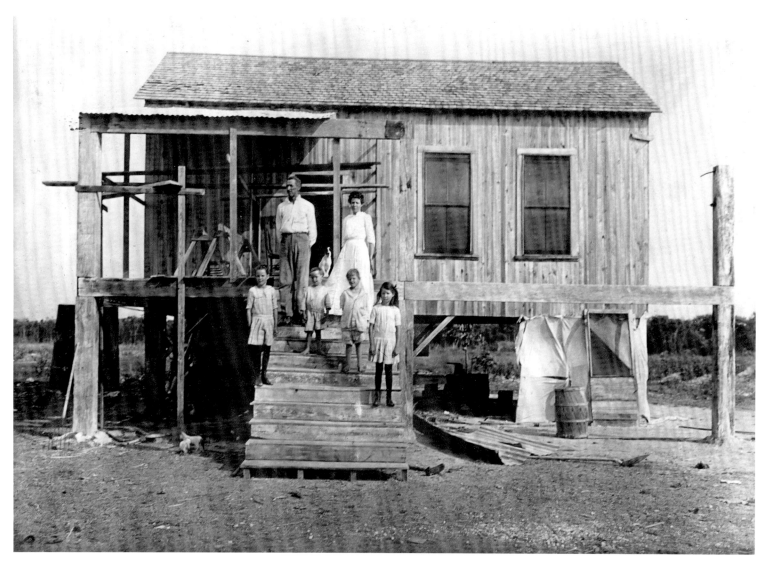

This Monroe County former townsite is reached by driving to the Flamingo campground in the Everglades, then hiking a trail four and a half miles to the Slagle Ditch. There around 1892, Duncan Brady and other settlers arrived, and when the post office opened the following year, the town consisting of 38 shacks was named for non-indigenous birds seen along the coast of the Gulf of Mexico. By 1910, a year after the post office closed, there were only three occupied houses in what was the southernmost community on the mainland of the continental United States. What was left became part of the Everglades National Park in 1947, and the few remaining residents were moved elsewhere. In this 1916 photo, John Douthet and his family pose on the steps of their home, which is elevated on stilts to allow hurricane flooding to pass underneath.

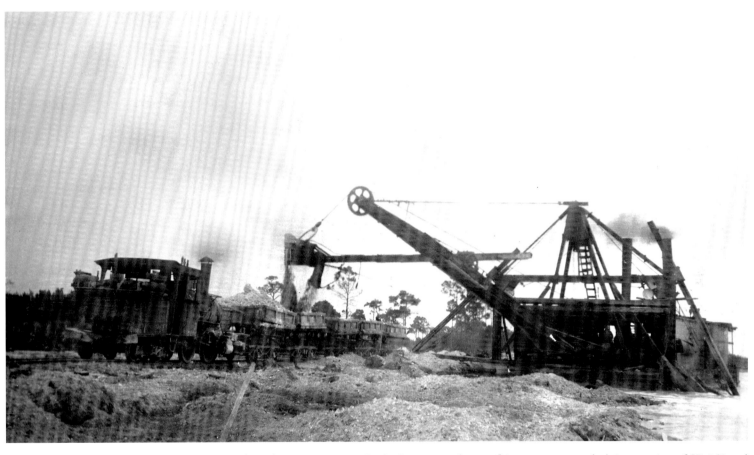

The town of Ojus was situated in what is now Miami-Dade County, southwest of Aventura, near today's intersection of SR 860 and Biscayne Boulevard (US 1). It was established as a vegetable- and fruit-growing settlement, and later became known for its rock quarries, which produced material for surfacing roadways. Shown here in 1924 is the dredge and freight train of the Maule-Ojus Rock Company. The name of the town is Seminole for "plenty," but during the 1930s, all that Ojus had plenty of was indebtedness. Because of that, in 1936 the Florida legislature abolished the town.

In Brevard County, just north of NASA's Vehicle Assembly Building and the space shuttle landing strip, is the site of the former company town of Wilson. It was established to serve the Wilson Lumber Company, named for the 1912 settler James Wilson. This is a photo of the lumber company during the 1930s. The town and company site were dismantled in the 1960s to provide room for the construction of the Kennedy Space Center. About all that remains are remnants of some of the old town roads.

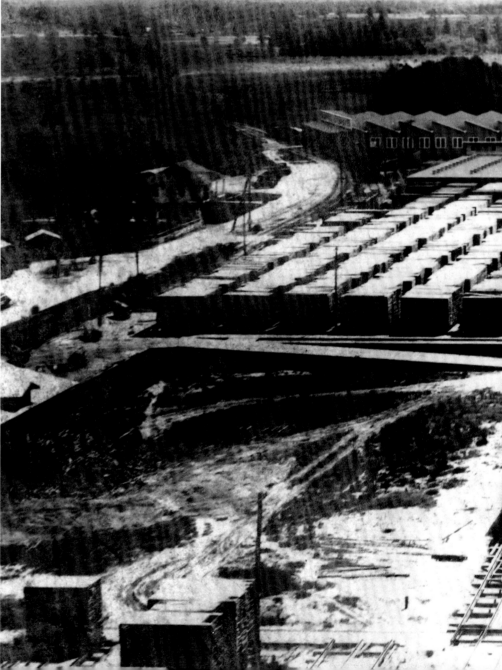

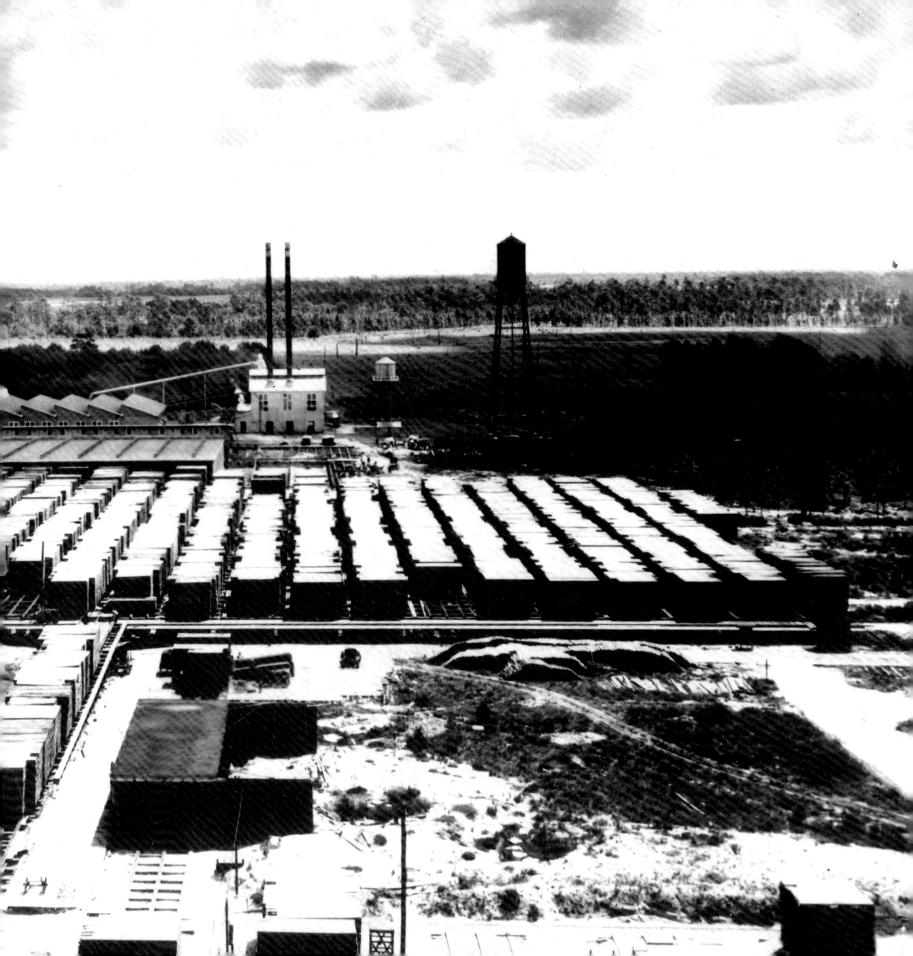

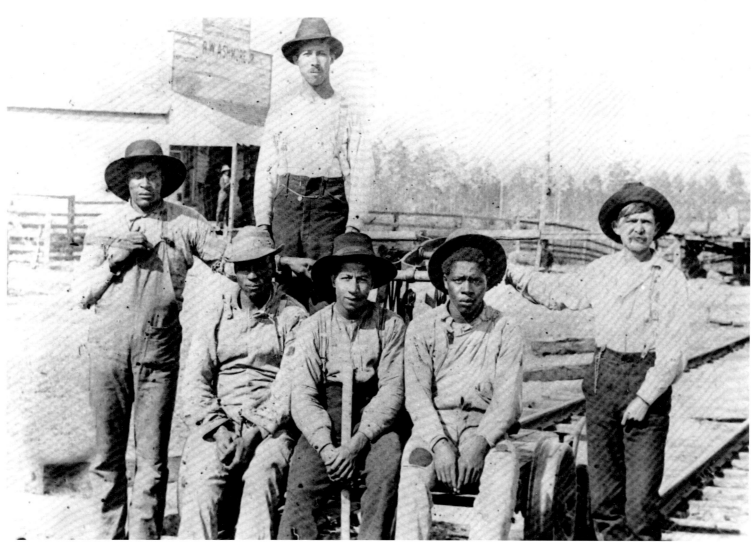

In Leon County, southwest of Tallahassee along today's Helen Guard Station Road, Helen was established as a Civilian Conservation Corps camp during the Great Depression. Foundations of the workers' barracks can still be found along dirt roads east of CR 2203 (Springhill Road). Other evidence of this once-active community are the remains of a forest service station and tower. A Georgia, Florida and Alabama Railway Company section foreman (the man on the right) and several of his workers are shown here in Helen.

In 1935, a new settlement was established in Marion County along US 301/441, named Camp Roosevelt after the then-president. A post office opened that year to serve crews from the Army Corps of Engineers who arrived to construct the Cross Florida Barge Canal. After that project was canceled, Camp Roosevelt was operated by the University of Florida and the Works Progress Administration for adult education classes. In 1938, the National Youth Administration used it as a girls' resident camp, and in 1943 it passed back to the Corps of Engineers. Years later, it ceased to be a separate community, and its remaining buildings were absorbed into an Ocala neighborhood.

At the intersection of SR 405 and Old SR A1A in Brevard County was Orsino, one of the towns eliminated by Kennedy Space Center construction. The name of the town is believed to have Shakespearean origins, being named for Orsino, the Duke of Illyria, in *Twelfth Night*. Although it had residences, some of whom were picked up and moved to other locations during the 1960s, it never evolved into a full-fledged city of its own. Well driller Peck Harris is shown in this photo from the 1940s in the Orsino vicinity.

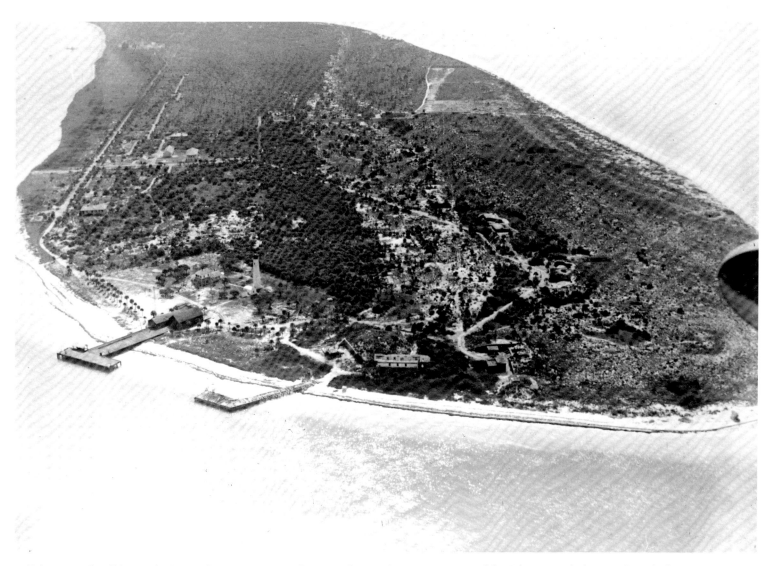

Off the coast of Hillsborough County lies Egmont Key, shown in this aerial view. It was named for John Percival, the British Earl of Egmont, whose brother-in-law was the second Viscount Hillsborough, who owned a large portion of Florida in the late eighteenth century. Egmont was a land agent when the island was named and had served as first lord of the admiralty for a time during the British occupation of Florida in the mid-1760s. The Egmont name also appears on early maps of Nassau County, with Egmont Island now known as Amelia Island and Egmont Town now called Fernandina Beach. Fortifications were built on Egmont Key by both the Spanish and Americans, and in 1858, the area served as a collection center for Seminoles before they were sent west. Fort Dade was built on Egmont Key during the Spanish-American War, and its ruins can still be toured there. Its post office operated from 1900 until 1910.

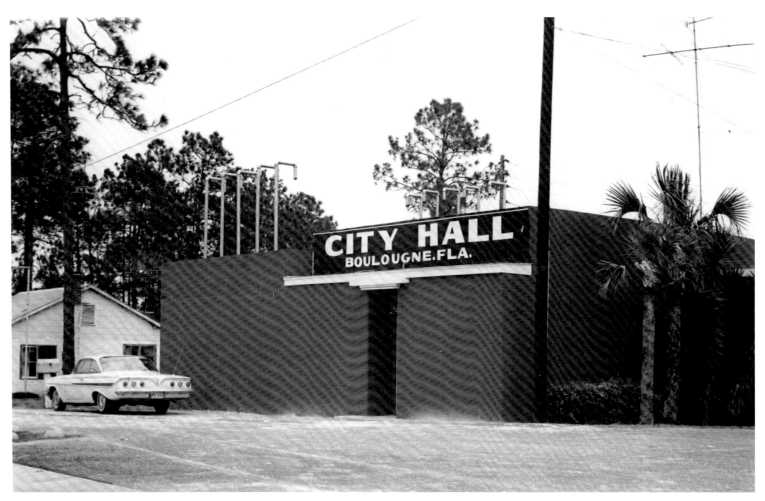

Boulougne (also spelled Boulogne) was located in Nassau County at the Atlantic Coast Line Railroad crossing of SR 121, just south of the Georgia border. Originally founded in 1880 about a mile to the south, it was likely named for a city in France. After the town was devastated by a hurricane in 1896, it was rebuilt at a second site along SR 121 that, by 1819, had been a settlement known as Calico Hill before it was referred to as Gardinia. Boulougne served as the northern terminus of the St. Marys, Lake City and Gulf Railroad. In the mid-1920s, Boulougne moved to a third site along US 1/301. In 1963, however, after being classified as a notorious speed trap depending on traffic fines for its revenue, the state legislature canceled its charter. The City Hall shown here is gone, and the area no longer resembles a town.

DISASTROUS WEATHER

Florida's relatively mild climate was a major draw for Northerners suffering from various maladies. Doctors recommended moving to Florida, and widely reported stories of cured illnesses helped increase the state's population and resulted in the growth of many towns. However, Florida's weather also caused many of those communities to turn into ghost towns. Numerous killer hurricanes, some with human names and some identified merely by the year they hit the state, contributed to the demise of several towns.

For example, the Panhandle was hit with a major hurricane on September 13, 1843, accompanied by ten feet of water that covered the land adjacent to the Gulf of Mexico and major rivers. When the water, or storm surge, retreated from the land, it took with it buildings, crops, and people. That storm eliminated towns including Port Leon and St. Joseph, at one time the state's largest city.

Killing freezes have occurred many times in Florida's history and have often caused substantial damage to crops such as tomatoes, ferns, and citrus. Occasionally, cities such as Gainesville and St. Augustine have survived by essentially shedding the damaged crops as important industries following the freezes, then shifting to other ventures. Towns depending solely upon growing and shipping oranges and related fruit often lost much of their population as a result of a crippling freeze.

The worst such freeze, still referred to as the Big Freeze or Great Freeze, was actually a pair of periods of sub-freezing temperatures. Just before Christmas in 1894, temperatures were unseasonably warm. In the Orlando area, midday temperatures were in the 80s. Thus, citrus trees were flourishing and were hit hard on December 26 when a 36-hour freeze arrived. The trees survived, however, and within a few weeks, produced one of the largest crops to date.

Then in early February, the temperature again turned cold, and many parts of the state reported record-low temperatures. The citrus trees' sap froze in their trunks, expanding quickly to essentially explode the trees, causing them to fall over and die. Groves with unusually large yields of fruit turned into worthless piles of debris in a matter of hours. That event caused many to leave their homes, and often even the state or the country, and resulted in ghost towns replacing thriving communities, including Boardman, Conant, Pittman, Rochelle, Vista, and many others.

The town of Atsena Otie, chartered in 1858, was located on Atsena Otie Key, a short distance offshore from the town of Cedar Key in Levy County. Ten years later, the Eberhard Faber Pencil Company constructed a lumber mill on the island, on which this stack of cedar posts sits. The name Atsena Otie comes from Creek words meaning "cedar island." On September 29, 1896, the island was crossed by a ten-foot storm surge resulting from a hurricane. It destroyed the mill and nearly all of the houses. The last residents left in 1897, and the one remaining house was destroyed by Hurricane Easy in 1950.

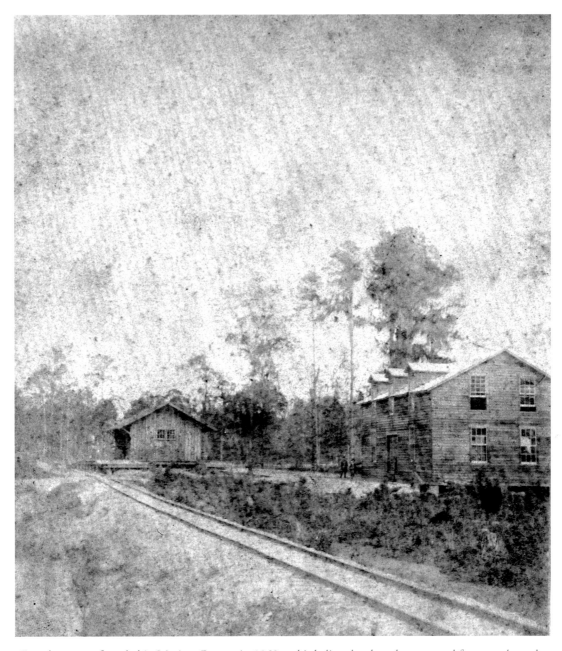

Boardman was founded in Marion County in 1863 and is believed to have been named for an early settler, L. Boardman. It was served by the railroad shown in this 1880s photo. After the 1894-95 freeze, it had a population of only 15. The post office was open from 1882 until 1947, when it moved south on US 441 to McIntosh, the town that shared a cemetery with Boardman.

In 1884, wealthy English settlers founded the Lake County town of Conant, naming it for Florida Southern Railway financier Major Sherman Conant. It was located around where today's city of The Villages is and included the three-story hotel shown in this photo from 1884. The residents of Conant were looked upon by others as snooty and above hard physical labor. This citrus-growing area was hit hard by the Big Freeze of 1894-95, which reduced its population to 100. The town was gone by 1919, when mail service moved south to Lady Lake. Ten years later, all that remained with the name Conant was a railroad sign and Conant Road, renamed Griffin Road during the 1950s.

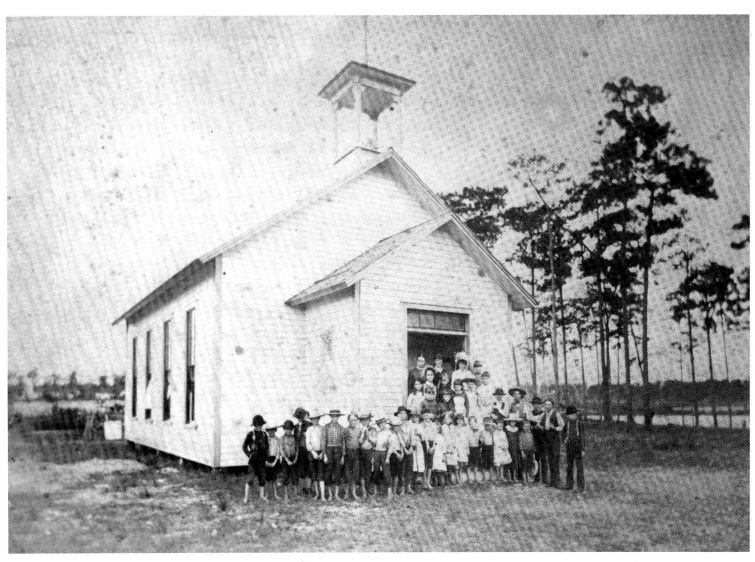

George T. Pittman moved from Kentucky to Lake County in 1883 and established a settlement near Lake Dorr, just north of Altoona. It was named Pittman and was served by the *Pittman Argus* newspaper. Murray Thomas owned the first store and the hotel. The town was home to a Presbyterian church, and the bank was owned by Pittman, Thomas, Robinson and Company. Pittman was located along the route of the St. Johns and Lake Eustis Railway, completed in 1881, which also included stops at Fort Mason, Umatilla, Glendale, and Altoona to the south, and Ravenswood, Summit, Sellers, Bryantsville, and Astor to the north. Pittman's Grassy Pond School is shown here from the 1880s, well before the Big Freeze of 1894-95 that destroyed the local citrus crop and prompted most of the residents to move elsewhere. There are now farms at the former townsite located near the intersection of SR 19 and Lake Dorr Road.

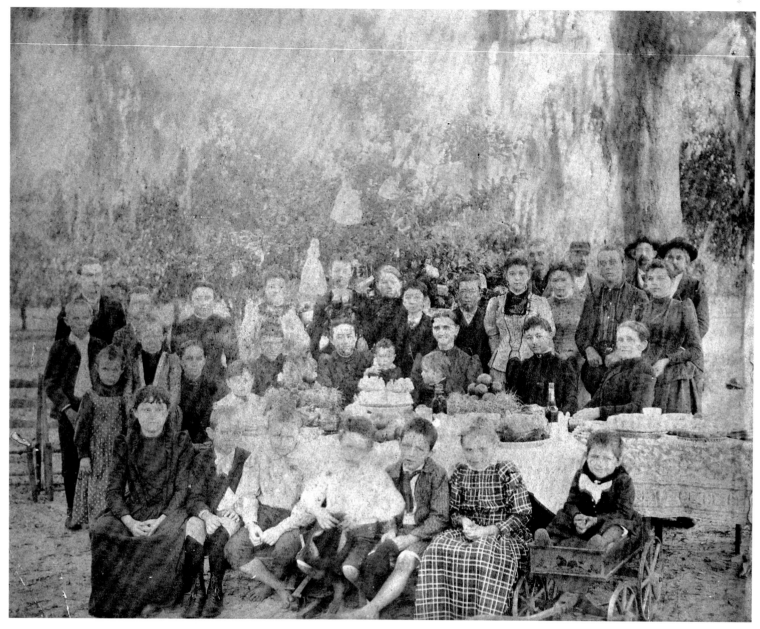

First called Perry Junction for Governor Madison Starke Perry who owned a plantation a little to the southeast, and then Gruelle for a railroad surveyor, the town was renamed in 1884 as Rochelle, perhaps for La Rochelle, France. It now consists of an abandoned two-story schoolhouse, an abandoned Methodist church, and a few rural homes. This area along CR 234 near Gainesville in Alachua County previously had a population of 175, and supported two schools, two churches, and a hotel. In its heyday of 1888, two dozen trains passed through Rochelle each day. The former railbed is now a recreational trail running from Gainesville to Hawthorne. The town began its decline as a result of the Big Freeze of 1894-95, which killed the citrus crop and caused the population to decrease dramatically. Shown here is the Croxton family celebrating Christmas of 1892 in their Rochelle home known as Croxton Park.

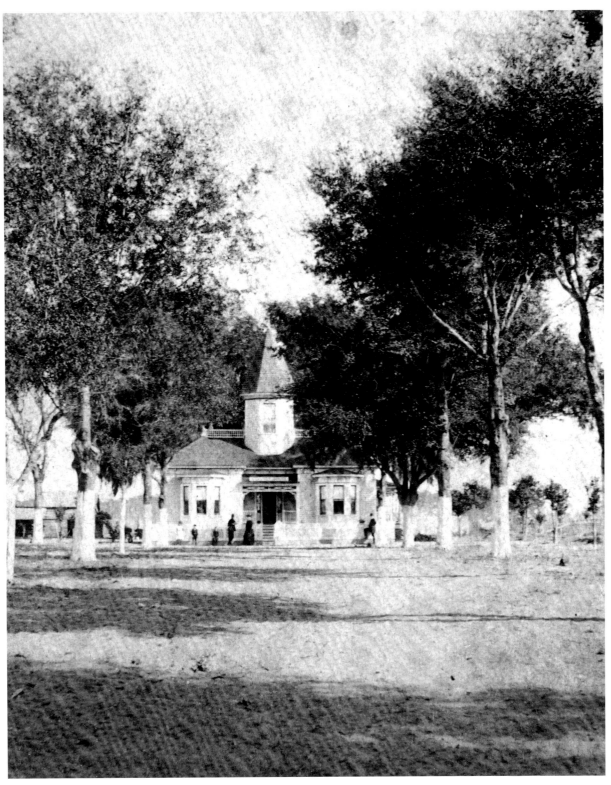

In Alachua County near Newnans Lake, west of US 301, are some old structures that composed a portion of Windsor, a town settled by English planters in 1846. Local residents were expecting the East Florida Seminary and a railroad to be built in Windsor, but Gainesville got them both. A bridge across the lake also got no further than the planning stages, and after the Big Freeze of 1894-95 and another in 1899 that brought six inches of snow, the local citrus industry came to an end. The post office, which opened in 1884 and operated in the general store along CR 234, closed in 1936. The town, then with a population of 302, faded into obscurity. In the distance in this photo is the Windsor home of P. M. Porcher, a real estate agent.

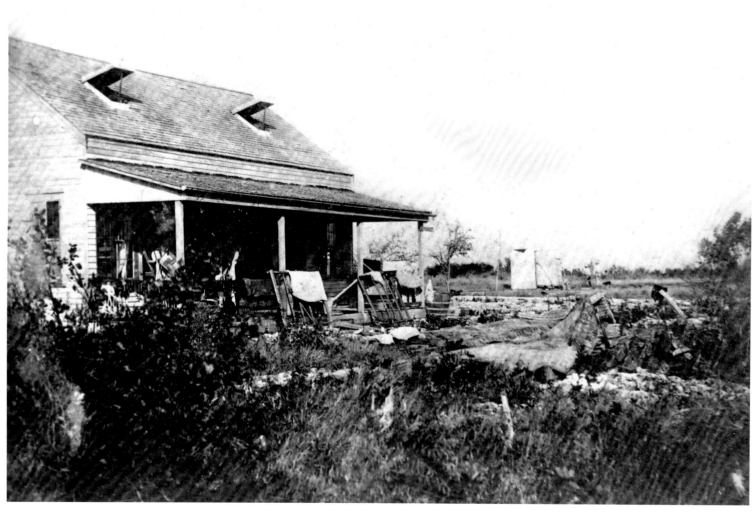

After the area was used by pirates, Indians, and immigrants from the Bahamas, Planter became Key Largo's first actual town in 1866. It was an agricultural settlement that raised pineapples, but that crop declined in importance because Caribbean countries could and did produce them at a cheaper price. The Planter Post Office established in 1891 was the only one between Key West and Miami. After hurricanes in 1906 and 1909 and the discontinuance of the railroad in 1935, the community died out, and many residents left the western shore and moved inland to the town of Tavernier. Pictured here in 1906 is the Planter home of John W. Johnson damaged by a recent hurricane. Today, the former Planter site is occupied by a Monroe County park.

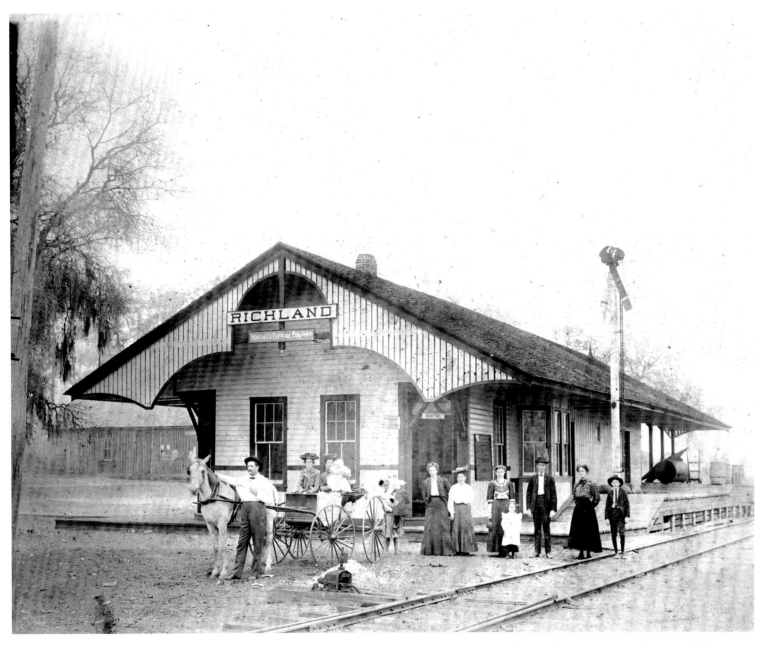

Richland was settled by the Tuckers around 1845, when they planted an orange grove and gave the area its original name of Tuckertown. When Pasco County was formed in 1887, Richland was already an established community with one of the county's 29 schools. It had one recitation room and sat 30 students, all white. The local economy was hit hard by the extreme 1894-95 freezes and eventually died out. This photo, taken around 1906, includes H. A., Lizzie, Kate and Council Elizabeth Brown, and Kate Johnson standing near the Richland railroad depot.

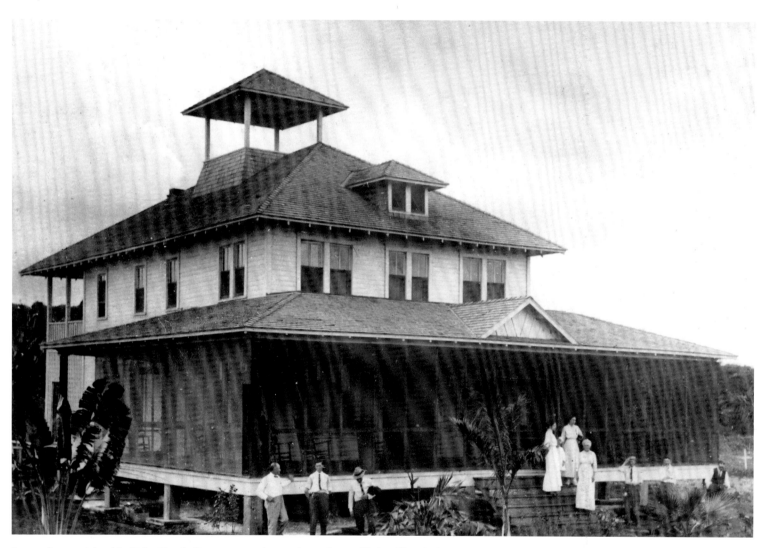

Located on an island in Palm Beach County near the southern shore of Lake Okeechobee, Ritta started getting its first settlers in 1909. The federal government officially opened it and other islands to homesteading in 1917, and the town grew crops such as corn, green beans, and onions. This is the Hotel Bolles, constructed in 1910-11 by developer Richard J. Bolles to house visitors who might buy land parcels in the nearby Everglades. Crops were ruined when the island was flooded in 1922, and the 1928 hurricane washed away all of the buildings, ending the existence of the town.

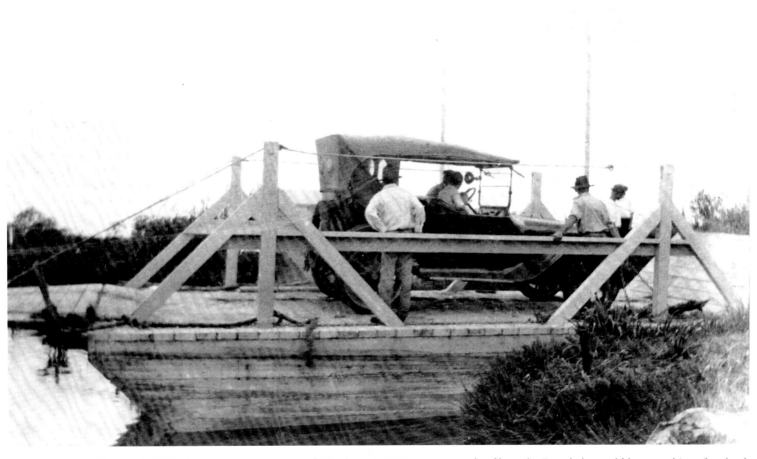

Thomas E. Will planned the community of Okeelanta in 1913 as an example of how the Everglades could be turned into farmland. Suffering through freezes, mosquitoes, floods, and wild animals, the town named for Lake Okeechobee and the Atlantic Ocean grew to a population of 200 in 1920. Beans, tomatoes, potatoes, corn, and eggplant were shipped from the area until the town was destroyed by a hurricane in 1928. This photo taken in 1920 shows an automobile being carried by ferryboat along the North New River Canal in Okeelanta, located at the intersection of today's US 27 and Hillsboro Canal Road in Palm Beach County.

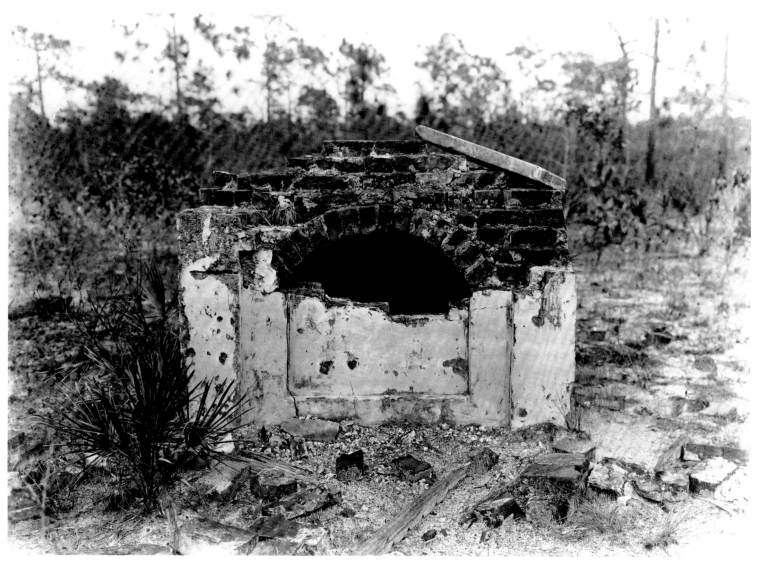

This town, and today's Port St. Joe located on a nearby site in Gulf County, were named for the adjacent St. Joseph Bay, which bears the name of a Roman Catholic saint. Founded in 1835, St. Joseph grew to be the largest city in Florida with a population of about 6,000. Two railroads connected it with the Apalachicola River. In October 1835, R. Dinsmore Westcott established the *St. Joseph Telegraph* newspaper and the following month merged it with the *Apalachicola Advertiser*. In late 1838, St. Joseph was the site of Florida's first constitutional convention, resulting in the delegates signing the constitution on January 11, 1839. Two years later, the town's population was reduced by a yellow fever epidemic brought by infected passengers on a ship from South America. The hurricane in 1843 destroyed the town with a killer storm surge. This photo from 1920 shows a tomb from the Old St. Joseph Cemetery where residents were buried after the hurricane.

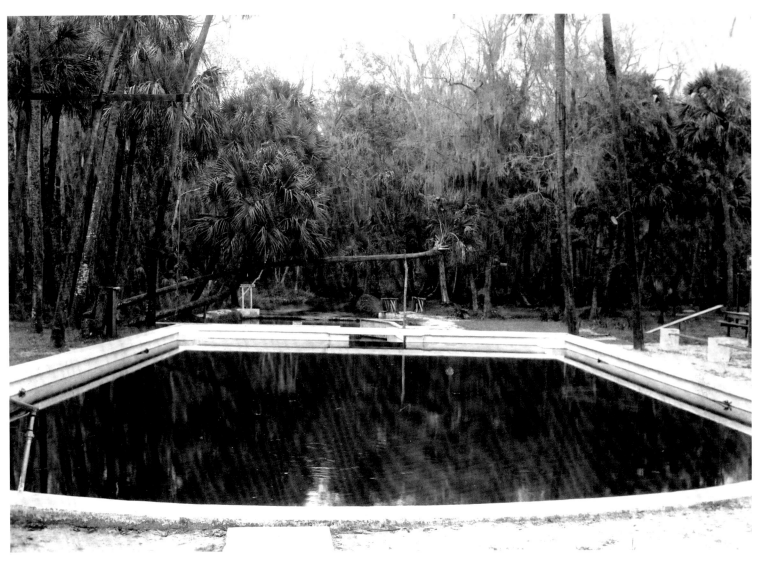

Pictured here in 1935 is Palm Springs, adjacent to which grew a community of the same name. It was located in Seminole County west of Longwood at the junction of the Florida Midland and the Orange Belt railroads. During the late 1880s, Palm Springs began to draw some activity from the town of Altamont and set up a post office with Frank Baker as its postmaster. After severe damage during the Big Freeze of 1894-95, the town declined, and the post office closed in 1900, with mail thereafter going through the Altamonte Springs Post Office.

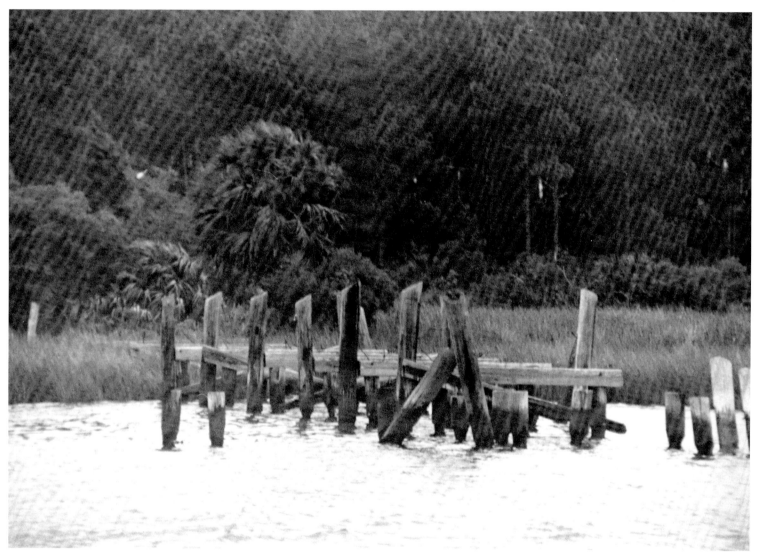

Port Leon, named for Juan Ponce de Leon, was established in 1837 to compete with a pair of other ports, St. Marks and Magnolia. It had stores, warehouses, a hotel, and one or two taverns. A post office opened in 1840, and the town incorporated the following year. When Wakulla County was created in March 1843, Port Leon was designated its county seat. It shipped out cotton via the Tallahassee-St. Marks Railroad across the St. Marks River to the Tallahassee Railroad. In June of 1843, Albert R. Alexander founded the *Commercial Gazette* newspaper in Port Leon. After the town was destroyed by a hurricane and ten-foot storm surge on September 13, 1843, many of its residents moved inland and established the town of Newport. Shown here in a 1960s photo are remnants of the government docks, located about a mile south of St. Marks.

FIRES

A quick way to turn a community into a ghost town is to burn it down. That has happened several times in Florida, sometimes by accident and sometimes intentionally.

During the nineteenth century, Florida was not only the site of a few battles during the Civil War, it was also the battleground for three Indian wars. Those earlier wars are known as the First, Second, and Third Seminole Wars, and they included skirmishes throughout Florida. Several attacks by bands of Seminoles resulted in white settlements being burned to the ground, including Bulow and Indian Key. Another intentional fire eliminated Rosewood when white vigilantes attacked a black town in response to an alleged assault on a white woman.

Communities revolving around major hotels or schools often turned into ghost towns when their major structures burned down. When the Hotel Hampton burned down, Hampton Springs headed toward ghost town status. So did Kerr City and Punta Rassa when the Kerr House and the Punta Rassa Hotel went up in flames.

Early Florida buildings were almost always constructed of wood, and rarely did the small towns have much in the way of fire departments. At best, a volunteer fire crew might arrive on the scene after flames had consumed one or more buildings, to attempt (often unsuccessfully) to prevent fires from spreading even further. Once part of a town was burning furiously, it was likely to result in the entire town turning into embers and ashes.

Especially susceptible were lumber mills, which had large quantities of flammable material piled up, with an operation powered by steam produced by very hot fires that could quickly get out of control. Lumber mill fires could mean instant ghost towns, such as what happened in 1930 in Woodmere and 1956 in Jerome. After a fire, it was often a better idea not to rebuild on the same site and instead start a new town down the road, such as when Venus burned and became the ghost town of Old Venus, while a new Venus was constructed not very far away.

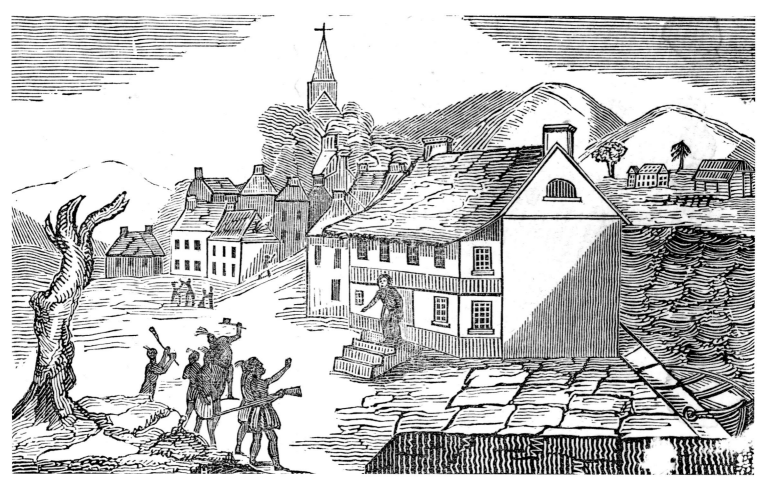

Indian Key became a wreck salvage station in 1831 and grew into an active port with homes, a hotel, warehouses, and a store. In 1836, it became the first county seat of Dade County, and is now located in Monroe County. In 1838, Dr. Henry E. Perrine was granted a township of land on the island, where he performed research on imported tropical plants. On August 7, 1840, the community was attacked by natives in an action known today as the Indian Key Massacre. Perrine and several of his neighbors were killed, but his wife and children survived by hiding in a turtle crawl under their house, standing in water while the house burned down above them. The illustration is a drawing from *The Pathetic and Lamentable Narrative of Miss Perrine on the Massacre and Destruction of Indian Key Village in Aug. 1840*. The last residents left after 1900, and the island was turned into a historical park.

Now in the middle of the Ocala National Forest in Marion County, Kerr City, named for Robert B. Kerr, was founded in 1884 by George Smiley on the site of a Civil War cotton plantation. In this 1885 photo is the three-story Kerr House hotel, built by Junis Terry. The Big Freeze of 1894-95 caused most of the 100-resident town to be abandoned, but it was later reoccupied. The hotel burned down in 1907, believed to be the victim of arson. The post office closed in 1941. Many of the old buildings have been preserved for tours, including a 1925 gas station, the post office, and several homes.

At the end of SR 867 just before the Lee County bridge to Sanibel Island was Punta Rassa ("flat point"), a cattle-shipping town during the 1800s. It was previously the site of a settlement during the Second Spanish Period and Fort Dulaney, active in the Second and Third Seminole Wars and the Civil War. In 1869, the site became the southern end of the telegraph line, and the telegraph operator and his wife established an inn, which burned down in 1906. It was replaced by the Punta Rassa Hotel, which served wealthy sport fishermen until it burned down in 1913. The small town then faded away. The photo shows a steamship moored at the Punta Rassa dock in the 1890s. One of the town's distinctions is that it was the first in the U.S. to learn by telegraph of the sinking of the *Maine* in Havana harbor.

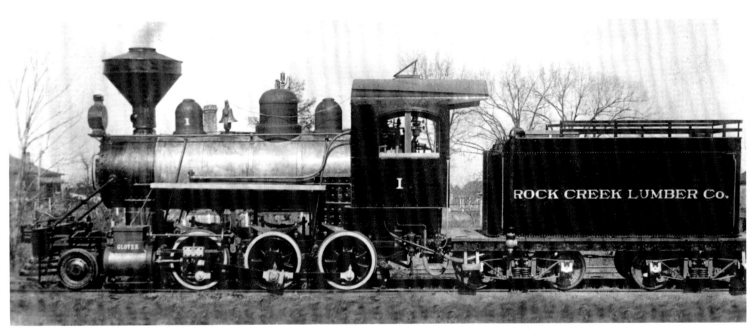

Near the Fenholloway River in Taylor County, north of Perry, are freshwater springs. Legend says that the wife of early settler Joe Hampton found relief from her rheumatism in the springs, so he bought them from the government for $10. In 1904, a hotel was built and a post office was established. The resort Hotel Hampton was built in 1910 over the spring, which bubbled up into an indoor swimming pool and then flowed into the river. That hotel burned down in 1954, and all that remains is the foundation with the pool and spring. In the 1920s, the University of Florida operated a camp in Hampton Springs as part of its Agricultural Experiment Station. Shown here in Hampton Springs is Rock Creek Lumber Company engine No. 1.

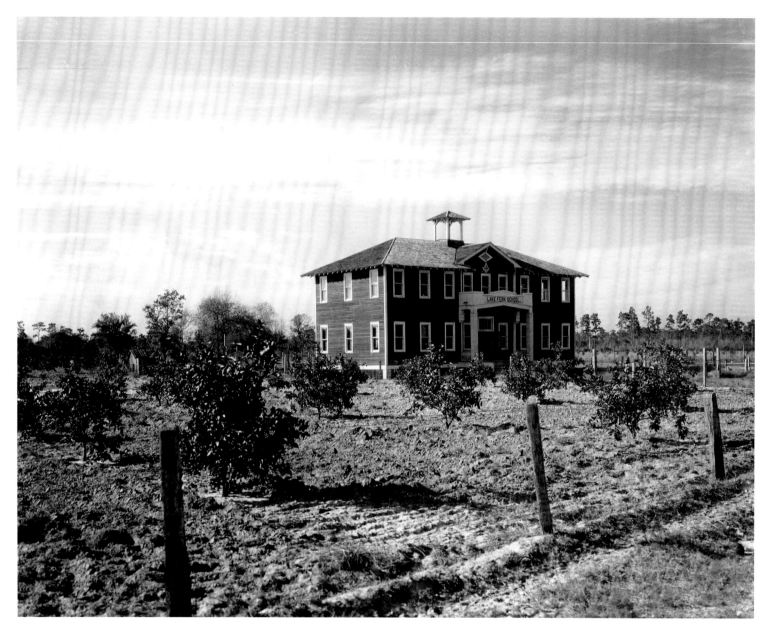

In about 1900, the town of Lake Fern was established in northern Hillsborough County for the growing of citrus and was named for the nearby lake, which derived its name from the lush ferns found nearby. Within one of the many area groves was built the large Lake Fern School, of which nothing remains today because it was destroyed by a fire in 1936. The area remained rural for decades but is likely to be developed for homes and commercial enterprises. The settlement's name is memorialized on signs for Lake Fern Road. The photo of the school located near the intersection of Gunn Highway and Tarpon Springs Road was taken on January 28, 1926.

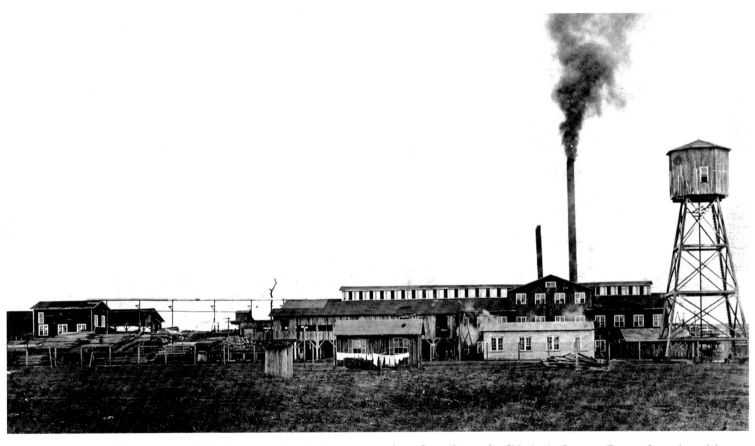

In 1918, the town of Woodmere was founded on ten acres about five miles south of Venice in Sarasota County. Its main activity was lumbering, but its 1,500 residents left in 1930 because the town and lumber mill burned down. Much of the lumber cut or processed at Herman Kluge's Woodmere Land and Timber Company mill wound up in the construction of Venice. In 1937, many of the stones used for Woodmere's building foundations were taken to Venice and used to construct its jetties extending into the Gulf of Mexico. Shown here is an engine of the Manasota Land and Timber Company that operated in Woodmere.

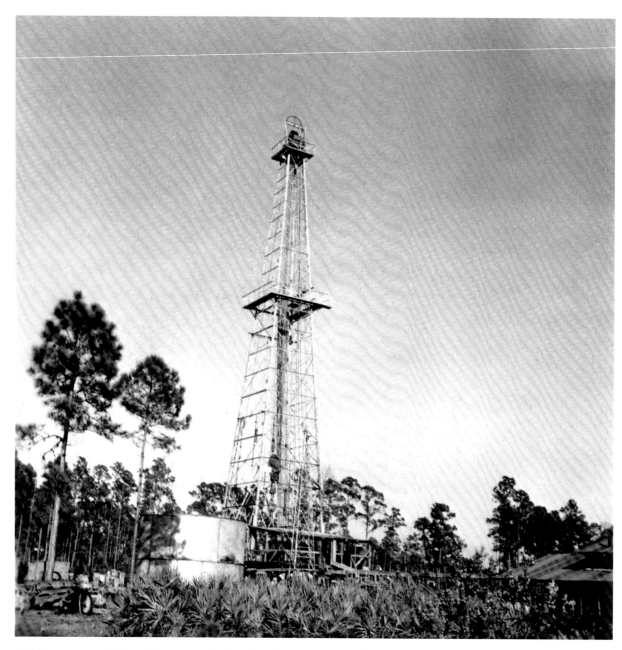

Old Venus was a Highlands County agricultural and turpentine town located on CR 731 west of US 27, along the railroad tracks. What remains is the First Baptist Church a little to the west, and the school foundation and the Venus General Store on the north side of CR 731, plus concrete curbs lining streets where there used to be buildings. Remains of the Albritton General Store and a few homes that survived a fire that eliminated the rest of the town many years ago may also be found. This is a well of the Humble Oil and Refining Company in the vicinity of Old Venus as it appeared in 1945.

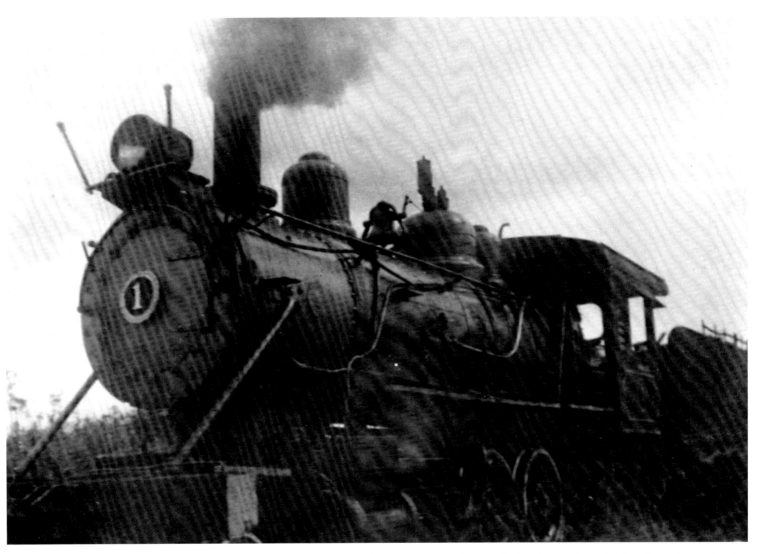

The C. J. Jones Lumber Company established Jerome as a logging and sawmill town during the 1920s, and shipped out dressed lumber northward on the Atlantic Coast Line Railroad. In 1956, the lumber mill burned down, and the contents of creosote vats spilled onto the ground, where the toxic chemical seeped into the water supply. The mill closed in 1957, and the company spent decades in litigation over the water contamination. A handful of residents remain in the Jerome area, located in Collier County about ten miles south of Interstate 75 along SR 29. The last wood-burning steam locomotive running in South Florida is pictured here in Jerome in 1954.

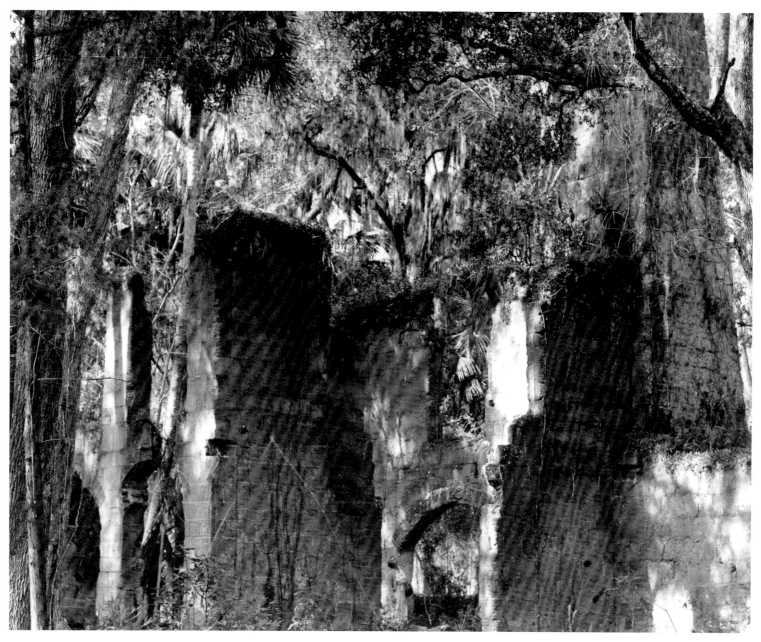

The Flagler County community known as Bulow (and as Bulowville) had a post office from 1899 to 1930 before it moved to Bunnell. The plantation previously located there was begun in 1812 by James Russell. Then beginning in 1821, coquina buildings for a sugar mill were constructed by Charles Wilhelm Bulow and were taken over by his son, John Joachim Bulow, two years later. The plantation, which served as a military headquarters during the Second Seminole War, was burned down by Seminoles on January 31, 1836. Later, a settlement grew up around the ruins and took on the name of the former owner. The ruins were placed under the jurisdiction of the Florida Park Service in 1945 and are shown here as they appeared in the 1950s, virtually identical to their appearance today.

Just Faded Away

A town is not unlike a living being, with a birth, youth, maturity, old age, and death. Major events such as company closings, hurricanes, freezes, and fires can quickly cut its life short and turn it into a ghost town. A community can also die a slow death of old age, with life spans varying with the character of the town and its people.

There is not always a single recognizable event that can be pointed to as the moment when the community "jumps the shark" and begins evolving into a ghost town. Often, it is a combination of factors including the weather, fires, railroad relocations and closings, and the reduction of activity in its major industry or industries. That many of the ghost towns in this section seemed to merely fade away rather than exhibit a fairly quick demise may just be an indication that their residents were not willing to give up without a fight, and remained years or decades in a gradually disappearing community.

It is often difficult to tell when a town is born and when it dies, especially when settlers gradually arrive and coalesce into a community, and when some linger in the area long after the societal relationships that gave it its corporate character have diminished. Although not absolutely definitive, the federal government provides one indicator of a town's existence through its process of establishing and terminating its post offices.

Until the federal government recognized a settlement by granting it a post office with a unique name, its residents had to travel to the next town's post office to pick up their mail or to send mail to other locations. When the settlement had sufficient size and organization, the Post Office Department granted it recognition. When the town was on the verge of turning into a ghost town, its permission to operate a post office was withdrawn, often with mail service being moved to the nearest thriving community with a post office.

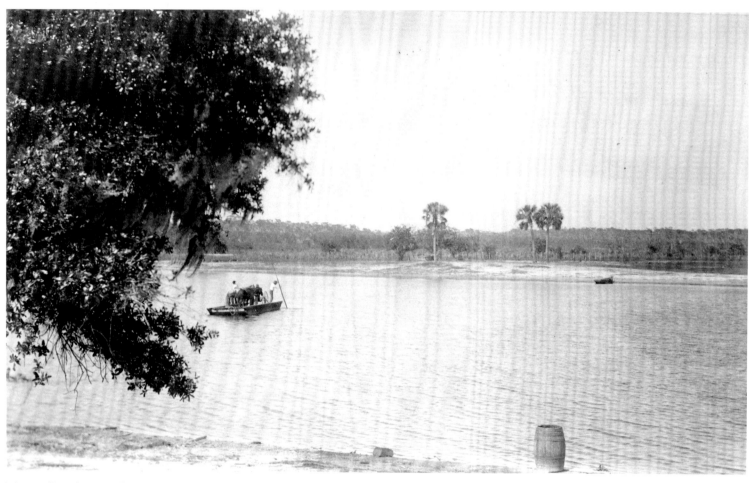

The small settlement of Cook's Ferry was located on the north end of Lake Harney in Seminole County, on a site occupied in 1836-37 by a band of Seminoles led by King Philip. Known as King Philipstown, it was the place from which the Indians headed to attack Fort Mellon. During the 1850s, Mr. Cook operated a hand-poled ferry to cross the lake, shown in this nineteenth-century photo. Guided by fixed submerged cables, the ferry enabled area growers to transport their citrus and other products to market. At its peak, Cook's Ferry was served by 39 steamboats. Today's site, designated a county historic site in 1985, is privately owned and blocked to public access by a gate across Osceola Fish Camp Road.

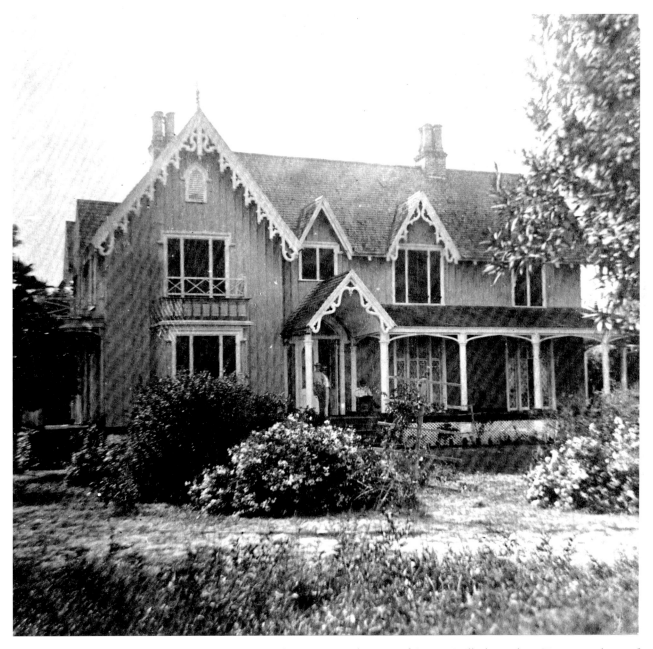

In the 1870s, this view was placed on a stereograph to represent the town of Orange Mills, located on SR 207 northeast of East Palatka in Putnam County. It depicts either a small hotel or a home. A freeze in 1835 killed the first commercial orange grove in Florida, which had been planted by Zephaniah Kingsley. It was replaced with a large sawmill, and the community that grew up around it was called Orange Mills. Its post office operated from 1850 until 1910, and from 1912 until 1925, when the mail service relocated to East Palatka.

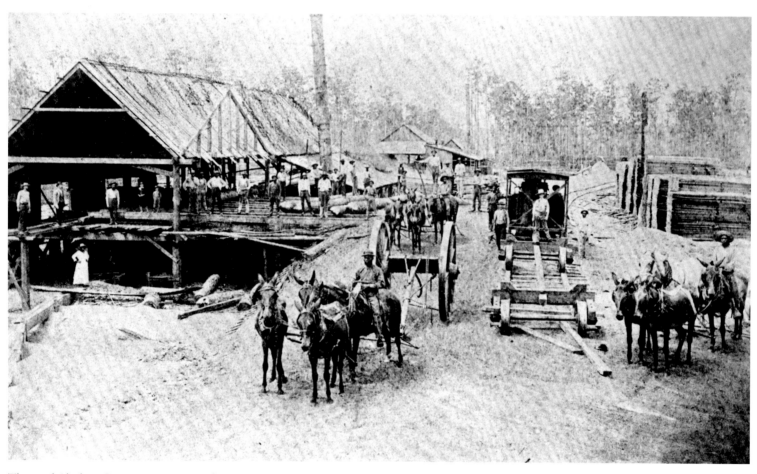

The rural Alachua County community of Hague, a railroad shipping town during the late 1800s on the route of the Savannah, Florida and Western Railway, was named for postmaster A. Hague in 1883. The population of Hague dwindled after most of the area's timber had been cut, and its agriculture was hurt by the boll weevil. It nearly completely disappeared, but in recent years there has been a movement to restore a portion of the town, including an 1880 combination church and school. Shown here is the Baird and Brother's saw and planing mill in Hague in the 1880s.

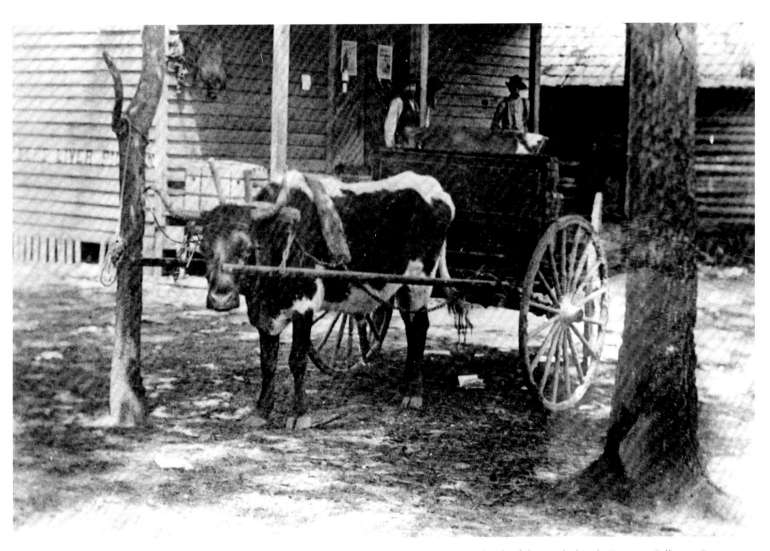

The town of Iola was established in 1835 between Blountstown and the west bank of the Apalachicola River in Calhoun County, on the site of a previous Seminole camp named Iolee. Its name is believed to mean "ceremonial cry," such as might be uttered when natives consumed the "black drink." Iola was served by the St. Joseph and Iola Railroad, constructed in 1839, and the town featured the Iola Hotel, owned by Claude Rish. This is an 1884 photo of an ox-drawn mail cart used to deliver mail in Iola. By 1962, the only remaining building was the former post office.

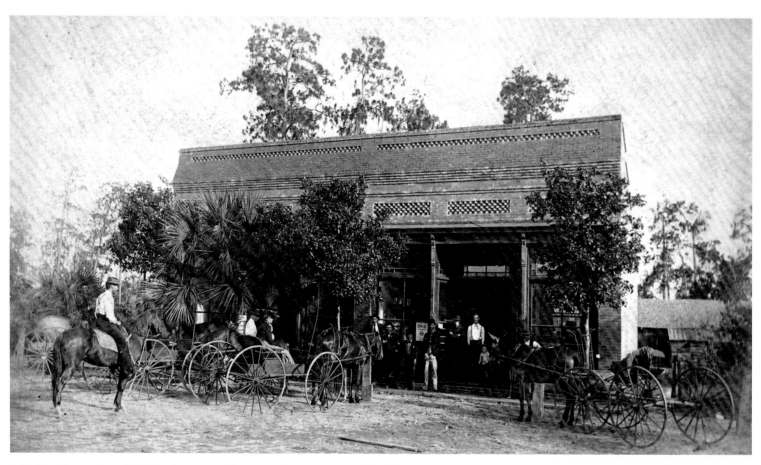

Initially, this portion of Volusia County was known as Astor Junction, platted by S. B. Wilson in 1886 and served by the Jacksonville, Tampa and Key West Railroad. By 1887, the station was renamed Eldridge for Lewis Henry Eldridge, the station agent. It was resettled around 1900 by Robert J. Bishop of South Carolina with his acquisition of about 12,000 acres. He operated a sawmill and named the town which grew up as Bishopville, after himself. By 1927, the settlement was known as Emporia, named for Emporium, Pennsylvania, where some of the settlers had moved from. Mail service was transferred to Pierson in 1954, and other than the name on a road sign, there is no evidence of its former existence. The photo of the general store is from the 1880s.

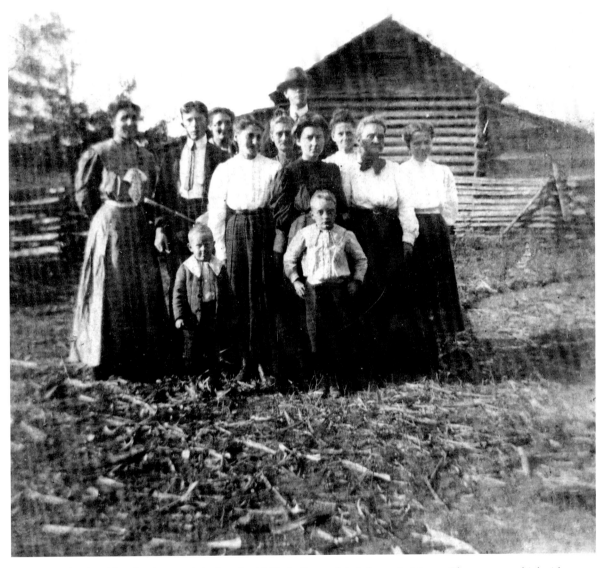

John A. Floyd and his family posed during the 1880s in front of their home in Mount Pleasant, on a high ridge near today's US 90 between Gretna and Oak Grove. The beginning of the settlement predated the Civil War, when in 1852, Ebanezer Stephens and John G. Smith received federal land patents. Following the 1895 freeze, the Gadsden County town had a population of only 32 but grew to about 200 by the end of 1928.

The town of Silver Springs was named after the state's largest spring, first reported by Colonel Gad Humphreys in 1825. It provides crystal-clear water at the head of the Silver River, east of the intersection of SR 40 and NE 55th Avenue east of Ocala.

The community grew up around the spring in central Marion County, later the site of amusement parks. Silver Springs opened its first post office in 1852 when it was a stage stop along the route from Palatka to Tampa. The post office closed in 1867, reopened in 1872, and closed for good in 1916. Shown in this photo from around 1887 are the Silver Springs Hotel and the tracks and cars of the Florida Railway and Navigation Company.

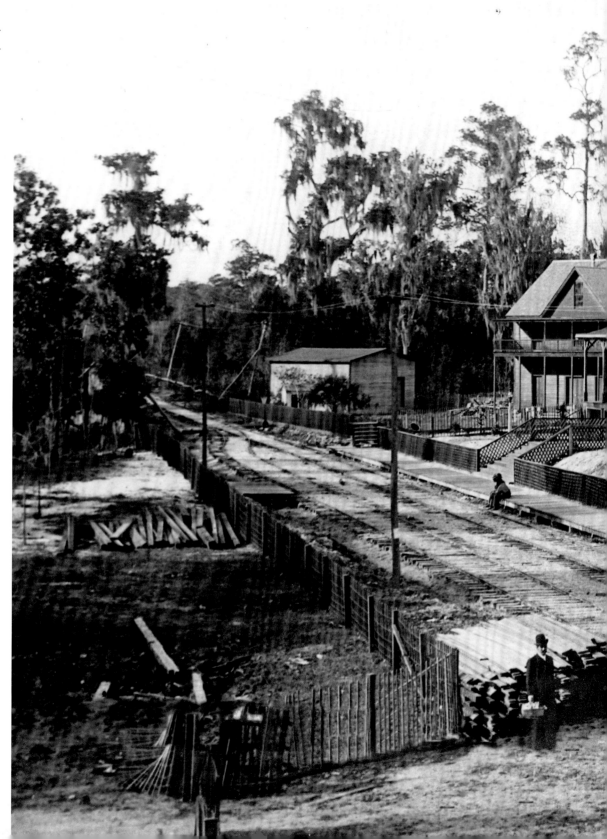

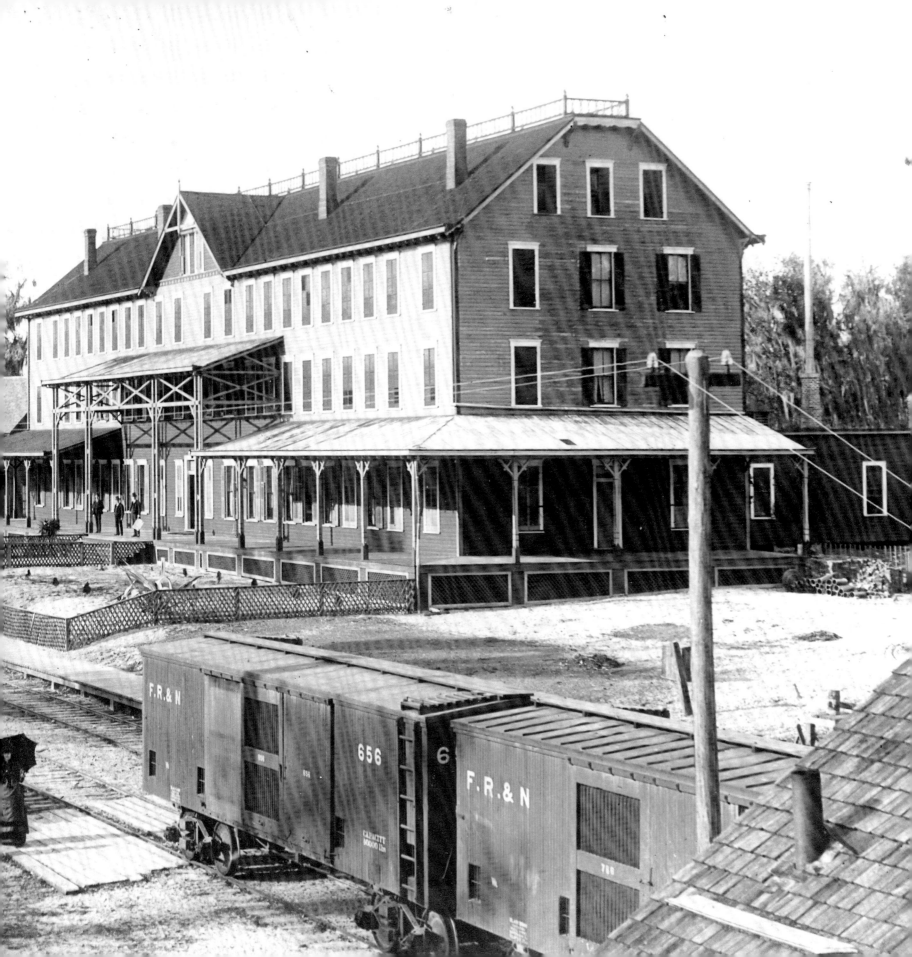

During the Civil War on Magnolia Point, Fort Magnolia, a Union outpost, sat on the shore of St. Johns River half a mile north of Green Cove Springs. Later in the 1800s, the Clay County site was home of the 250-acre Florida Military and Naval Academy operated by Colonel George W. Hulvey. The post office operated in 1848-49 as Magnolia Point, reopened as Magnolia Mills in 1870, and was renamed Magnolia in 1873 and Magnolia Springs in 1890. It closed in 1925. This nineteenth-century pen-and-ink drawing depicts the Magnolia Point Bridge over the St. Johns River northeast of US 17 along CR 209.

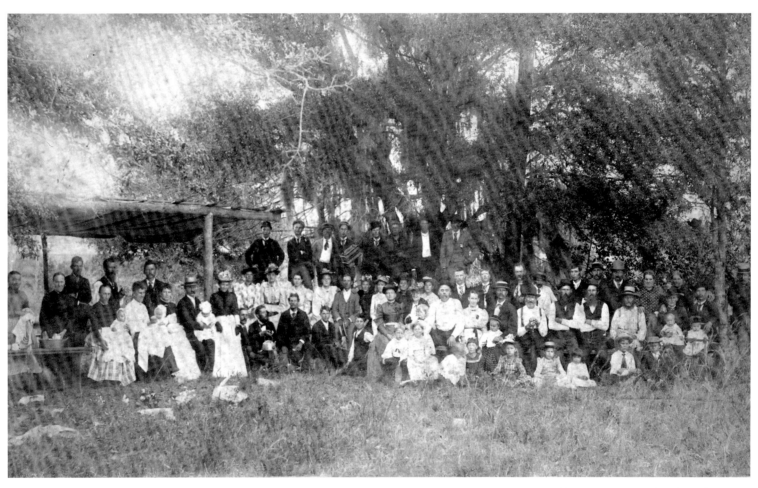

Piedmont, south of Bear Lake, was a close-knit community of Swedish immigrants begun in the late 1870s. The railroad would stop at Piedmont if flagged, but after it became the Florida Central and Peninsula Railroad in the 1890s, a station was built in the town. This photo shows Piedmont residents at a midsummer day celebration in 1892. Orange County allowed residents to organize schools, so long as a minimum of seven students were enrolled. To meet this requirement, Piedmont registered a three-year-old child as the seventh student in its school. The post office opened in 1903 and closed in 1922.

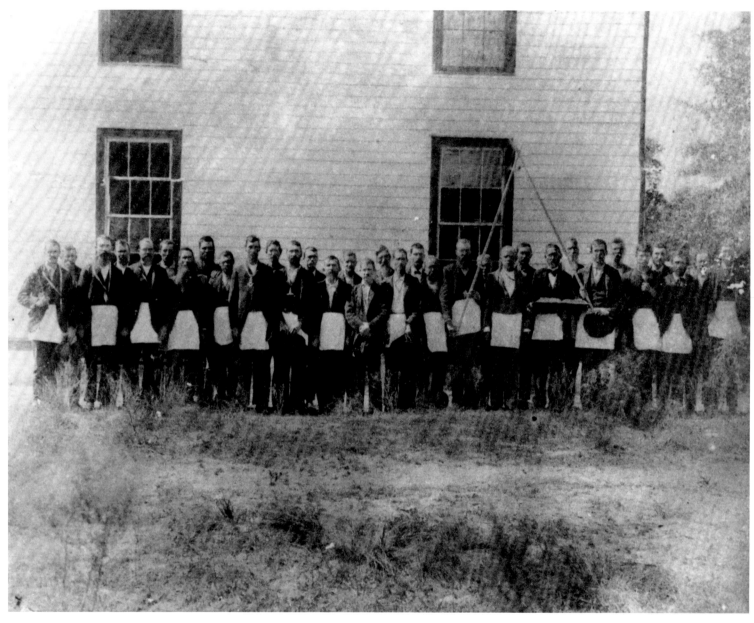

The men in this early 1890s photo are the Masons of the Judson Lodge No. 100, located in the Levy County town of Judson. It was named for Judson Carter, who operated a sawmill and store there around 1880. Judson had been established by 1867 with the name of Wacasassee and had six stores and by 1871, the Pine Grove Baptist Church. The Judson Post Office opened in 1886, but by 1912, mail service was shifted to Trenton.

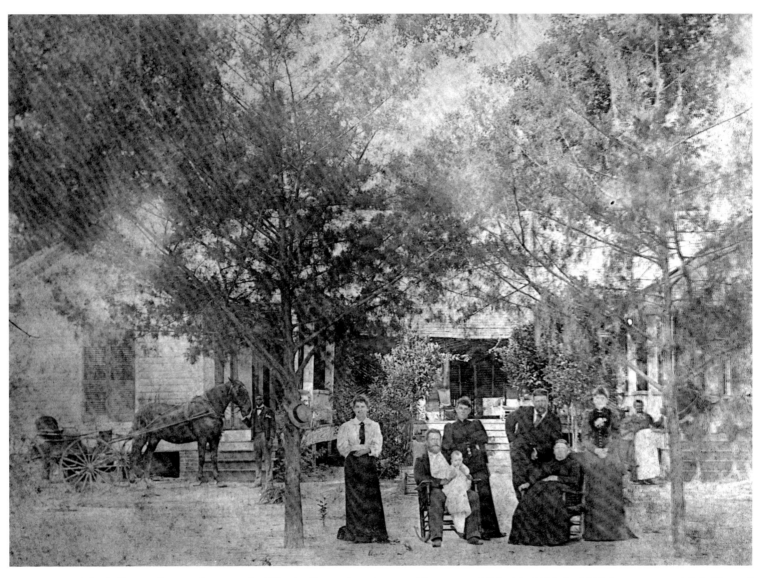

This Jefferson County site was called Rhodes Store when the post office was established in 1886. In 1894, it was renamed Ashville, and when it closed in 1932, mail service moved to Greenville. This 1893 photo shows 64-year-old Margaret May and her family in front of their Ashville home. She and her husband, Asa May, who died in 1878, previously lived at the Rosewood Plantation in Capps.

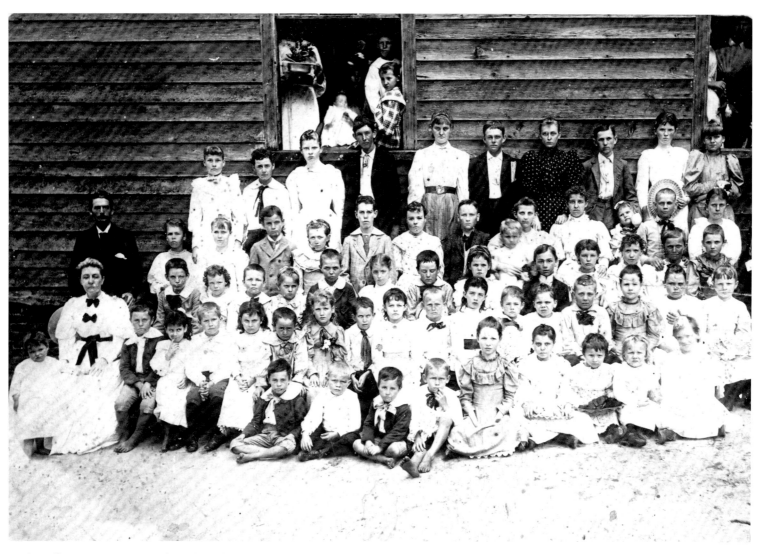

In the Jefferson County town of Waukeenah, Mr. Woodbery served as the school principal in 1893. He is shown here on the left of the group posed in front of the Waukeenah Academy. It was located along US 27 at the intersection with CR 259, slightly west of Capps. In 1856, the name was spelled Wakeena, which appears to have come from Seminole-Creek words meaning "cow's body." It also has the same pronunciation as Joachina, the nearby plantation of John G. Gamble that he named for a woman of Spanish ancestry. The plantation's post office was moved in 1827, but its vicinity continued to be called Joachina, which may have evolved into Waukeenah.

In 1824, William Miller established Miller's Ferry along the Holmes River. The settlement existed to provide a means to carry people, animals, and later, automobiles across the river, until a bridge was constructed in 1951. The ferry was free during daylight hours and operated under the auspices of Washington County. There were stores operated by Mobley and Brock, J. W. Cravey and Company, F. W. Woodward, and Abner Quincy Jones, Sr., who also ran a logging operation. The small town began to decline when the Olin G. Shivers Bridge opened along SR 284. In 1953, when postmaster Daisy Morrell retired after 30 years of service, the post office closed for good. Jones's home is shown here during the 1890s.

This image from around 1895 depicts a Florida Railway and Navigation Company train at Eldorado by Lake Harris in Lake County. By 1888, the railroad would take a passenger to Fort Mason and Leesburg for a fare of 15 cents. The fare was waived for families who donated land for the railroad right-of-way. Eldorado was connected to Astor by steamboat, where a passenger could also board a train of the St. Johns and Lake Eustis Railway. Eldorado's post office, located about five miles southeast of Leesburg, operated from 1886 until 1910. The town's name originated from the golden color of the fruit of local citrus trees.

The seaside town of Lotus was located in Brevard County on Merritt Island across the Indian River from Pineda. Maud Hardee Ronald suggested the name in 1894 because lotus blossoms grew on Merritt Island. The town's post office opened in 1894 with Charles D. Provost as postmaster, then moved to Cocoa in 1933. Shown here on May 4, 1895, is Mr. Kimball relaxing in the hall of Normandie, the home of Mrs. Green. The settlers in Lotus grew beans as well as citrus, and their crops were hurt—but not destroyed—by a cold wave in January 1898.

Hinson was located along US 27 and the railroad track in Gadsden County, north of Havana. It was named for Daniel Hinson and his family, who arrived in 1839 just four years after Moses Kirkland became the first area settler. Tobacco was a major crop for the town. During 1901, Hinson became a stop along the Georgia, Florida and Alabama Railway, which connected it to Tallahassee and Georgia. Not long afterward, the Hinson stop was moved to the new town of Havana. In 1902, Hinson opened its own post office, which operated until 1956, when the mail was shifted to Havana. This is the 1896 class portrait from the Hinson school.

By 1876, the Marion County settlement of Moss Bluff had a post office, a pair of stores, and the Waterman and Company steam-powered sawmill. The settlement was connected to the main line of the Oklawaha Valley Railroad by a spur logging line of the Rentz Lumber Company, which connected at Silver Springs to the west. A portion of that right-of-way can still be seen a little south of the CR 464c bridge crossing the Oklawaha River northeast into Moss Bluff. The final Moss Bluff Post Office closed in 1932. Pictured here around 1898 is the Martin family in front of their Moss Bluff home.

Calhoun County's Marysville was located two miles east of Scotts Ferry at the intersection of CRs (County Routes) 69 and 275. It had a population of 42 in 1895. This is a photo from around 1900 showing a Marysville house and, at left, a combination store and post office.

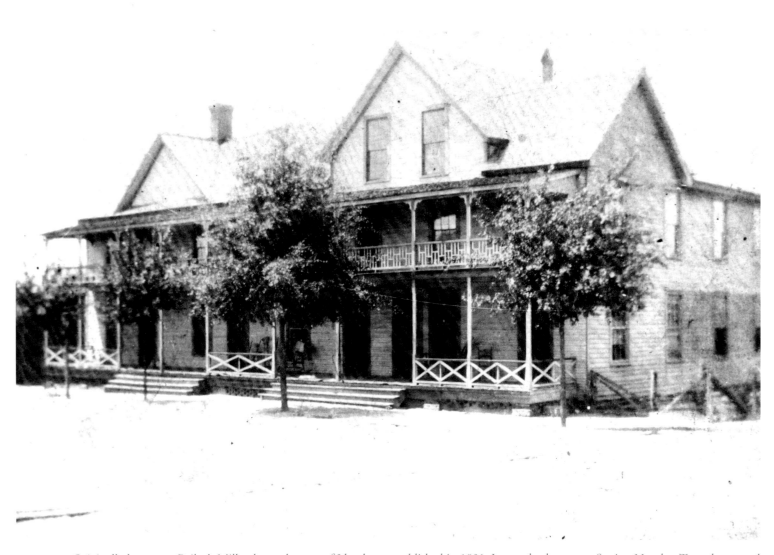

Originally known as Bailey's Mills, the settlement of Lloyd was established in 1831. It was also known as Station Number Two, the second railroad stop east of Tallahassee, in Jefferson County. It was renamed in 1857 for carpenter Walter Franklin Lloyd of Flatbush, New York, who convinced the Jacksonville, Pensacola and Mobile Railroad to choose a route that carried it through the town. The railroad station constructed in 1858 is the state's oldest one made of brick and is on the National Register of Historic Places. This is a home in Lloyd photographed in 1900.

Shown here around 1900 is Wilfred Raymond with his wife and cat at their home in Owanita, Lee County. Wilfred, the son of Reverend G. T. Raymond, managed a local cooperative citrus packing house. The Owanita Post Office opened in 1904 and moved to Fort Myers in 1930.

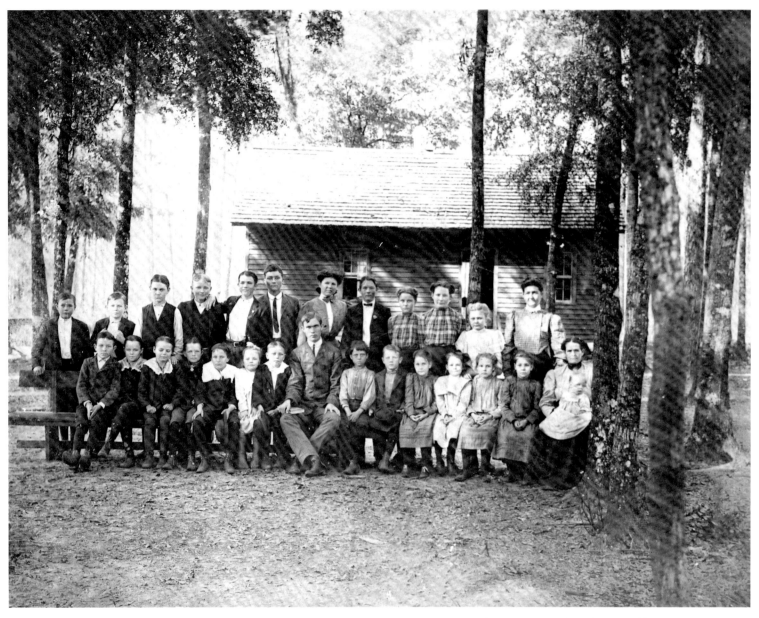

Athena, named for the Greek goddess of wisdom, had a post office from 1898 until 1922, and then it was moved to the post office in Carbur. Athena was located in Taylor County six miles south of Perry along the Atlantic Coast Line Railroad track, along what is now CR 372 (Athena Road), just east of US 19/27. Pictured here shortly after 1900 is the Warrior School located in Athena.

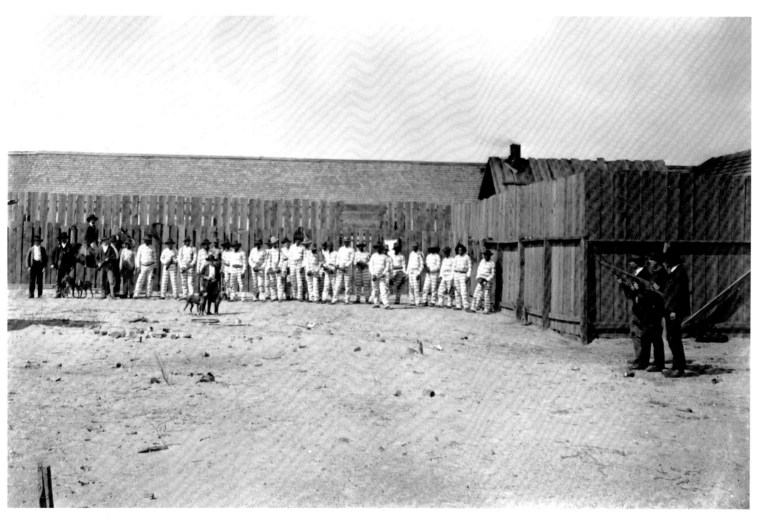

Romeo, the area a little north of Dunnellon, was first settled by the 1850s with a sister town, Juliette. Some believe that a boy lived in one town and a girl in the other, their lives ending tragically because their families were enemies, but that is likely just a local romantic legend. A post office opened in Romeo in 1888, closed in 1893, reopened in 1894, and then mail service was shifted to Ocala in 1955. The one remaining store in the area was built long after the town's boomtown years. Shown here in the early 1900s is the Marion County Prison in Romeo. The town was located along the railroad track paralleling US 41, a little north of CR 328.

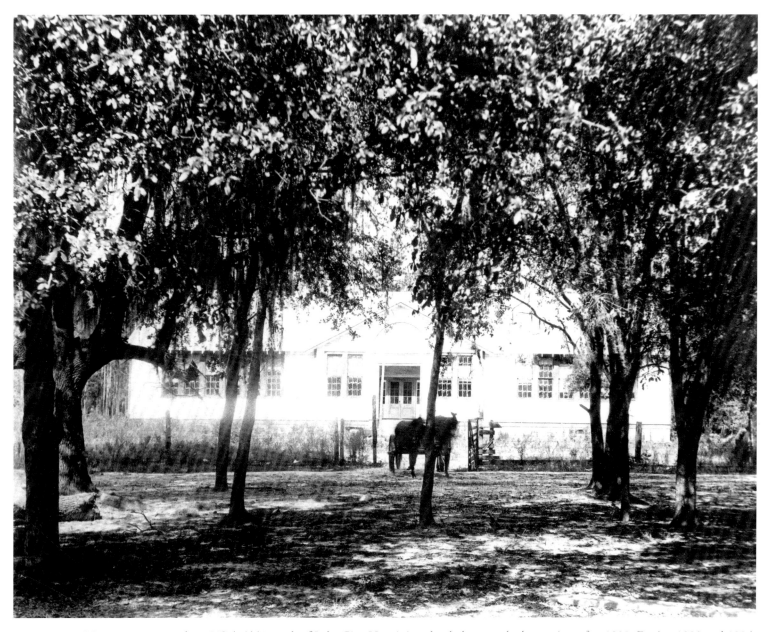

Mason was a town along US 41/441 south of Lake City. Here is its school photographed sometime after 1900. During 1923 and 1924, several of the smaller area schools were consolidated into the school and three other Columbia County schools. In addition to the Mason School, those remaining were the Columbia City School, the Fort White School, and the Kings' Welcome School.

Shown here in the early 1900s is the Parkinson landing at Upcohall along the Caloosahatchee River in Lee County. The town was founded in 1896 by William P. Pearde, who adapted a modified version of the name Upton Hall, his home in Devonshire, England. Upcohall's post office opened in 1905, but by 1918, its mail service was transferred to Olga.

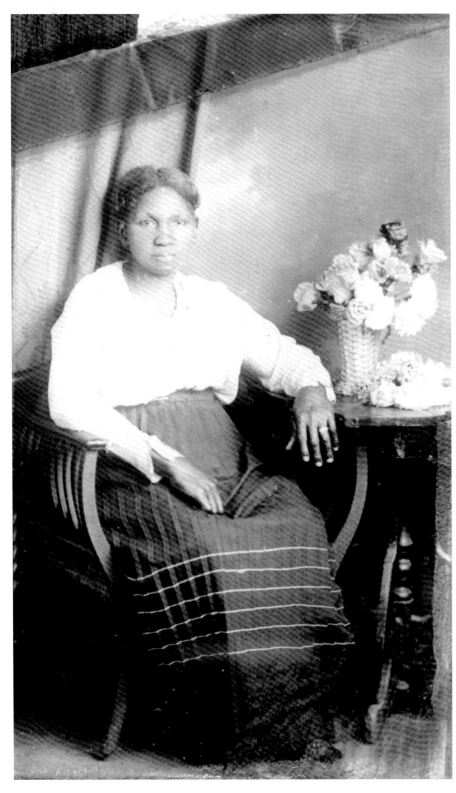

The settlement of Hamburg was founded by the late 1820s. Before 1840, it was served by the Ebenezer Methodist Church. Around 1900, Burress Chapel, one of the state's few Universalist churches, was constructed. Hamburg's post office opened in 1851, closed in 1867, reopened in 1880, then moved to Madison in 1907. Pictured here is Hamburg resident Martha Williams Morgan. The Hamburg townsite is located at the intersection of Hamburg Road and Bobwhite Terrace, west of CR 146 in Madison County and southeast of Lovett. In 1840, founder Samuel S. Hinton named Hamburg after his former hometown in South Carolina.

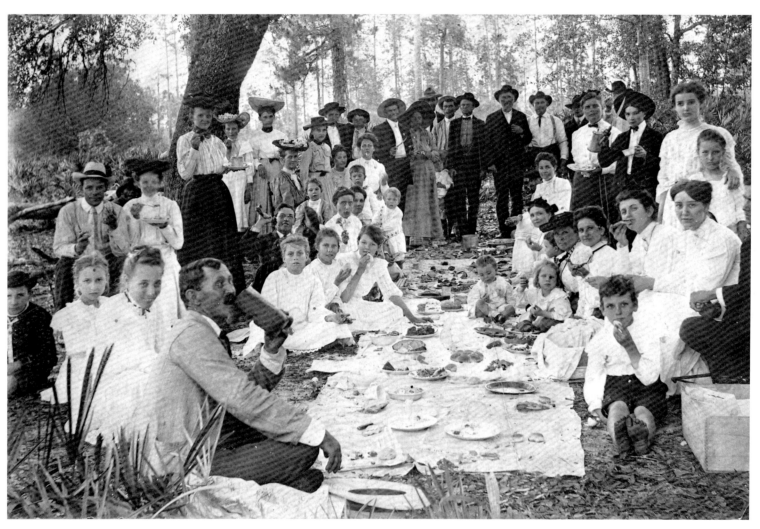

Located at the intersection of SR 369 (Bloxham Cutoff Road) and CR 373 in Wakulla County was Hilliardville, established as a stop on the Carrabelle, Tallahassee and Georgia Railroad. The site is now in the northwest corner of Edward Ball Wakulla Springs State Park. Shown here picnicking in Hilliardville during the early 1900s are the Ashmore, Pierce, and Cook families.

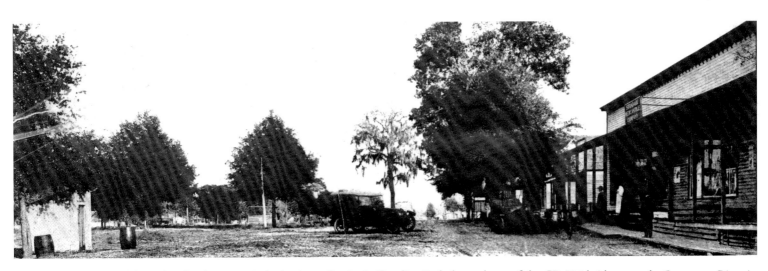

Pictured here shortly after 1900 is the business district in Dowling Park, located east of the CR 520 bridge over the Suwannee River in Suwannee County. The site was named Charles Ferry in 1837, and previously a Spanish mission, San Francisco de Chuayain, sat nearby. The area's post office opened as Lancaster in 1896 and was renamed Dowling Park in 1906 for Thomas and Robert L. Dowling, who owned a turpentine camp there. It closed in 1941, and mail service was moved to Live Oak.

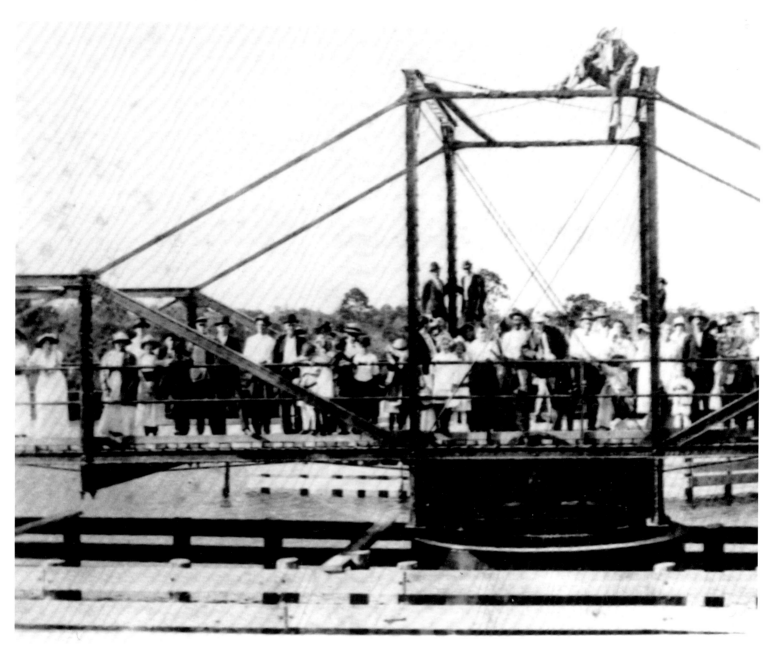

Olga was located in Lee County along the south shore of the Caloosahatchee River. It was founded, along with the town of Alva, in 1883 by Norwegian sea captain Peter Nelson, who named Olga for a Russian princess. Its post office operated from 1895 until 1930 before it was moved to Fort Myers. Olga was the site of the first steel bridge to cross the Caloosahatchee, with its 1903 grand opening celebration shown here.

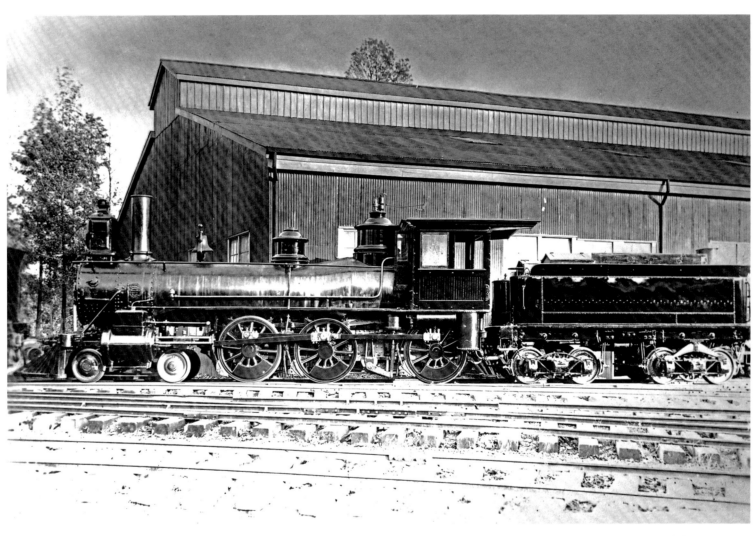

A Walton County townsite was a stop along the Red Ground Trail running from Alabama to Escambia Bay, at a lake called Big Pond by the Creeks. When many natives departed from the area in the 1830s, white settlers began a timber industry. Big Pond was renamed Lake Jackson to honor territorial governor Andrew Jackson. The Florala Sawmill Company lumber mill organized by Tom Hughes opened in 1903, and the adjacent town was named for John Paxton of Chicago, one of its investors. The Paxton Post Office opened in 1904, the same year this photo of the Louisville and Nashville Railroad engine was taken in the town. The mill closed in 1924, and four years later, mail service was moved to Florala, Alabama. Few residents remain in this rural community, located a mile south of Alabama on US 331.

Elliott Key, an island in the Atlantic Ocean south of Key Biscayne and east of Homestead in Miami-Dade County, was previously known as Ledbury Key for the *Ledbury,* a British ship that ran aground there in 1769. It is now known as Islandia, and with a population of only six in 2000, was Florida's smallest incorporated city. A post office operated there briefly in 1891. Depicted here is a portion of a plantation located on Elliott Key.

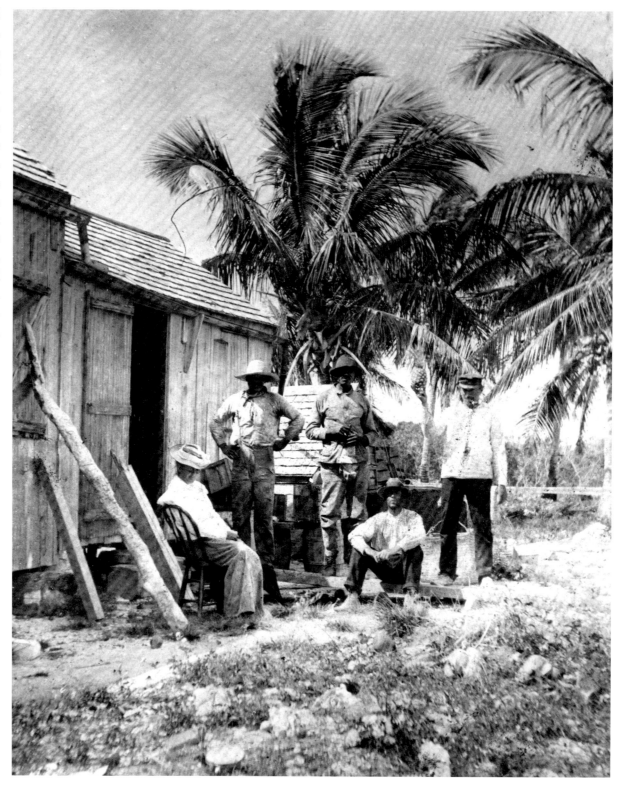

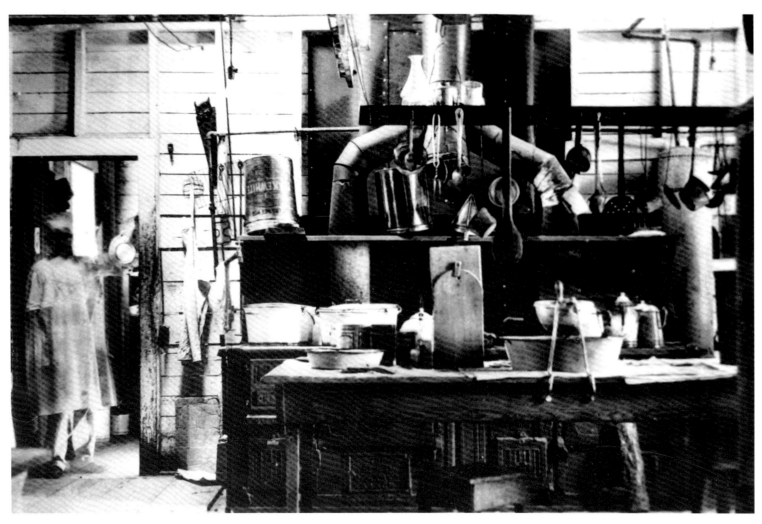

In 1884, Cyrus Teed moved to Lee County from Chicago to establish a new way of life and religion he called Koreshanity in an area he named New Jerusalem. His beliefs included God being both male and female and the earth existing as an enclosed sphere with all people, stars, and planets on its inside. His Koreshan colony was flourishing by 1893 and continued well into 1908, when Teed died. The colony lost members and shrank until 1961, when the four remaining residents conveyed the property to the state, which turned it into a historical park. Shown here around 1905 is one of the Koreshan kitchens for the colony, located along US 41 near Estero.

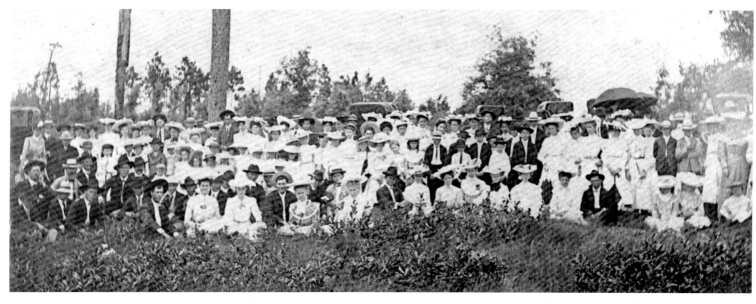

Pleasant Grove was a town located at the west end of Escambia County's Bayou Grande, between today's Gulf Beach Highway and the Pensacola Naval Air Station. Gathered here in 1905 is a Sunday school class in Pleasant Grove.

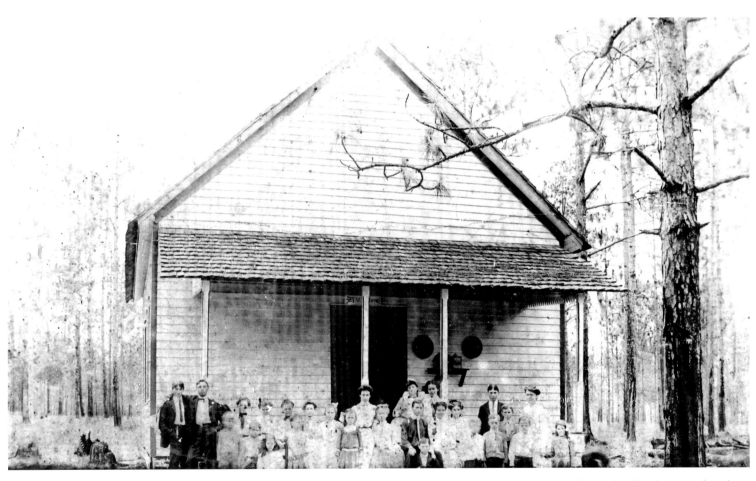

Located along the railroad track off SR 12 a little south of Greensboro in Gadsden County was Juniper, whose school is shown in this photo from around 1907. Juniper's post office operated from 1901 until 1927, when Juniper's population was about 100, and the mail was moved to Quincy. In 1854, David H. McDougald became the first white resident in the settlement that became the agricultural town of Juniper.

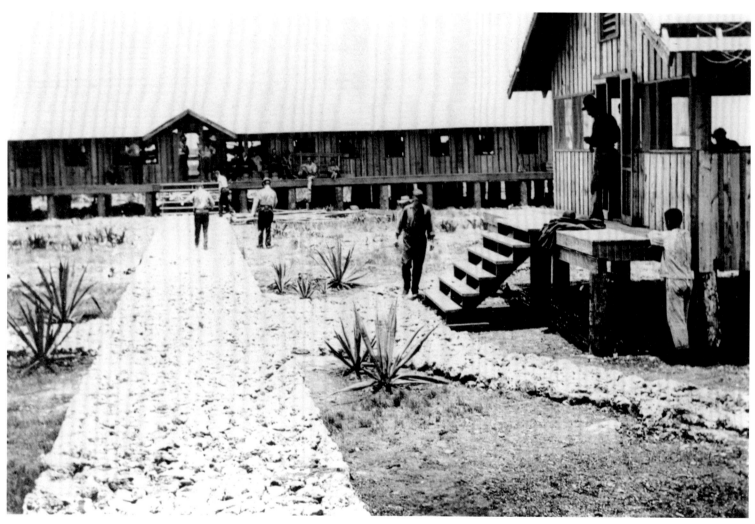

During construction of Henry Flagler's Overseas Railroad to Key West in 1908, the camp shown here was built on the five-acre Pigeon Key for men working on the Seven Mile Bridge connecting Marathon and Bahia Honda Key. The island, named for the indigenous white-crowned pigeons, became a maintenance camp for the bridge tender when the railroad was completed in 1912. In 1923, a Monroe County school and the Pigeon Key Post Office attempted to attract more residents. The railroad was later converted to an automobile route, and the island became home to maintenance crews, bridge painters, and tenders until the 1950s. In 1987, it was leased to the University of Miami as a marine research facility. The original Flagler mess hall, dormitories, paint supply buildings, and the post office remain open for tours.

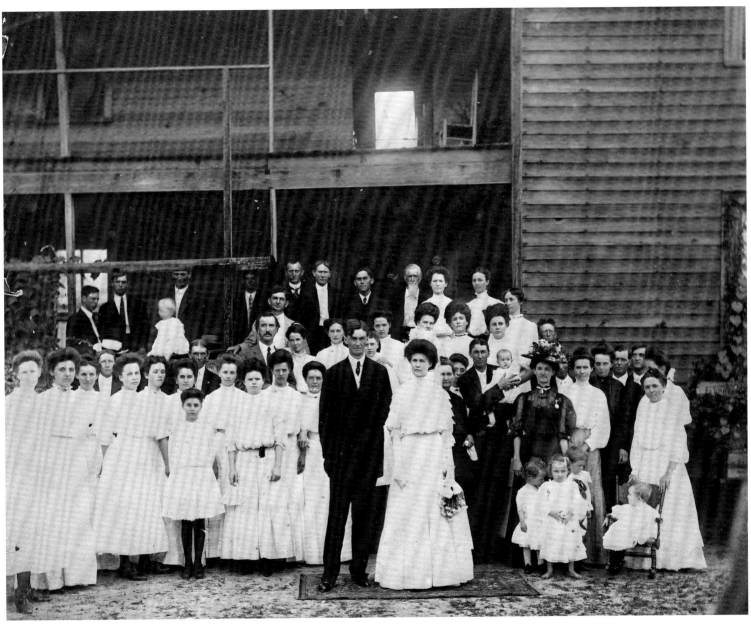

The Gadsden County town of Concord was named for its founders' ideal of concord, a unity of feeling or interest. It was located near Coonbottom about two miles south of Georgia along today's CR 157, and dated back to at least 1841, when Richard John Mays was pastor of its Baptist church. Concord was home of the county's third Masonic lodge, established in 1852. The town was officially founded in 1855, and its post office opened on August 28 of that year. It closed in 1867, reopened in 1870, and mail service was moved to Havana in 1953. The 1894-95 freeze reduced the population to 100, but it grew to 400 by 1928. This portrait shows guests at the Concord home of Jordan and Laura Walsh for the 1908 wedding of their daughter, Martha Matilda Walsh, and groom Talmadge Edwards.

Kinard was a town west of the intersection of SR 73 and CR 392 in Calhoun County, two miles southeast of Chafin. Its post office opened in 1901, and in 1959 it became a rural station of the Marianna Post Office. This photo from around 1909 shows Kinard residents Sally Land, Sude Land, baby Lilly Land, and Fred Land.

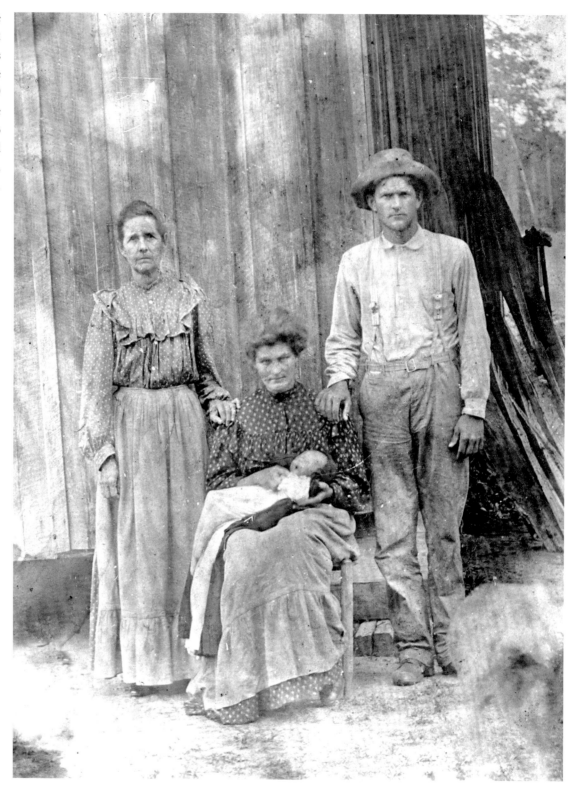

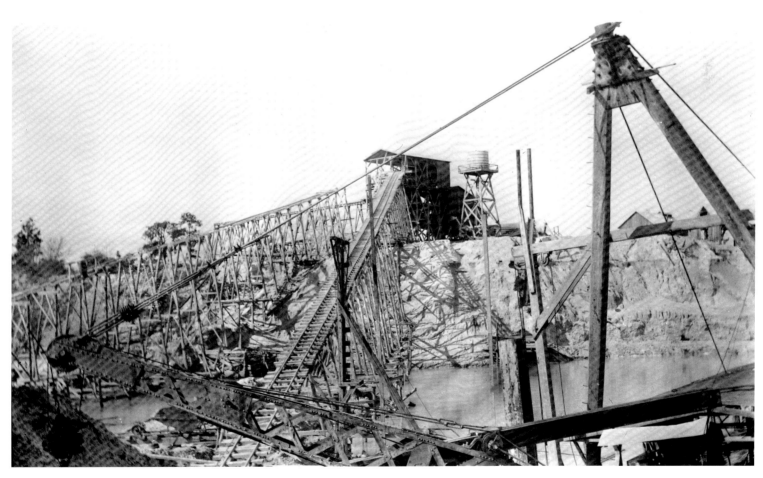

Now a wildlife management area and part of the Withlacoochee State Forest, Croom was a Hernando County agricultural town in the 1890s that produced turpentine, sugar, and lumber. It was served by a bridge across the Withlacoochee River and a railroad switch-out. What remains are the 1900 house of the Thomas family, building foundations, and ruins of the iron railroad bridge that carried trains eastward to St. Catherine. In 1893, the post office opened with the name of Fitzgerald, then was renamed Croom in 1902 and closed in 1935. The J. Buttgenbach and Company phosphate mine in Croom is shown here in 1910.

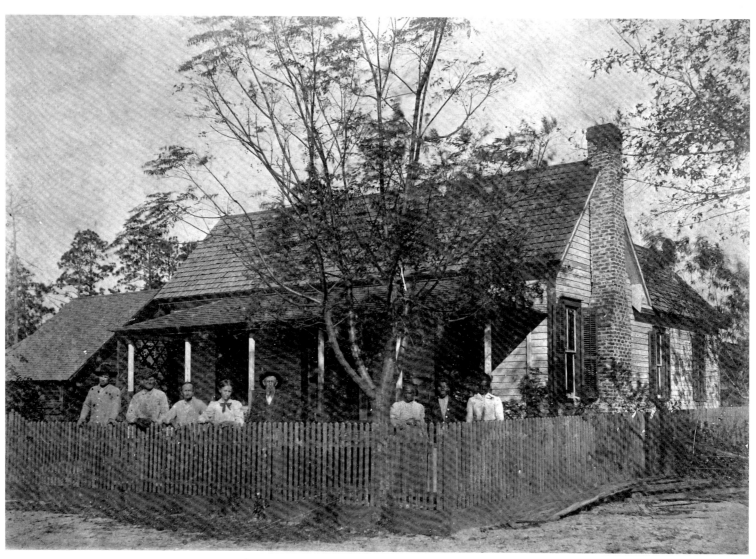

Nash was located in Jefferson County along US 19, approximately one mile south of today's Interstate 10. Walter Jasper Hatchett and his family are shown here in 1910 in front of their Nash farmhouse. The post office opened in 1904, and its applicant Henry Wheeler first proposed the name Bolton. He changed his mind about the name and eventually became Nash's postmaster. The post office closed in 1937, and mail was moved to Lamont.

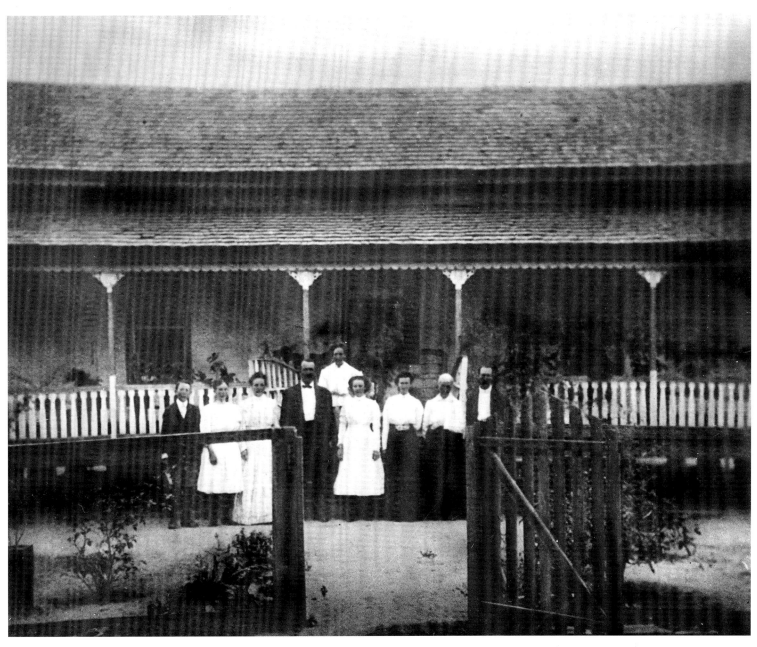

In Liberty County west of CR 12 along the Apalachicola River was Estiffanulga. Its post office opened in 1889 and moved to Bristol in 1930. Pictured here around 1910 was the homestead of James Albert Armstrong, whose family owned a store in Estiffanulga until the 1930s. The name of the town may have a Creek origin meaning "Spanish clan," the designation of one of the nine Creek clans.

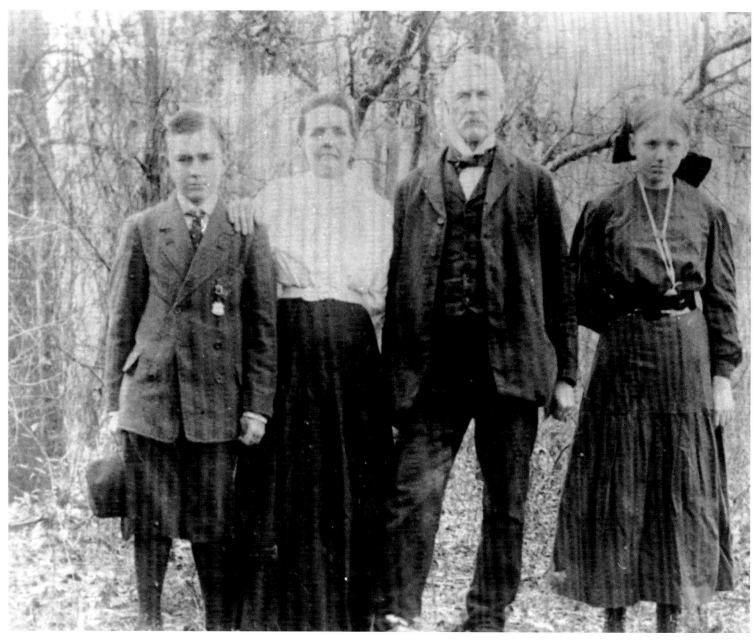

Located in Madison County north of Greenville where CR 140 meets the railroad tracks was the town of Spray. Near those tracks the community had a sawmill and several farms, served by a post office run by Fountain Hayne Cone, Jr. He also served as teacher and minister and ran the general store. The post office closed in 1921, when mail service was moved to Greenville. Shown here is the Cone family sometime after 1910.

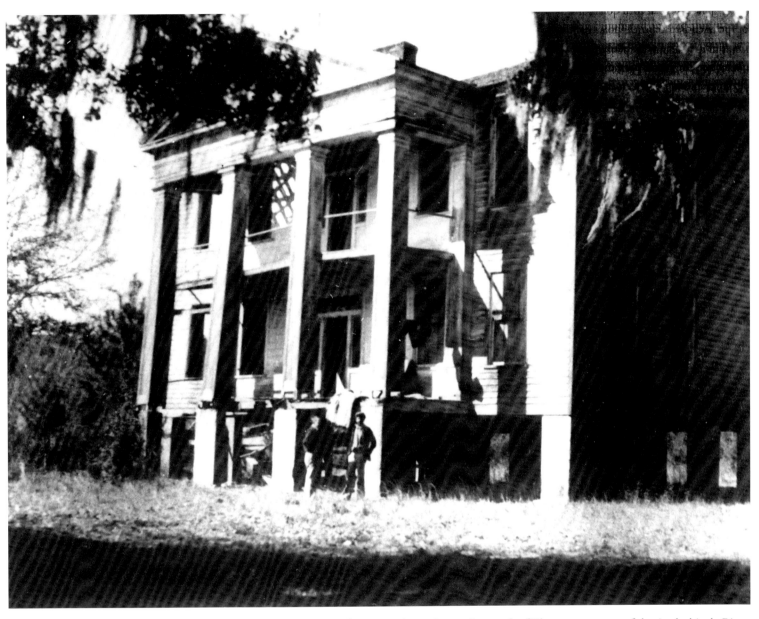

Beginning as an Indian town in Calhoun County, Ocheesee was located ten miles north of Blountstown west of the Apalachicola River, along SR 286 at the intersection with today's Charles Pippin Road. Ocheesee's most famous structure, the Gregory House, is shown here before it was moved in 1936 to the other side of the river, where it now stands in Torreya State Park. The name Ocheesee comes from Hitchiti words meaning "those of a different speech," and the Ocheesee tribe who lived at the village of Ochesulga.

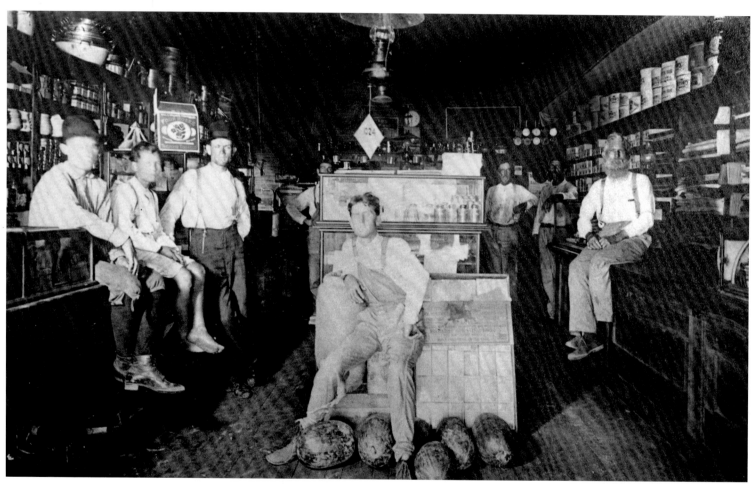

This picture was taken around 1910 inside the H. G. Hires grocery store in Fenholloway. Mr. Hires is the second man from the right. The name Fenholloway comes from Creek words meaning "high bridge" and may have come from the Creek settlement Finhalui in Wayne County, Georgia, that was occupied in 1832. In his guide to Florida in 1876, Sidney Lanier designated the Taylor County, Florida, town Finalawa. In 1918, the town's population was reported to be only 34.

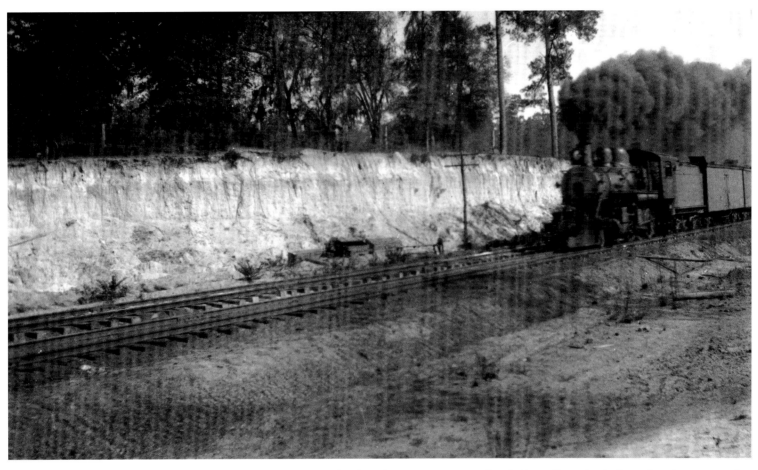

The Nassau County town of Camp Perry was served by the Atlantic Coast Line Railroad. One of its trains is shown here in 1910 passing through a cut made through the natural terrain to avoid pulling the cars up too steep a grade. Camp Perry was located west of Boulougne on the east bank of the St. Marys River, at a site previously known as Owens Field. In 1887, it was used as a yellow fever quarantine camp for those fleeing Jacksonville. The local post office lasted only from 1888 until 1890, and the settlement was soon disbanded.

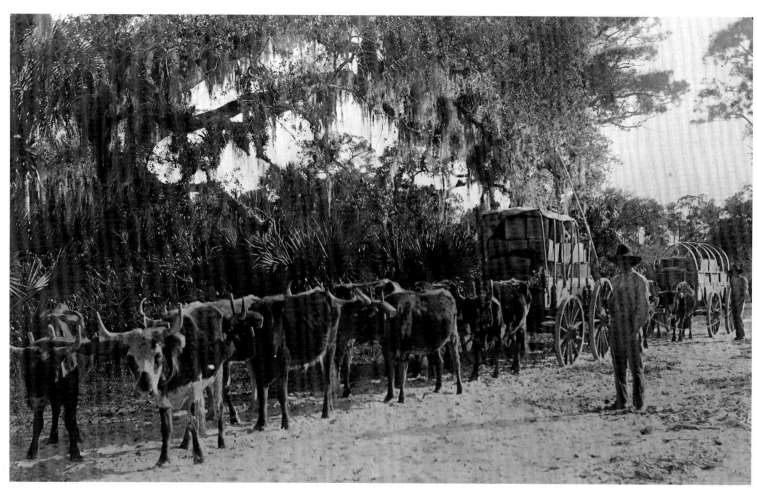

At the intersection of Okeechobee County's old wire road and the road from Fort Basinger was Fort Drum, established in 1840. The area, along US 441 south of Yeehaw Junction and north of SR 68, was first settled in 1877 by Joel W. Swain, who built and preached in a local church, and in 1878 by Henry Parker, who started a general store and trading post. His customers included many Seminoles who remained in the area. Parker's son-in-law, Henry Allen Holmes, came at about the same time and entered the cattle business. The area was used for growing oranges, some of which are shown here being taken to market by ox cart. The town was reached by the Kissimmee Valley Extension of the Florida East Coast Railroad in 1914.

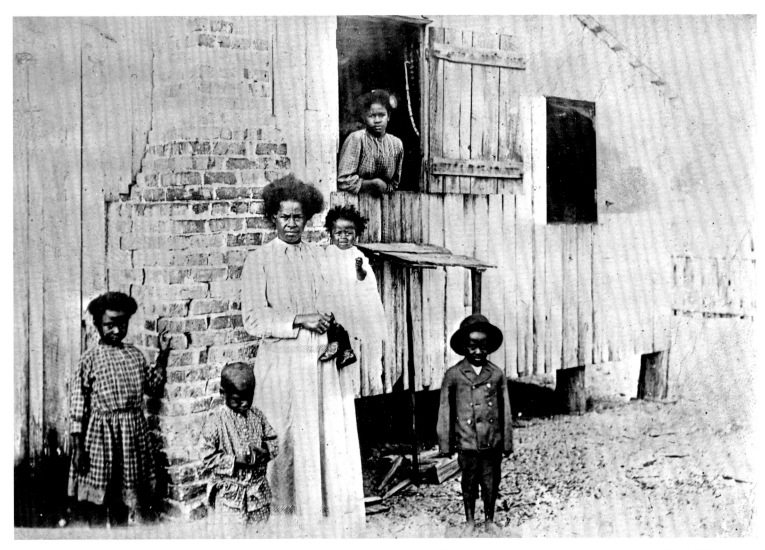

The Osceola County town of Ashton had a post office from 1904 until 1913, when mail service was moved to St. Cloud. When it was established along the St. Cloud and Sugar Belt Railway, it was named Ashton Station for an English family of early settlers. This photo from the second decade of the twentieth century shows Ashton resident Liza Neal and her family in front of their home, located not far from the intersection of US 192/441 and CR 15.

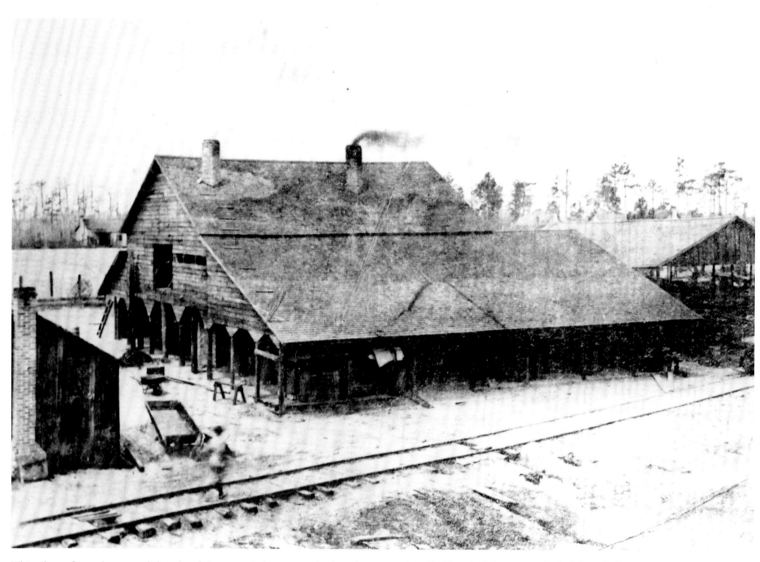

This photo from the second decade of the twentieth century depicts the turpentine distillery in Majette. Included from left to right are the glue house, the distillery, the gum barrels shed, and a storehouse. Majette was located along US 231 in Bay County and was named for a family that produced turpentine and other naval stores in the area. There was also an identically named town, named for the same family, in Gulf County.

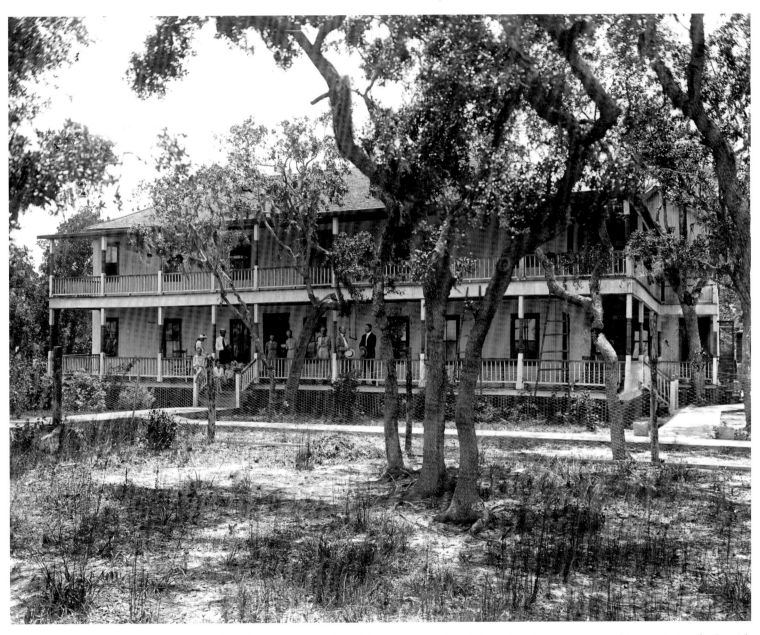

Located near Pace was Floridatown, which included the Floridatown Hotel shown here between 1910 and 1920. During the Spanish occupation of Florida, the site in the Escambia River's delta near Escambia Bay was a trading post. In 1814, General Andrew Jackson camped there, and it is believed that he was accompanied by frontiersman Davy Crockett. The town served as the county seat of Santa Rosa County before Florida became a state, but after the 1842 yellow fever epidemic raged through Floridatown, the county seat was moved elsewhere.

The settlement of Berlin in Manatee County had its own post office only for a portion of 1880. Shown here in front of the school building in 1912 is Berlin resident Chellie Collins Skiles. The town may have been named for a German city.

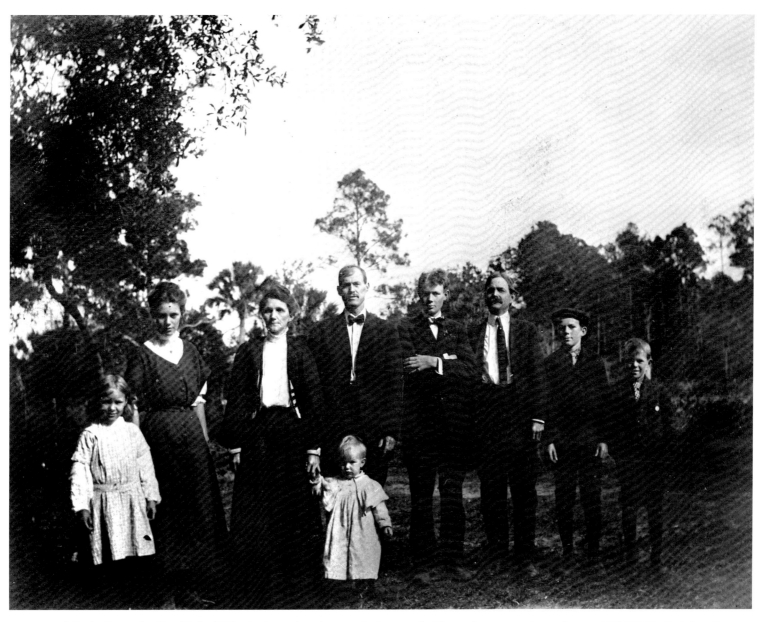

The DeGrove family of Palm Valley is shown here in a 1913 photograph. The settlement was located west of SR A1A in St. Johns County, south of Ponte Vedra Beach. It was first known as Diego for San Diego, the early eighteenth-century cattle ranch located nearby owned by Don Diego de Espinosa. The town was renamed Palm Valley in 1907. It was isolated from the mainland and other settlements, but the completion of the Intracoastal Canal in 1908 brought increased activity to the area, now part of the large Ponte Vedra Beach resort area. Jacksonville Beach took over the mail service to what remained of Palm Valley in 1932.

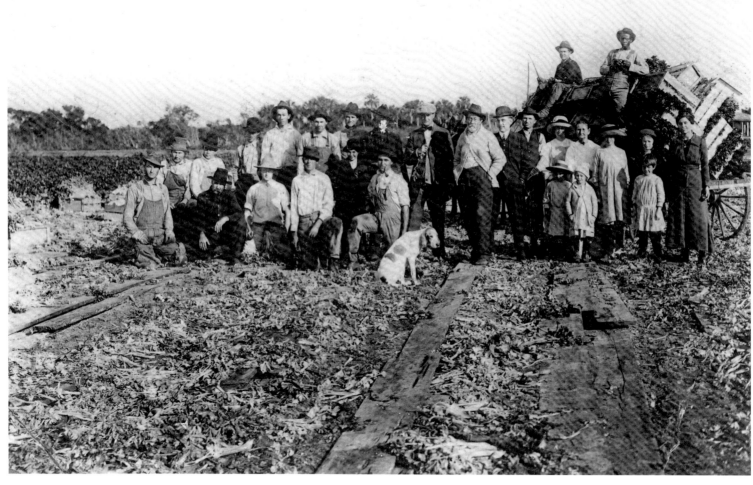

On a site along today's Moccasin Wallow Road, between US 41 and Interstate 75 in Manatee County near Terra Ceia Bay, a town was started prior to the Civil War. Known as Frog Creek, its pioneers included Daniel Gillett, who arrived with his family during the 1840s. He and his family remained prominent in the community, which came to be known as Gillette, with a slightly modified spelling. It had a post office from 1895 until 1910 and opened a school in 1925, which closed in 1948. The small rural community was served by the Gillette First Baptist Church and produced crops such as the celery shown here in this 1914 photo.

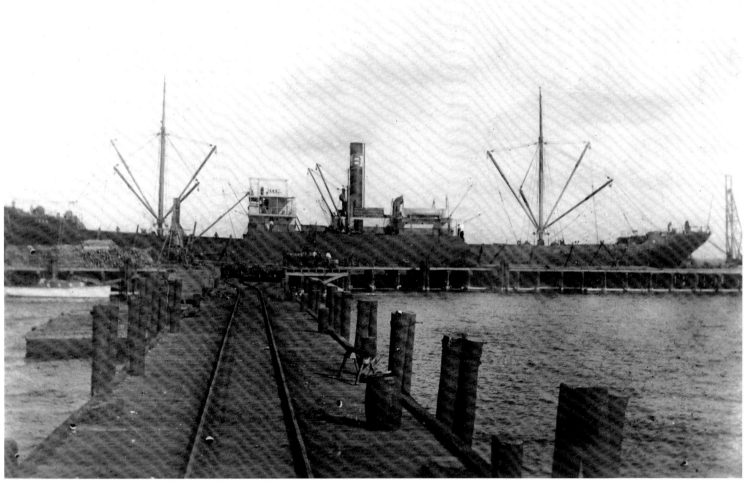

The Charlotte County town of Charlotte Harbor, formerly known as Hickory Bluffs, was a major shipping port located across the Peace River from Punta Gorda. It had a post office from 1872 until 1874 and 1876 until 1955, when it was moved to Punta Gorda. From 1888 until 1890, Charlotte Harbor was where the *South Florida Home* was published, then it was moved to become St. Petersburg's first newspaper. Charlotte Harbor got its next paper in 1893, the *Charlotte Sun Herald*. The county and town may have been named to honor Queen Charlotte of England, wife of King George III. Old maps of the area also show the harbor area with the name of Carlos Bay, dating back to Spanish days. This photo from around 1915 shows the steamship *SS Jean* captained by Peter Nelson and moored at the Charlotte Harbor pier served by the railroad.

In the last half of the nineteenth century, Midland was established as a settlement in Polk County between Lake Buffum and Crooked Lake. It comprised about two dozen homes, and its main product was turpentine. Even the few gravestones found in 1974 offering proof that a town once existed are now nowhere to be seen. The former townsite has been turned into private pasture land. The man second-from-left in this 1915 photo is Curtis Clark, one of the butchers in the Midland meat market.

The area of Sumter County including Linden, where CR 719 crosses SR 50, was settled by George Washington Gideons from Telfair County, Georgia, who arrived in 1851. The town was named by its first postmaster, W. H. Hood, for his hometown of Linden, New Jersey, named after the linden tree. A major feature of the formerly thriving town is the Linden Cemetery. For more than a century, a popular annual event, the Linden Cemetery Picnic, has been held in the small nearby community of Mabel. George P. and Rosa Parish are shown in this photo from around 1915 behind the counter of their Linden store, which also served as the post office.

In 1885, a town first called Wharton was established in Osceola County on the shore of Lake Runnymede, northwest of the intersection of US 192/441 and CR 15 (Narcoosee Road). Beauchamp Wilson operated the three-story Hotel Runnymede on the eastern shore of Lake Tohopekaliga, and around it grew a small town known as Runnymede. It was served by the St. Cloud and Sugar Belt Railway, and the hotel building was used as an agricultural school and then as headquarters of the Disston Drainage Company. This photo from the second decade of the twentieth century shows the private school located at Runnymede. The hotel and surrounding settlement were abandoned around 1930. The hotel was torn down during the 1940s by John J. Padgett, who used its lumber to construct at least 15 small homes in Orlando.

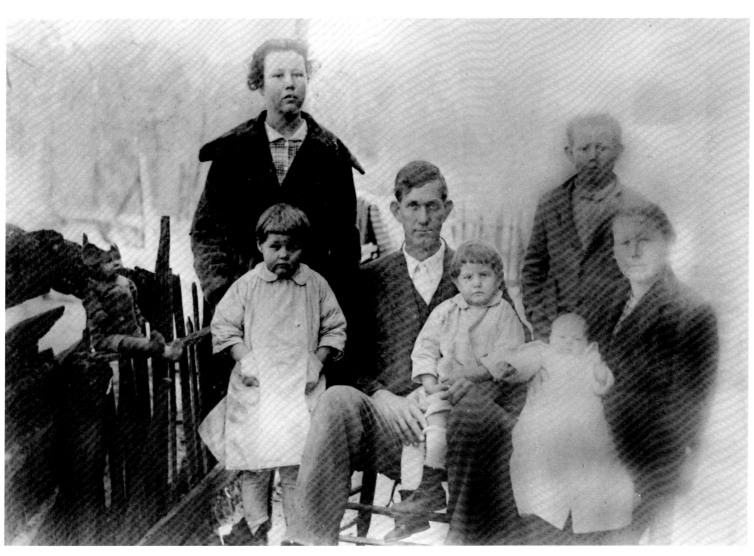

Shown here in 1919 is the Arnold and Alberta Shuler family at home in Walton County's Luana. The home was built on the site of the post office and grist mill. The post office, which opened on November 26, 1895, closed two decades later on January 31, 1914.

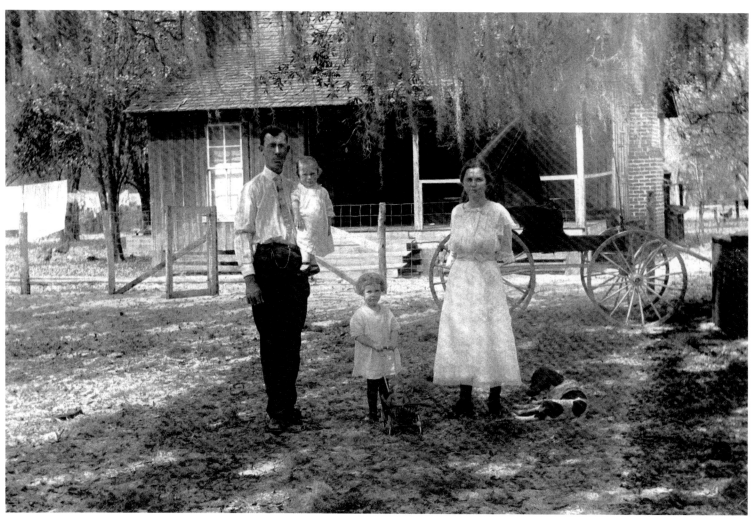

Mabel, a small rural community in Sumter County, had its own post office beginning in 1894. It was named for Mabel Phelps Page, the daughter of postmaster J. P. Phelps. The post office closed and mail service was transferred to Linden in 1918. Today, there are a few rural homes and no commercial activity, despite the former town being located along a major road (SR 50, between CRs 772 and 773). The only three signs with Mabel's name are two green and white D.O.T. signs along the road, and one painted on the pavement at the northern end of the Van Fleet Trail, a 29-mile multi-use trail stretching from Mabel to Polk City. This 1916 photo shows Scarboro Washington Stanfield, his wife, and his children in front of their Mabel home.

Arran was a town in Wakulla County west of Crawfordville, perhaps named for a Firth of Clyde island in Scotland. A post office was established in 1894 and lasted until 1954, when mail service was moved to Crawfordville. Pictured here are the female students of the Arran school.

Hildreth residents are shown here in about 1920 celebrating the Fourth of July near the Ichetucknee River. The town was located in Suwannee County along US 27 at the southwest corner of today's Ichetucknee River State Park. Hildreth was named to honor turpentine camp owner C. M. Hildreth, Sr.

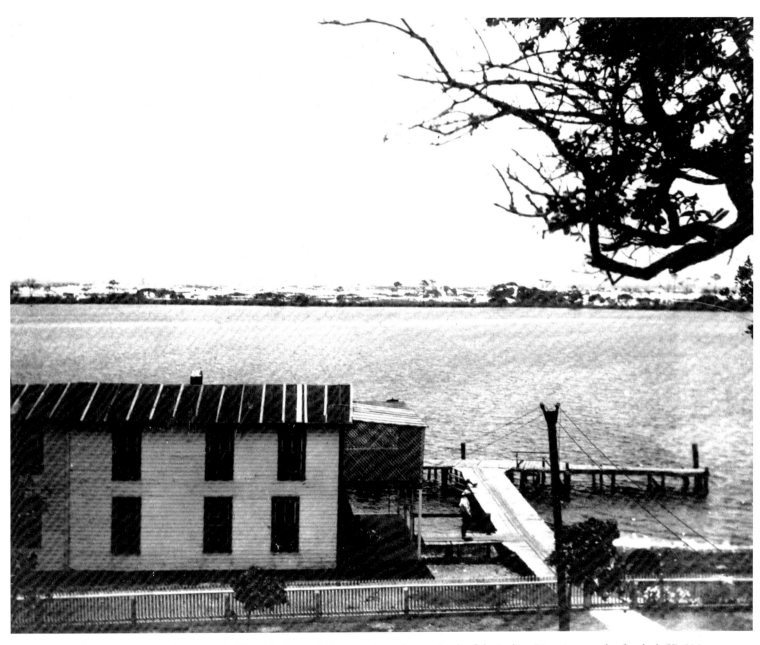

Indianola was located on Merritt Island in Brevard County, along the east bank of the Indian River just south of today's SR 528 causeway. When they arrived in the 1880s, John R. Field and his wife named the settlement Indianola because of the nearby Indian mounds. This photograph from around 1921 is of Indianola's wharf and post office, which opened in the late 1880s with Samuel J. Field as the postmaster. It closed in 1925, and mail was thereafter handled in Cocoa.

The Escambia County town of Oak Grove was settled in the 1850s by a few pioneers, including Tom Wiggins. The settlement was initially called Wiggins because the Wiggins store is where the stagecoach left the mail. In 1915, a brick school replaced the one-room building from 1890, the year the community was renamed Oak Grove. The school closed in 1949, and the building was converted into a pavilion in 1978. In this photo, a pair of 4-H club boys are seen arriving at a club meeting in 1923. Ten years later, SR 97, on the western boundary of town, became Oak Grove's first paved road. The next one was paved in 1954.

Today's city of Newport has no remaining structures of the original Newport, which was created in October 1843 after residents of hurricane-destroyed Port Leon moved to a new townsite up the St. Marks River in Wakulla County. Streets were laid out on a grid, a bridge was constructed over the river, and the Hamlin family built a foundry, several homes, stores, two hotels, a sawmill, turpentine stills, and the Wakulla Iron Works shipping port. Albert R. Alexander, the newspaper editor who had fled from Port Leon after the hurricane, started the *Newport Patriot* in 1844. By 1872, however, the population that had grown to 1,500 dipped to 30. The town rebounded to some degree with an increased shipbuilding industry, but little was left by the 1970s. Most of the former town is now owned by a logging company. Shown here in 1924 are several homes near the seawall of Newport's sulphur springs.

The Wakulla County town of Smith Creek was established in 1845 by settlers from South Carolina and Georgia, including James Kees. It was named for an early settler and had a population of only 32 in 1895. The town was located along CR 325 (Smith Creek Road) midway between Sanborn and the Leon County line. The John H. Langston family is shown here around 1926. Their log home in Smith Creek was moved to Perry in 1970.

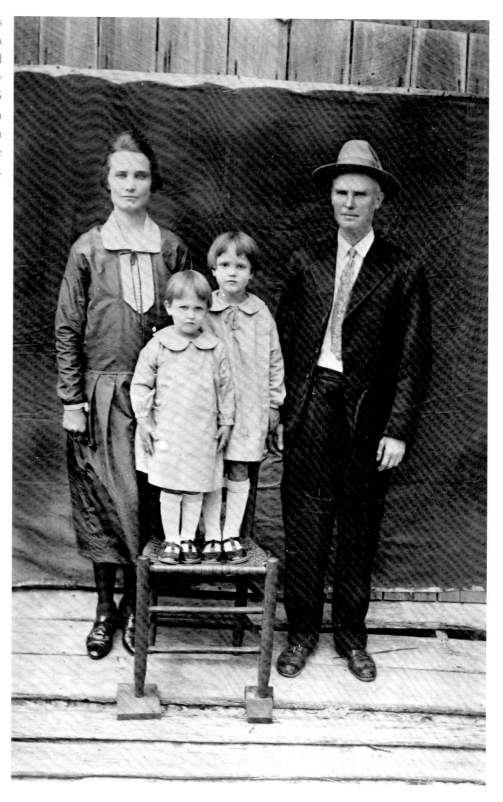

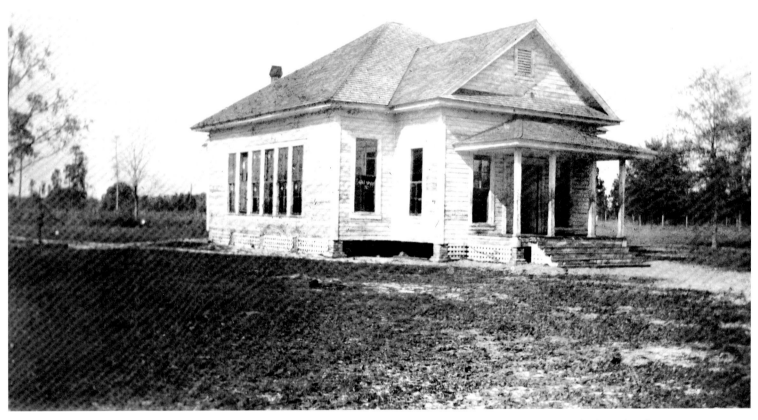

Hanson was a Madison County town along SR 145 located about two miles east of Cherry Lake. The Hanson Methodist Church was founded in 1902, and five years later that congregation and a group of Baptists worked together to construct a jointly used tabernacle seating 2,000. It stood in Hanson until 1920. Pictured here is the Hanson School from around 1928.

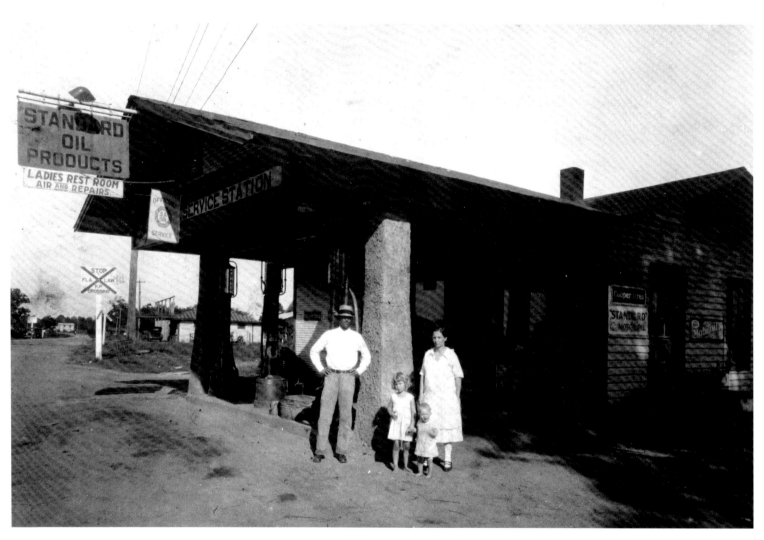

The Averett family is shown in front of their gas station in Salem, a town founded in 1842 with a population of 101 in 1895. It was located at the intersection of Alt US 19/27 and Fish Creek Road in Taylor County. Salem had a post office from 1878 to 1882 and from 1883 to 1917, the year it was moved to Carbur. A new Salem post office opened in 1924, but it closed down two years later and again moved to Carbur.

Shown here is the old wooden bridge serving Harbeson City in Franklin County. It got its name from a family active in hotel management and lumbering in the Panhandle. Harbeson City's last post office operated from 1925 until 1942, and thereafter the region's mail was handled through Carrabelle.

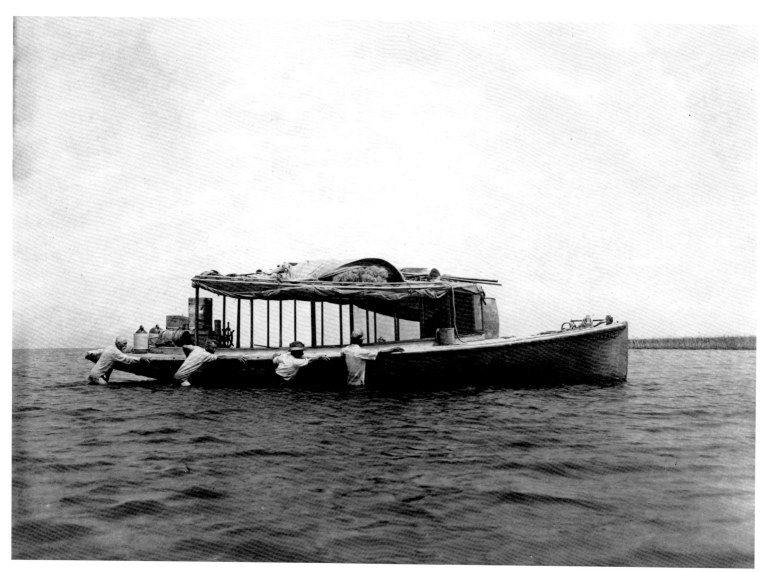

At the southeastern corner of Lake Okeechobee on Kreamer Island, southwest of Pahokee in Palm Beach County, was the settlement of Kreamer. It had a post office with the spelling of Kraemer beginning in 1918, but the spelling was changed to Kreamer in 1932. It was named for Hamilton Disston's chief engineer involved with the draining of the Everglades. Shown here is the *Barbee* stuck in the shallow water in the vicinity of the island. The post office shut down in 1936, and mail was thereafter handled in Chosen.

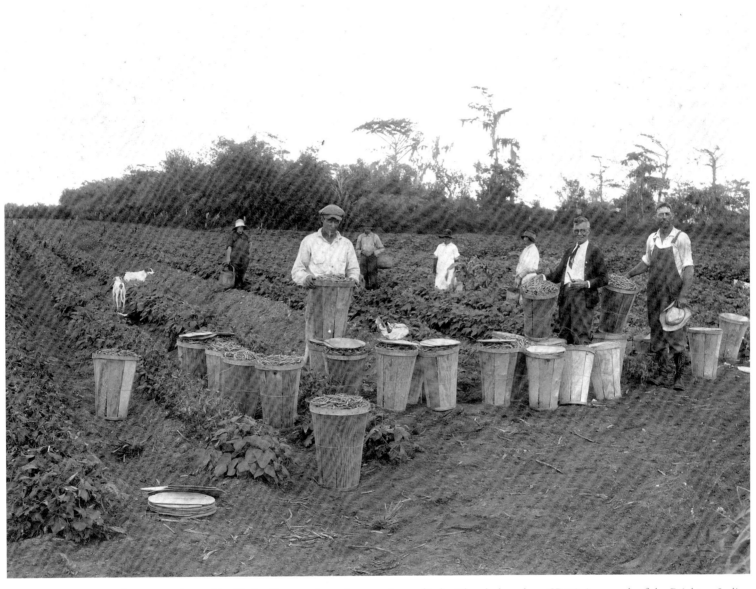

Lakeport was located in Glades County along the west shore of Lake Okeechobee along SR 78, just south of the Brighton Indian Reservation. It was established by Gene Sebring in 1913 at the site where Fisheating Creek meets the lake. An attempt was made to sell farmsites to those who would raise vegetables, and one of the proposed crops in the Lakeport area was beans, a harvest of which is shown here in 1929. They did not grow well, and the town shifted to fishing for bass and catfish. The area was hurt by the 1926 hurricane but remains a small agricultural community.

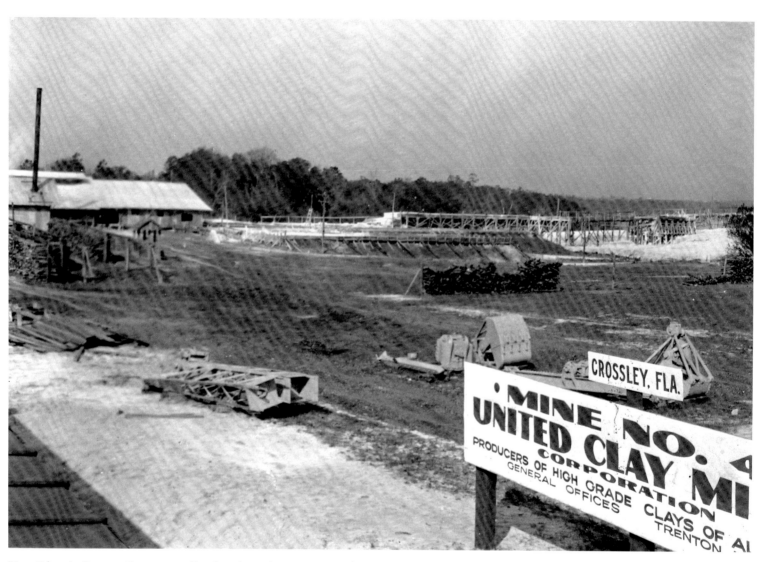

Near Edgar in Putnam County was Crossley, shown here in a 1930 photo. It was situated on a site chosen in 1924 by United Clay Mines Corporation for the kaolin mining operation, and it was named for United Mines' president, G. C. Crossley. The area was hit hard by the Great Depression, but by December 1934, it was reported that the Crossley kaolin mine was busy, working both a day and a night crew to try to keep up with the increasing need for kaolin. The town of Crossley, located near Cowpen Lake, is no more. A large summer campground was established there by the South Atlantic Conference of Seventh-Day Adventists.

During the 1850s, Captain Samuel Agnew cleared land around Blue Springs, planted sea island cotton, and established the Marion County settlement of Juliette. The town incorporated in 1883 and had a hotel, post office, sawmill, three general stores, and a railroad depot. Phosphate mining and farming were its major industries. The town began to fade away in the 1920s, and the springs became a popular tourist attraction known as Rainbow Springs, now a state park. Blue Springs is shown here in 1931.

Located in Madison County near the junction of SR 53 and CR 150 was a settlement started in 1827 by Lucius Church of New Hampshire. It opened its first post office, Overstreet's, in 1833, named to honor postmaster Silas Overstreet. It was renamed Townsend in 1834 when Asa Townsend became the postmaster, then became Cherry Lake in 1837 because of the many cherry trees growing by the lake. Two years later, another post office named Church's opened, and the following year it was consolidated with Cherry Lake. It finally closed in 1907. The 4-H Club maintained a camp in the town in the 1930s, and some of its campers are shown here.

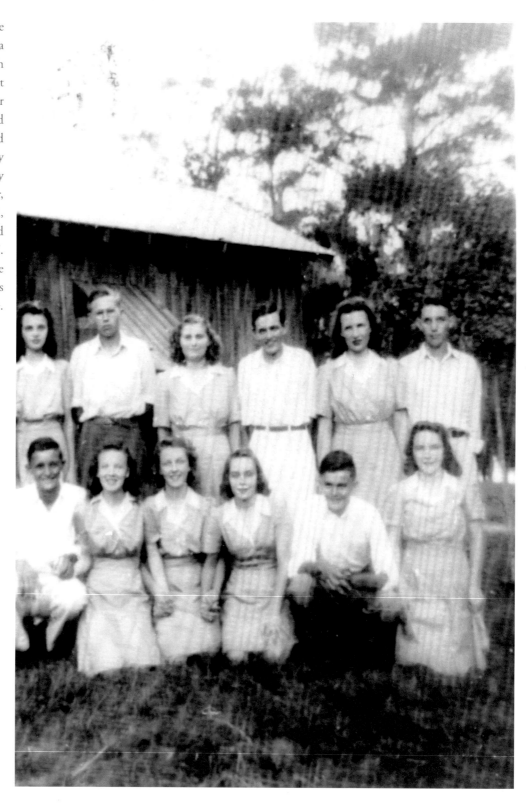

This 1934 photo shows an outhouse in the Neighbors Guild Cooperative Colony located at Lake Ashby, near a lake of the same name. Both took the name of Major James A. Ashby, an officer during the Second Seminole War. Lake Ashby was located along SR 415 between Osteen and Samsula in Volusia County and had a post office from 1890 until 1894. Thereafter, the mail was handled in Osteen.

Near the site of the Lafayette County town of Day was Fort Atkinson, named for Colonel Henry Atkinson. It was established on January 18, 1839, during the Second Seminole War and was abandoned less than six months later. Years later, Day was established with the name of a local family and was reached by the Live Oak, Perry and Gulf Railroad in 1905. Its depot was located just north of the Day Cemetery. The town's early crops included watermelons and tobacco. Day has had a post office since October 4, 1892, despite having a population of less than 60 in 2000 and essentially no commercial activity. The Day school is shown here as it appeared in 1935.

162

The Alachua County town of Jonesville ran a post office from 1870 until 1879, when it moved to Newberry. This 1936 photo shows the Farnsworth family in front of their Ten-Mile Trade Post Grocery Store and Amoco Station, located near the intersection of SR 26 and SW 170th Street. In the vicinity today is the recently constructed Town of Tioga, along with its homes and businesses.

In Jefferson County at the intersection of US 19/27 and SR 257, a post office was established in 1848 with the name of Beasley for Sam Beasley's store, where mail was left on the stagecoach run from Tallahassee to St. Augustine. It was renamed Perry in 1850, and went back to Beasley from 1851 to 1859 and from 1860 to 1861. In the meantime, the town was also locally known as Lick Skillet and McCains Store. It was designated Lamont in 1885 to honor Grover Cleveland's Secretary of War, Daniel Scott Lamont, who had recently visited the state. This 1936 photo shows landscaping at the John R. Roberts home in Lamont, inspired by recommendations of the local home demonstration club.

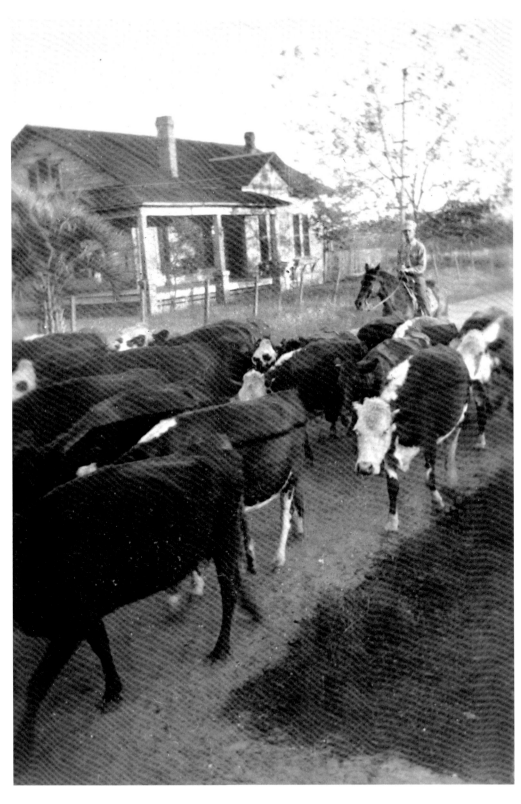

North of Quincy in Gadsden County, the town of Hardaway was dependent upon a large tobacco plantation nearby. The first landowner in the area, who received his land from the federal government in 1892, was Thomas Harvey. In the late 1920s when the population reached 180, the crop was ruined by a tobacco blight, so most of the agricultural workers moved elsewhere, abandoning the town. By the 1960s, the buildings were succeeded by a pine forest. This photo taken in 1939 shows J. H. Campbell driving cattle past one of the former Hardaway homes.

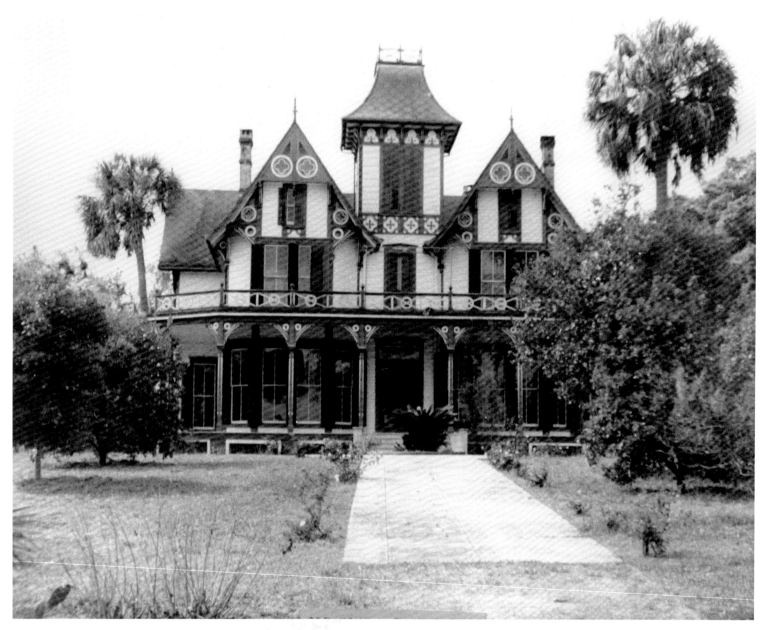

Along the western bank of the St. Johns River, north of Georgetown, was the town of Fort Gates, founded as a British fort in 1786 and named for Sir Thomas Gates of Virginia. A permanent settlement began to grow at the site in 1859, and by the mid-1880s, there were about 40 families residing in the area. In 1939, in anticipation of filming *The Yearling,* based on a novel by Marjorie Kinnan Rawlings, MGM representatives went to Putnam County looking for a farm to use as the home of the movie's Baxter family. This is the Fort Gates home they leased for the filming, which began in 1940 (when this photo was taken) and was finally completed in 1947. In 1974, it was reported that there were only three houses remaining in Fort Gates.

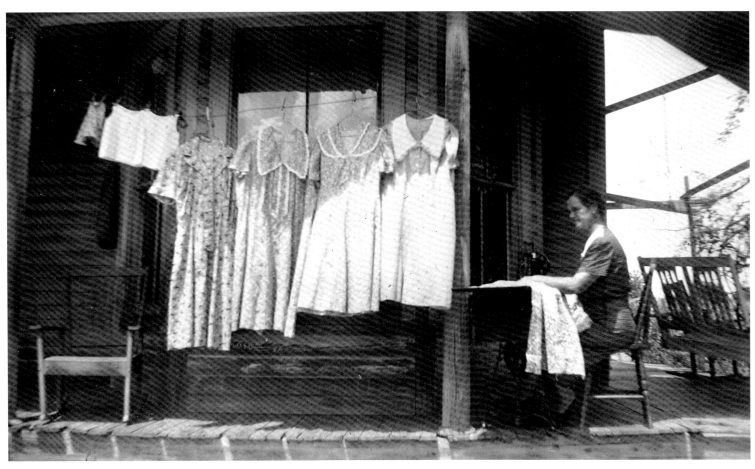

In 1832, the settlement Ocello was established in Jefferson County with a post office, which closed in 1834. In 1842, Ocello reopened as Aucilla and operated until 1848, then from 1850 until 1852, 1860 until 1870, and 1884 until 1955, when mail service was moved to Monticello. It served as an overnight stop along the Salt Road, over which wagons carried salt from the Gulf of Mexico to Georgia. As the fourth stop along the railroad from Tallahassee, Ocello was also called Stop Four. The town's name comes from the Seminole village of Oscillee, found on the east bank of the Aucilla River in Taylor County. It is Timucuan in origin, but its meaning has been lost. This 1942 photo shows Mrs. Hancock and part of her sewing display for the local home demonstration club, set up to enhance the domestic lives of rural women during World War II.

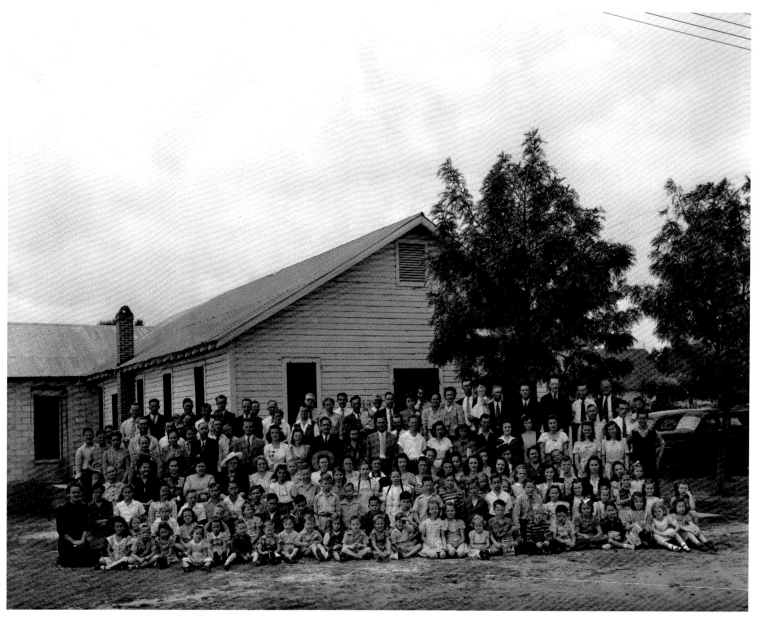

Posed here during the 1940s are the Sunday school participants of the Eloise Church of God. The town was located in Polk County along US 17 between Winter Haven and Eagle Lake. It had a post office from 1894 until 1899 and from 1901 until 1916, when mail service was transferred to Winter Haven.

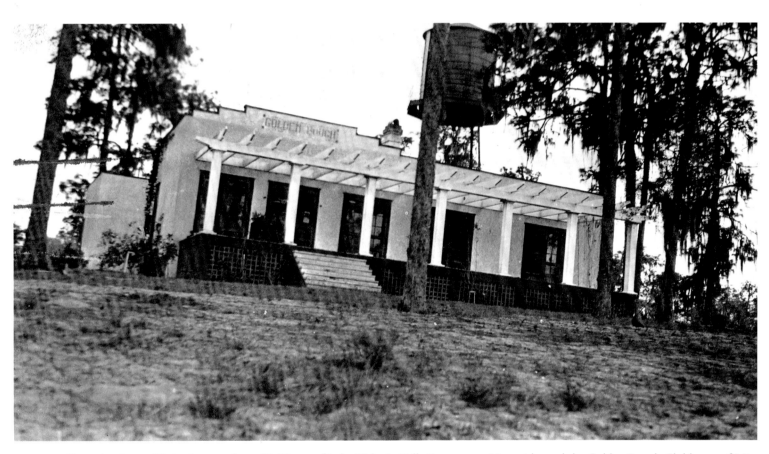

Along the shore of Lake Aurora, along SR 60 east of Lake Wales in Polk County, was Hesperides and the Golden Bough Clubhouse of Miss Tilden's colony, pictured here. The town was named for the legendary Greek Garden of the Hesperides, where the golden apples of Hera grew.

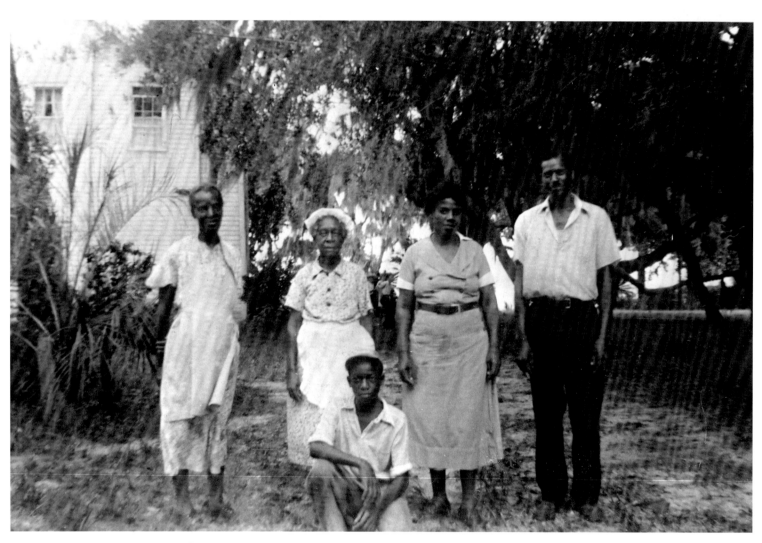

Hibernia was located in Clay County on Fleming's Island in the St. Johns River, north of Green Cove Springs. A cotton plantation was established there in 1790 by George Fleming, who named the settlement after his Irish homeland. His first home in Hibernia was burned down by Indians but was replaced in 1856 by a mansion that survived until the middle of the twentieth century. Hibernia's post office operated from 1849 until 1853, then mail service was moved to Magnolia Mills in 1853 and to Green Cove Springs in 1866. Pictured here in the 1940s were employees of Hibernia's Fleming House Hotel.

Located in Marion County just west of Interstate 75 at the intersection of CRs 225 and 318, Irvine is a small rural community located about a mile and a half north of the Fort Drane site, built in 1835. Its post office, named for local landowner Dr. O. B. Irvine, opened in 1871 and closed the following year, reopened in 1875 and closed in 1876, and reopened again in 1896 and closed after 2000. Shown here in 1946 on his Irvine ranch is Bill Davis with a three-month-old Karakul sheep named Abdul.

Otter Creek was located in Levy County at the intersection of US 19/98 and SR 24, along the railroad track east of Ellzey. During 1895, it had a population of only 26. The nearby landscape included the cypress domes shown in this photo from the 1940s. The name of both the town and the waterway may be a reflection of a formerly important industry in Levy County, otter trapping. The first Otter Creek Post Office opened with that name in 1871.

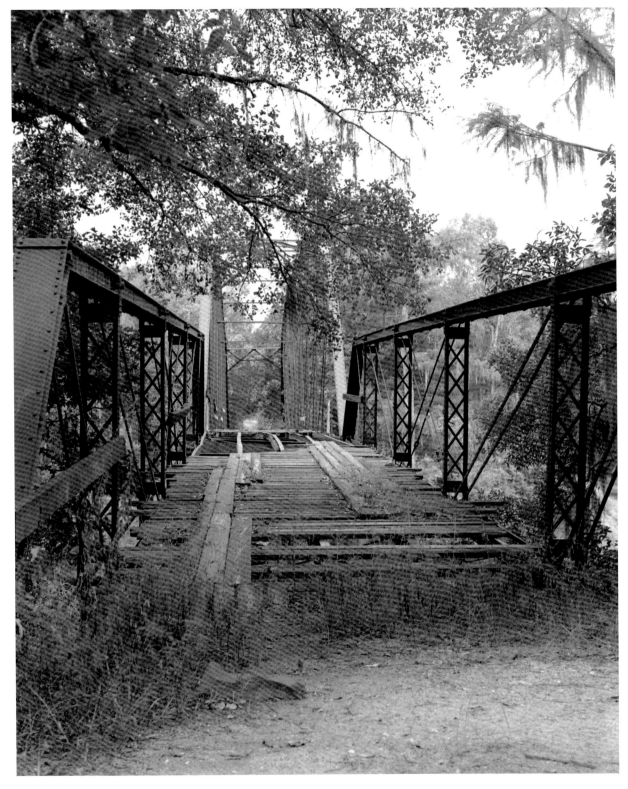

Bellville, located in Hamilton County close to the Georgia border, is reached by leaving Florida via Interstate 75, then heading southwest back into Florida on Bellville Road (CR 152). There is little evidence of a community other than a few rural dwellings, the Bethel A.M.E. Church, and the Bellville Community Cemetery. A post office named Benton opened in 1841 but was renamed Bellville in 1847 for Colonel James S. Bell and his brother, Daniel, who had arrived in the area in 1824. The post office closed in 1868, reopened a year later, and closed for good in 1906. This is a photo of the bridge constructed in 1912 along Bellville Road. It crosses the Withlacoochee River.

The Polk County town of Willow Oak was located along SR 60 west of the intersection with SR 37. This photo from the 1890s depicts Mrs. W. O. Gibson Johnson and Mrs. Frank Hall returning from church in Willow Oak.

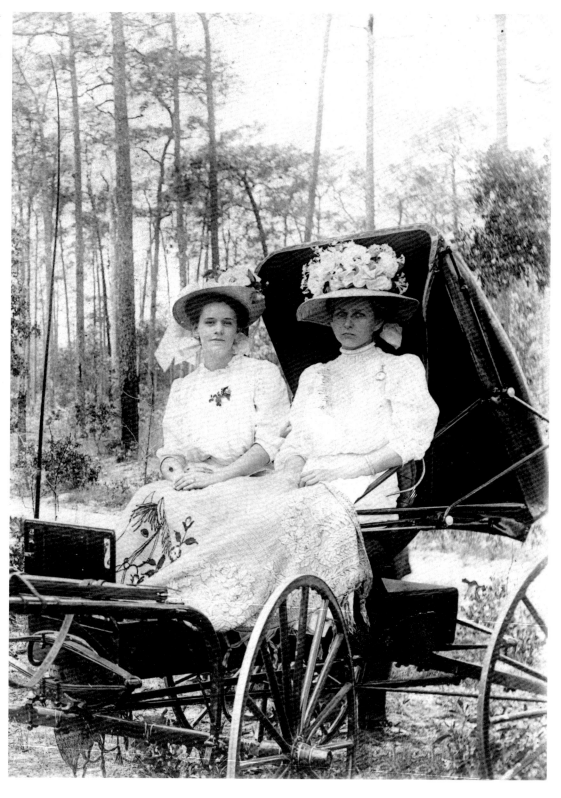

The Okaloosa County town of Bethel, located along the Yellow River near the intersection of SR 267 (Bloxham Cutoff Road) and CR 365 (Spring Creek Highway), was settled in 1835 by about 60 families from South Carolina who shared a Scottish ancestry. They were followed by settlers from Alabama. Originally named Almarante, the town had a post office that opened in 1883 and closed in 1909. The name Bethel is biblical in origin, meaning "house of God" in Hebrew. During 1895, it had a population of 302 and remained a community for several years. Town residents used the building shown here as their community center when this picture was taken in 1955.

Bean City, named for the string beans grown there, was one of several farming communities begun in the early 1920s in the Everglades of Palm Beach County. A school opened in 1923 to serve the vegetable farm and sugar plantation owners and workers. After a hurricane flooded the town in 1928, only one home remained, but rebuilding allowed the school and post office to reopen in 1936. However, the school eventually closed in 1952, and the post office was eliminated in 1973. Except for about six rural homes along Old US 27 near the Hendry County line, there is nothing left of the town. This 1960 photo shows another one of the crops grown in and around Bean City.

Absorbed by Another City

Competition among towns often results in the survival of one and the elimination of the other. Generally, it is the result of each attempting to draw the same businesses or the same potential residents, with one having the slightly better location or resources—or just plain luck.

Sometimes the competition existed between towns located miles apart, as were Columbus and Ellaville, both along the Suwannee River. Columbus was the older city, having been established prior to the Civil War. When Ellaville was founded after the war, it became the more important community in the region. Only one post office was needed to cover the entire area, so the old established Columbus Post Office was closed, and a new one opened in the up-and-coming Ellaville.

The newer town also drew settlers and businesses, and Columbus faded into obscurity. Eventually, Ellaville also turned into a ghost town, not because of competition from another town, but instead from closing down the single industry on which it depended, the cutting of lumber. Another example of an emerging ghost town due to competition was sponge-dependent Bailey's Bluff, which disappeared following the growth of the sponge industry up the Anclote River in Tarpon Springs.

Other instances of competition deal with towns located close to each other, with one gaining the edge on growth and taking over the other. Arlington used to be a separate city but was relegated to a neighborhood within a growing Jacksonville. Lakeland's expansion southward surrounded and absorbed Medulla, similar to Tampa's annexing the formerly independent community of Sulphur Springs.

In these examples, the ghost towns are hardly devoid of live humans. Often, they are quite densely populated. Those who live and work there, however, are citizens of the towns that won the competition over those that passed into history. The original towns, now often memorialized only on road signs, if memorialized at all, have ceased to exist.

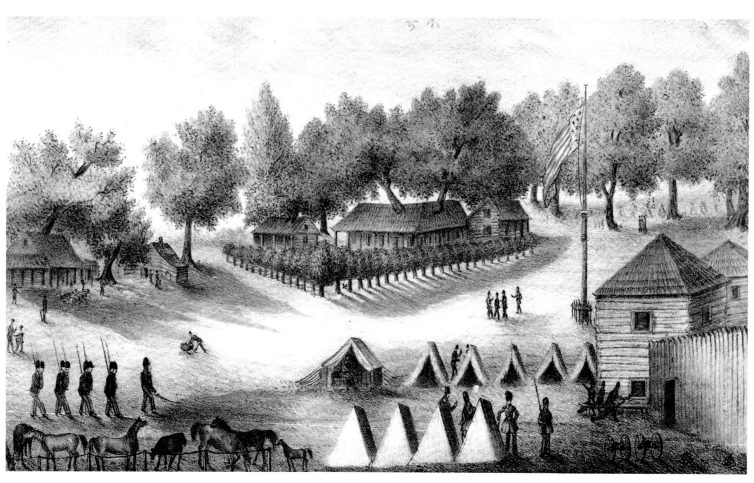

In 1824, Colonel George Mercer Brooke established a military post in Hillsborough County, where the Hillsborough River flows into Hillsborough Bay, on a 16-square-mile site suggested by Andrew Jackson. Named Cantonment Brooke and then Fort Brooke, it protected the area during two Seminole wars. Union gunboats were repelled by its guns during the Civil War. The fort closed in 1883, and the town of Tampa spread out and annexed the remaining settlement in 1907. Fort Brooke was at one end of the military road stretching to Fort King (Ocala), along which Major Francis L. Dade and over 100 of his men were killed by Seminoles on December 23, 1835. The garrison site is now beneath the Tampa Convention Center and the Marriott Hotel. This lithograph from the 1830s depicts the tents and barracks at Fort Brooke.

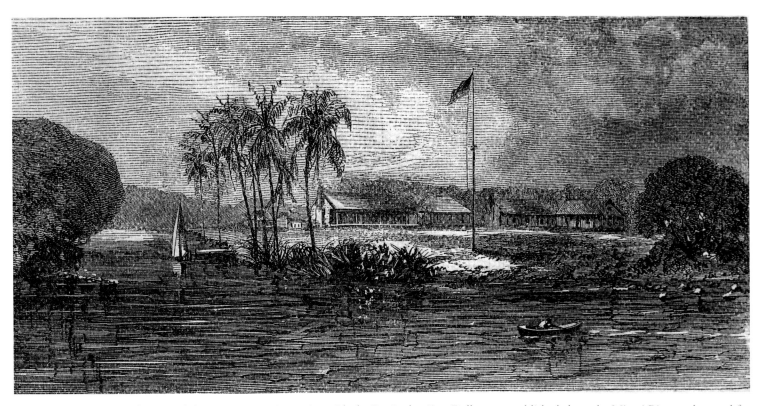

Around 1836, while tensions were increasing with the Seminoles, Fort Dallas was established along the Miami River and named for Commodore Alexander James Dallas. The enlisted men's barracks also served as the Dade County Courthouse. The post bakery and residences for the officers burned down in 1870-71, about the time this drawing of the fort was made. The property was purchased in 1890 by Julia D. Tuttle, and in 1924, the barracks were removed to Lummas Park. An apartment building was constructed on the site, which is now part of Miami in Miami-Dade County.

About two miles south of Fort Mellon along today's Mellonville Avenue was Fort Reid, named after Robert Raymond Reid, the fourth territorial governor. The fort served as a commissary and soldiers' camp. A. J. Vaughn, considered the area's first white settler, had enlisted for duty at Fort Mellon in December 1837 and later homesteaded at Fort Reid, which for a long time was little more than the pines and palmettos shown in this 1870s photo. In 1875, developers called their nearby subdivision Fort Reed (and Fort Read), and that was also the name of the railroad station near the former fort site. This area of Seminole County is now a south Sanford neighborhood.

The building in the middle of this nineteenth-century photo is the Charles Smith and Company General Merchandise store. To the right is the Fort Mason railroad depot, adjacent to tracks in use since 1880, serving the Lake County town. Located near the northeastern corner of Lake Eustis, it was named for Major Richard Barnes Mason and is now part of the city of Eustis. Fort Mason served as a shipping center, receiving citrus and other crops by rail and transferring them to lake steamers, which would take them to the Oklawaha River and points beyond.

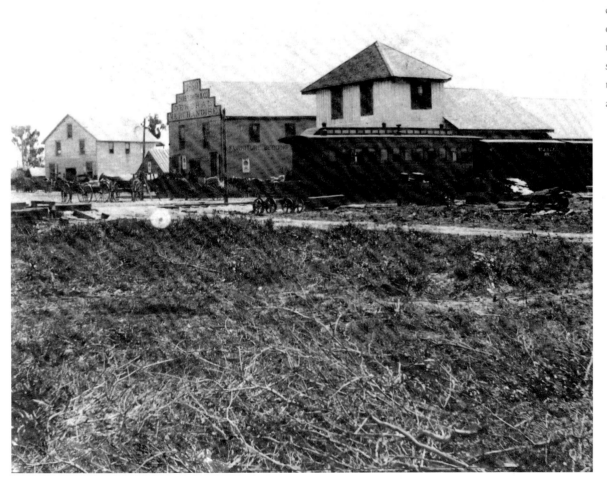

The town of Arlington, established in 1868, was named for the Virginia home of General Robert E. Lee. The town's post office opened under the name of Matthews in 1894 then was renamed Arlington in 1912. It became a branch of the Jacksonville Post Office in 1954. This 1880s view features a house in Arlington along the St. Johns River as it passes through Duval County. Located between today's Arlington Expressway and Jacksonville University, the town is now part of Jacksonville.

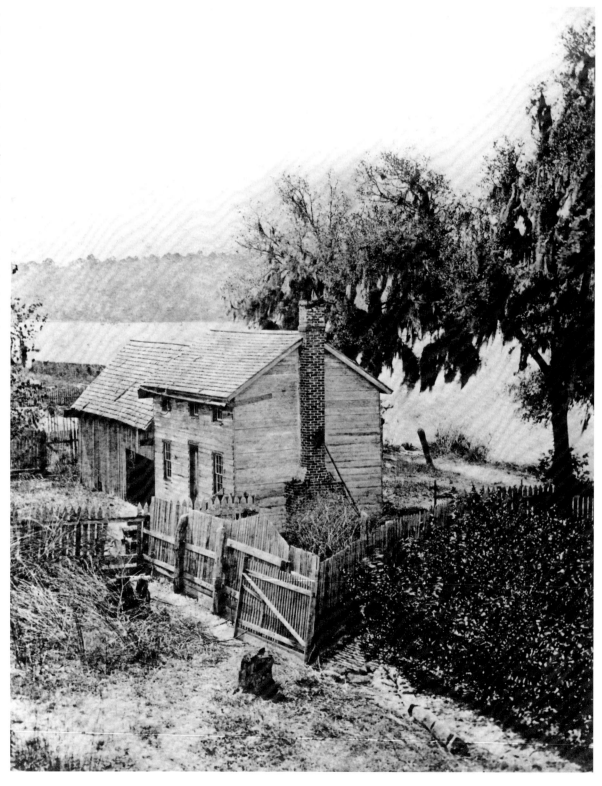

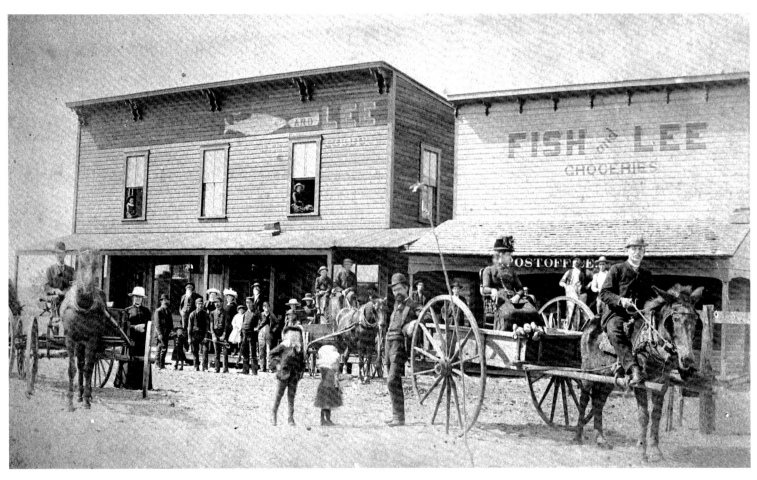

Spring Garden, in Volusia County near the town of Deleon Springs, was laid out by Major George H. Norris in 1872 in an area where Captain George Stark had raised cotton prior to the Civil War. The name Spring Garden dates back to the Spanish occupation of the area. Shown here around 1885 is the Fish and Lee General Store that also served as the post office. The town was situated along the eastern shore of Spring Garden Lake, fed in part by the water flowing up from the Deleon Springs aquifer. A post office opened in 1878 and closed in 1933, with mail service being transferred to DeLand.

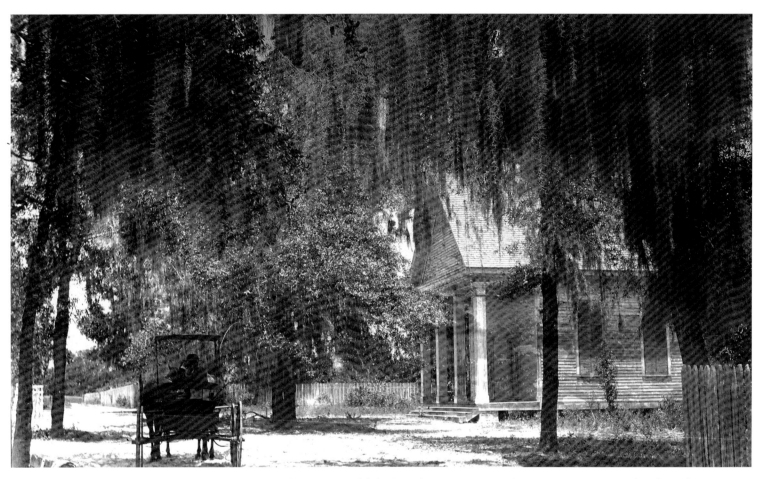

Camp Monroe and Camp Fanning, an 1826 camp of soldiers, was established in what is now Seminole County to protect settlers from the Indians. On February 8, 1837, it was attacked by Seminoles. The sole fatality was Captain Charles Mellon, and soon a fort was erected and named for him. The main column of soldiers moved out on December 17, 1837, toward Fort Christmas. The town of Mellonville, founded near the fort by Daniel Stewart in 1842, was later added to a city named for General Henry Shelton Sanford. This is Mellonville's Earnest Chapel as it appeared in the mid-1880s.

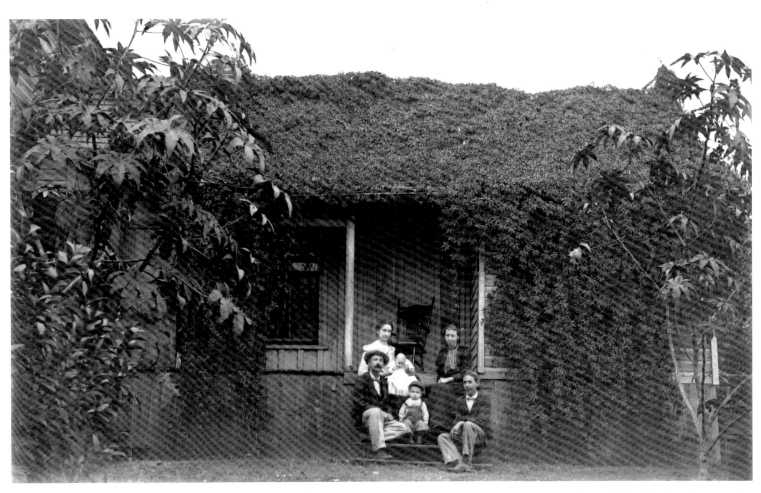

Shown here in a photo from around 1890 is the Mohawk home of Charles and Minnie Hart Stokes and their family, who moved to Florida from Lee Center, New York. They purchased their land from Mr. Palmer, who had settled there in 1882. Mohawk's post office was located in the living room of the Stokes house. In 1887, the Orange Belt and Tavares and Gulf Railroads arrived in Mohawk. A decade later, Charles Stokes expanded his home into Jolly Palms, a hunting and fishing lodge that burned down in 1912. Located near Lake County's Plum Lake, Mohawk had a population of only 45 in the mid-1930s and is now part of Minneola. The name is derived from the Narragansett word meaning "cannibals."

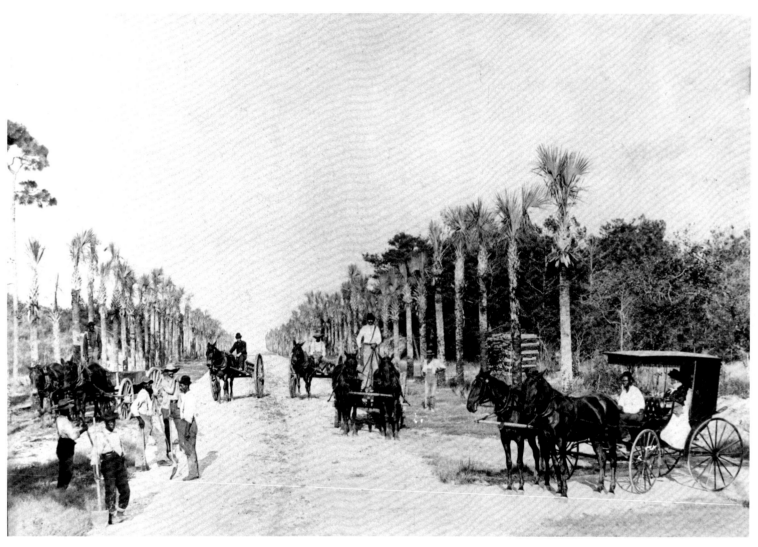

Shown here in 1893, shortly after the planting of the palm trees lining Seabreeze Boulevard, Helen Wilman Post watches from her carriage at the intersection with Halifax Boulevard. Seabreeze, a Volusia County town on the barrier island separating the Halifax River from the Atlantic Ocean, was established when David D. Rogers cut 47 acres into lots and named the land after a Delaware Bay town. In 1886, the post office opened at this intersection as Halifax but was renamed Seabreeze just four years later. C. C. and Helen Williams platted the town in 1896, and it was incorporated in 1901. On January 1, 1926, Seabreeze merged with Daytona on the mainland and Daytona Beach on the barrier island to form a new city of Daytona Beach.

Shown here during the 1890s is the large sponge market operated under the shade of the trees at Bailey's Bluff, named for surveyor P. K. Bailey. The area along the north shore of the Anclote River, in Pasco County just north of the Pinellas County line, was first settled by Frederic and Franklin B. Meyer, who built log cabins on the river bank in 1867 and called their settlement Anclote. Nearby on the river bluff in 1890, John K. Cheyney opened a warehouse that was later used by Wyatt Meyer for a sponge market. Across the river, William Wallace Kingsbury Decker had a sponge house, hardware store, and a shop for plain and fancy edibles. The Bailey's Bluff sponge business died when the town of Tarpon Springs established its own sponge industry, and the region's sponge trade became headquartered there.

The Lake Charm Chapel, now remodeled into a residence, is shown here on the south shore of the lake during the 1890s. Next to it was a parsonage that was torn down in 1972. Both were built by Dr. Henry Foster of Clifton Springs, New York, as a memorial to his brother, William. Prominent Northern ministers visited the area to conduct services at Foster's invitation. The chapel building was acquired by Samuel Murphy in 1920, and he remodeled it into a residence. The community of Lake Charm was named for the adjacent lake, surrounded by land acquired from the state by Walter Gwynn. His daughter, when told that the lake had no name, exclaimed, "It's such a charming lake!" and from then on it was called Lake Charm. The community is now a neighborhood north of downtown Oviedo in Seminole County.

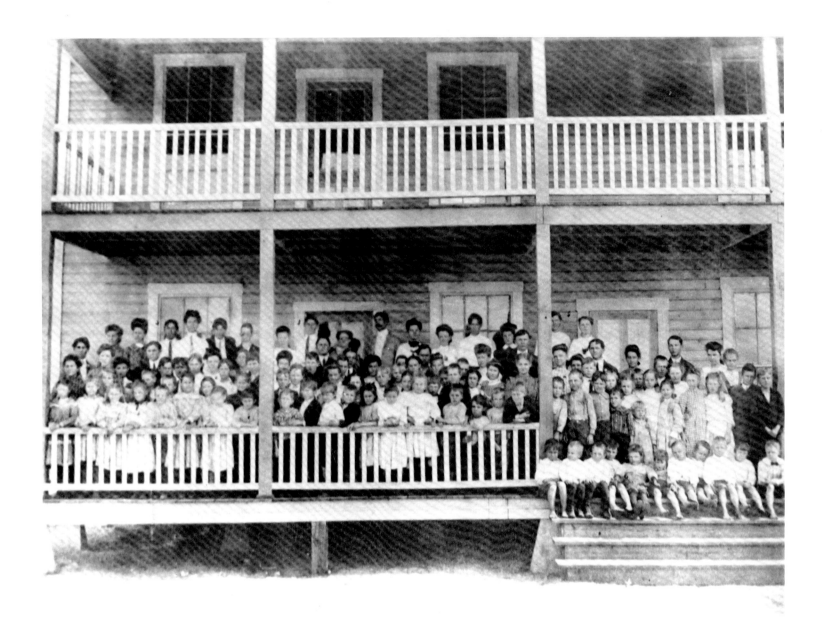

The Polk County settlement known as Medulla began in 1850 with the name of Spring Hill. L. M. Ballard established a post office there in the early 1880s and named it Medulla, then moved it (without the government's permission) to Lakeland. Medulla has a Latin meaning of "prime," indicating that it was a prime place to be. The community was known for its school shown here, established in 1905 to replace several one-room schools operating since the 1880s. The 1905 building is gone, and the present school includes a two-story brick section built in 1927. The community is essentially a neighborhood of southern Lakeland west of Harden Boulevard and north of Elwell Road.

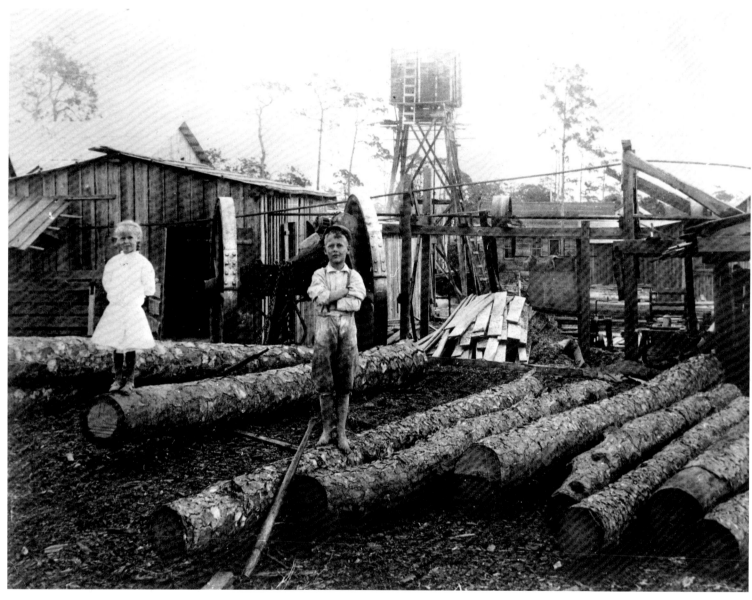

The Miami-Dade County settlement, first called Motto in 1889, was renamed Lemon City in 1893 after a lemon grove planted by Samuel Filer. The town had one of the largest docks reaching out into Biscayne Bay. Early settlers included William Filer of Key West and Mr. and Mrs. Carey, who built the town's first hotel. The Lemon City sawmill operated by A. B. Hurst is shown here around 1909. Mail service was moved to Miami in 1925, and the former town is now part of Miami near the intersection of NE 2nd Avenue and 59th Street.

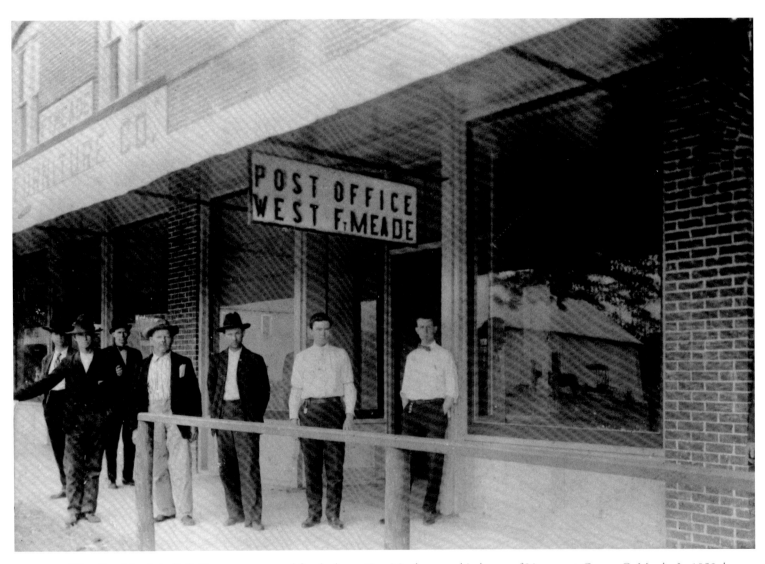

West Fort Meade in Polk County was named for the larger Fort Meade, named in honor of Lieutenant George G. Meade. In 1852, he was part of a group making a topological survey in the area and was looking for the 1849 Fort Clinch site. After Meade successfully located the site, General Twiggs, his pleased commanding officer, declared, "Here shall be Fort Meade!" This 1908 photo was taken the year its post office was established. The community was absorbed into Fort Meade in December 1910.

The town of Oak was located in Marion County along SR 200 in the northern part of today's Ocala. This 1910 photo shows engine No. 2 of the McDowell Crate and Lumber Company while it was parked in Oak. The town had its own post office from 1904 until 1936, when the Ocala Post Office took over mail service for the area.

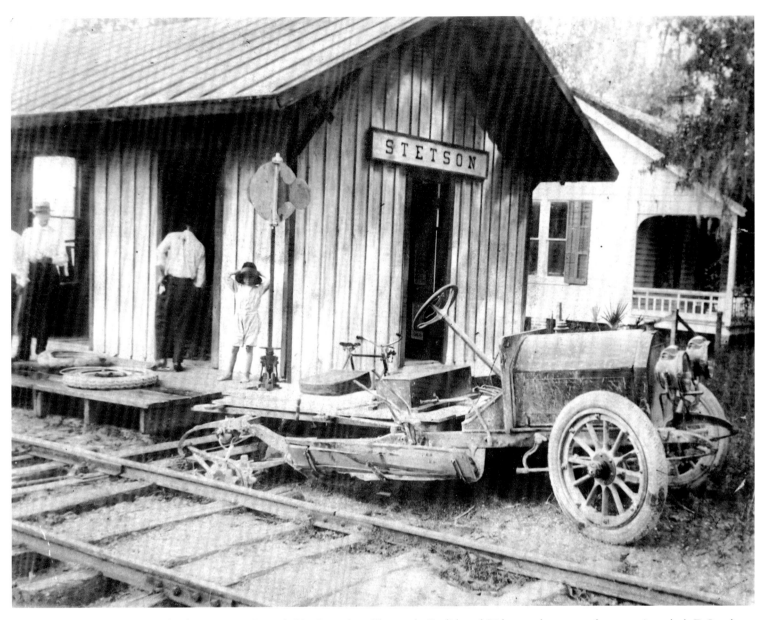

The portion of Volusia County bounded by Boundary, Plymouth, Euclid, and Ridgewood streets and avenues in today's DeLand was owned by John B. Stetson. It was known as West DeLand in 1887, and by the mid-1890s, it became known as Stetson. The community featured a railroad freight depot and post office (1895 to 1906), and John Stetson's personal office was located just south of the depot. This photo from around 1916 includes an automobile, demolished after colliding with a train.

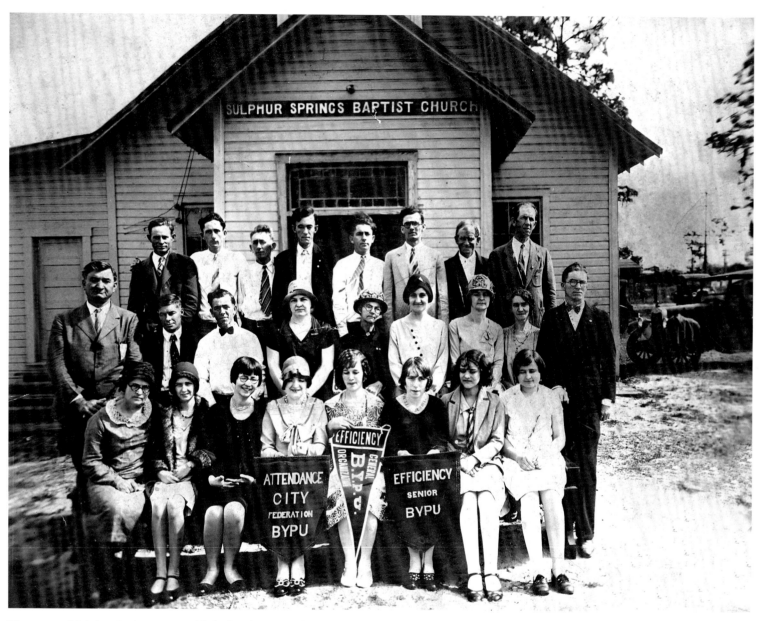

The town of Sulphur Springs was established with a post office in 1924, a little north of Tampa in Hillsborough County along the Hillsborough River. The health-giving springs were served by an adjacent hotel and amusement park, and a 1938 movie theater a block away has been remodeled into a recording studio. The area, easily found because a 210-foot-tall 1927 water tower stands adjacent to the springs, has now been absorbed into the city of Tampa. Around 1925, the Baptist Youth Peoples Union of Sulphur Springs poses for the camera in front of their church.

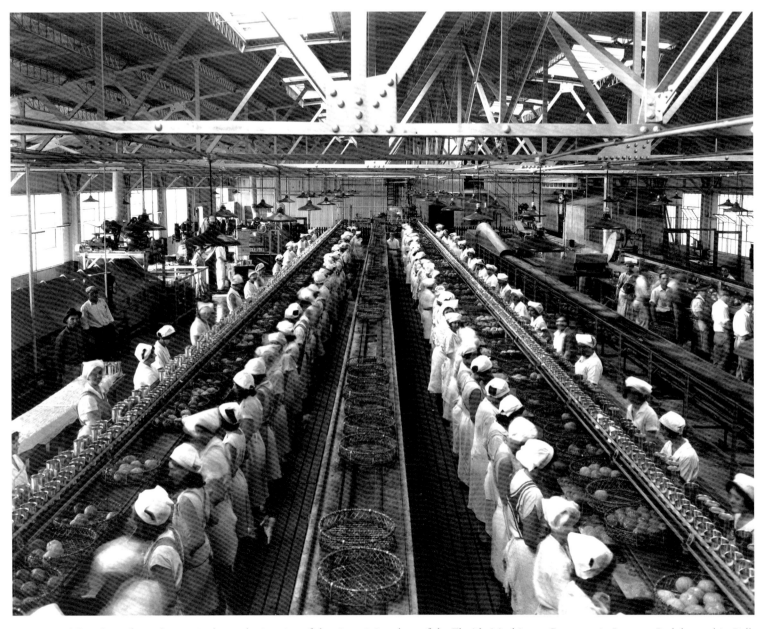

This photo from the 1930s shows the interior of the citrus juice plant of the Florida Machinery Company in Lucerne Park located in Polk County, southwest of Lake Henry in what is now Winter Haven. Lucerne Park was likely named for a city in Switzerland. The post office opened in 1912 and closed in 1930, and thereafter, mail service was transferred to Winter Haven.

Beulah, located along Reaves Road west of Lake Beulah, was originally known as the Reaves Settlement. In 1860, B. B. Reams and his family arrived there from Georgia, followed by the Reaves family in 1867 and the O'Berrys in the 1890s. There were many Reaves living in or near Beulah, as evidenced by the high percentage of headstones bearing that name in the sole remaining cemetery. The only other evidence of the Beulah name in this community absorbed by the city of Winter Garden is the Beulah Baptist Church, the oldest remaining church in Orange County that was constructed between 1860 and 1865. Shown here is an outhouse in Beulah dating from around 1936.

River Junction was located in Gadsden County at the intersection of the tracks of the Apalachicola Northern Railway and CR 269, near the junction of the Apalachicola River and South Mosquito Creek. Its early settlers included Briant McCulloh, who in 1827 received the first federal patent for land in the area. River Junction opened its post office in 1884, and 11 years later, the population reached 403. The post office closed in 1951, and mail service was moved to Chattahoochee. Shown here in 1942 are newlyweds Alice and Woodrow Butler. River Junction was absorbed by and is still a part of Chattahoochee.

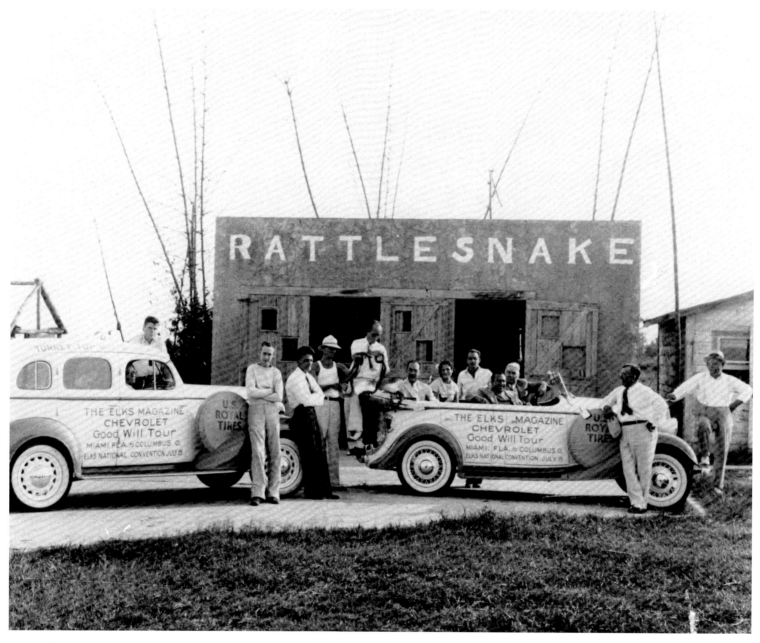

During the 1930s, George K. End came from Arcadia to Hillsborough County and opened a business canning rattlesnake meat, which was located between Gandy Boulevard and Port Tampa. He also sold rattlesnake oil to treat rheumatism and venom to treat snakebites. The town that grew up around it was called Rattlesnake and had its own post office from 1939 until June 1, 1954. In addition to the cannery, there was a general store and a snake pit attraction. End died from a bite from one of his own rattlesnakes. During the 1950s, the area was annexed into Tampa.

When William Bartram visited in 1774, land along the eastern shore of Lake Beresford was already owned by the Beresford family. In 1803, Spain granted the land in what is now Volusia County to Francis P. Fatio, Jr., but he never lived there. In 1819, it was owned by Irish nobleman John Beresford and his brother. The nearby lake was named for their family, and when A. H. Alexander founded the community of Beresford in 1874, he named it after the lake. A post office opened in 1876 and closed in 1954, when mail service was transferred to DeLand. This photo from the 1940s shows a Seaboard Air Line Railroad train passing by Beresford's American Machinery Boatworks factory, close to the northeast shore of Lake Beresford. The town is now a community on the outskirts of DeLand.

Shown here is a portion of one of a pair of earthworks erected by Confederate soldiers to protect the covered railroad bridge crossing the Suwannee River at Columbus. The town also was served by a ferry, stagecoach, and steamboats and grew to a population of about 500. The Columbus Post Office was established in 1842 but was moved in 1872 to Ellaville to better serve that new sawmill town. The Madison County townsite is within today's Suwannee River State Park and includes the small walled Old Columbus Cemetery.

This 1950 photo shows engine No. 1527 of the Louisville and Nashville Railroad while it was in Goulding in Escambia County. That town, now part of Pensacola, was located along the railroad track south of SR 752. It was named for H. M. and W. J. Goulding from Dublin, Ireland, who in 1889 owned the Goulding Fertilizer Company, later the American Agricultural Chemical Company. Goulding's last post office closed in 1906 when mail service was taken over by Pensacola.

NOTES ON THE PHOTOGRAPHS

These notes, listed by page number, attempt to include all aspects known of the photographs. Each photograph is identified by the page number, photograph's title or description, photographer and collection, archive, and call or box number when applicable. Although every attempt was made to collect available data, in some cases complete data was unavailable due to the age and condition of some of the photographs and records.

II **MINERAL CITY**
James Hart Curry Martens
Florida State Archives
GEN063

VI **BENSON JUNCTION/ ENTERPRISE JUNCTION**
Florida State Archives
RC10530

X **CHRISTINA/TANCREDE/ MEDULLA MINE**
Burgert Bros.
Florida State Archives
RC03812

2 **KING'S FERRY/MILLS FERRY/WHITEHOUSE/ DRUMMOND'S FERRY**
Florida State Archives
RC18101

3 **BAMBOO**
Florida State Archives
PR05098

4 **WARNELL**
Ensminger Brothers
Florida State Archives
PR00815

5 **ELLAVILLE**
Florida State Archives
RC00032

6 **PHOSPHORIA**
Florida State Archives
RC08201

7 **PEMBROKE**
Florida State Archives
RC09839

8 **BRICKYARD/SANDAG/ SANDY BLUFF**
Florida State Archives
PR07462

9 **BOYD**
Florida State Archives
RC04280

10 **LESSIE**
Herman Gunter
Florida State Archives
GE0131

11 **ZUBER**
Herman Gunter
Florida State Archives
GE0356

12 **BREWSTER/NEW CHICORA**
Florida State Archives
N048000

13 **MUSCOGEE**
Florida State Archives
RC17722

14 **CAMPVILLE**
Florida State Archives
GE1145

15 **RIDGEWOOD**
Florida State Archives
PR09398

16 **SHAMROCK**
H. H. Pollitt
Florida State Archives
N039305

17 **EDGAR**
Florida State Archives
GE0655

18 **BENOTIS**
Herman Gunter
Florida State Archives
GE0626

19 **PAUWAY**
Florida State Archives
RC17538

20 **AGRICOLA**
Florida State Archives
PR00001

21 **KEUKA**
James Hart Curry Martens
Florida State Archives
GE0898

22 **OCALA**
Florida State Archives
GE1069

23 **CLARKSVILLE/BAILEY**
Florida State Archives
N029110

24 **BAY HARBOR**
Herman Gunter
Florida State Archives
GE1268

25 **PIERCE/PHILIPPI**
Florida State Archives
PR20342

26 **WILLOW**
Boynton and Patton
Florida State Archives
024957

27 **CARYVILLE/HALF MOON BLUFF**
Florida State Archives
RC04638

28 **BRIDGEND/OSCEOLA**
Florida State Archives
N039280

29 **WATERTOWN**
Florida State Archives
RC06460

30 **KINGSFORD/MITCHELL**
Florida State Archives
RC17486

32 **HOPEWELL**
Florida State Archives
MA0761

33 **NEW SMYRNA**
Florida State Archives
PR07596

34 **HAILE**
Donated by Don Davis
Florida State Archives
NE095e

35 **DRIFTON**
Florida State Archives
N030200

36 **CAPPS**
Donated by Doris J. Dyen
Florida State Archives
FP8173

38 **CHICORA**
Florida State Archives
RC09948

39 PICOLATA
Stereoview by A. F. Styles
Florida State Archives
N036954

40 LENO/KENO/OLD LENO
Jim Alexander
Florida State Archives
N044950

41 ST. FRANCIS/OLD TOWN
Florida State Archives
RC08518

42 PORT INGLIS
Florida State Archives
PR08858

43 FANLEW/DELPH
Florida State Archives
RC11319

44 MUNSON
Florida State Archives
N035652

45 MILLVIEW
Florida State Archives
N039191

46 CUTLER
Florida State Archives
SM1115b

47 BAYPORT
Florida State Archives
AG23194

48 NEWNANSVILLE
Florida State Archives
N036770

50 FORT BARNWELL/FORT COLUMBIA/FORT CALL/ CAMP VOLUSIA
Lithograph published by T. F. Gray and James
Florida State Archives
RC07670

51 WARRINGTON
Jay Dearborn Edwards
Florida State Archives
RC02582

52 EUREKA
Florida State Archives
RC10444

53 FORT DENAUD
Florida State Archives
RC01700

54 ALLENHURST/HAULOVER
Florida State Archives
PR00127

55 WEEDON ISLAND/THE BAYOU
Florida State Archives
N044493

56 FLAMINGO
John Kunkel Small
Donated by George Small
Florida State Archives
SM0203

57 OJUS
D. Stuart Mossom
Florida State Archives
GE0734

58 WILSON
Florida State Archives
RC04289

60 HELEN
Florida State Archives
RC12936

61 CAMP ROOSEVELT
Florida State Archives
N035932

62 ORSINO
Florida State Archives
PR08331

63 EGMONT KEY
Florida State Archives
N046232

64 BOULOUGNE/CALICO HILL/GARDENIA
Florida State Archives
RC15388

66 ATSENA OTIE
Florida State Archives
RC03280

67 BOARDMAN
J. G. Mangold
Florida State Archives
N028304

68 CONANT
Florida State Archives
N029237

69 PITTMAN
Florida State Archives
N037003

70 ROCHELLE/PERRY JUNCTION/GRUELLE
Florida State Archives
N039069

71 WINDSOR
John A. Walker
Florida State Archives
RC09082

72 PLANTER
Florida State Archives
N041561

73 RICHLAND/TUCKERTOWN
Florida State Archives
N038836

74 RITTA
Florida State Archives
RC03306

75 OKEELANTA
Florida State Archives
RC16517

76 ST. JOSEPH
John Kunkel Small
Florida State Archives
SM1121a

77 PALM SPRINGS
Herman Gunter
Florida State Archives
GE1377

78 PORT LEON
Hugh Williams
Florida State Archives
RC19326

80 INDIAN KEY
Florida State Archives
RC02768

81 KERR CITY
Florida State Archives
PR05922

82 PUNTA RASSA/FORT DULANEY
Florida State Archives
RC19392

83 HAMPTON SPRINGS
Florida State
ArchivesPR09397

84 LAKE FERN
Florida State Archives
RC07709

85 WOODMERE
Florida State Archives
RC01613

86 OLD VENUS
John Henry Davis
Florida State Archives
GE1647

87 JEROME
Florida State Archives
FA0831b

88 BULOW
Florida State Archives
RC20154

90 COOK'S FERRY/KING PHILIPSTOWN
Florida State Archives
RC16519

91 ORANGE MILLS
Wood and Beckel
Florida State Archives
N036302

92 HAGUE
Florida State Archives
PR05071

93 IOLA
Florida State Archives
RC07286

94 EMPORIA/ASTOR JUNCTION/ELDRIDGE/ BISHOPVILLE
Florida State Archives
N030305

95 MOUNT PLEASANT
Florida State Archives
PR07200

96 SILVER SPRINGS
Stanley J. Morrow
Florida State Archives
RC03487

98 MAGNOLIA
Florida State Archives
PR01103

99 PIEDMONT
Florida State Archives
N036958

100 JUDSON/WACASASSEE
Donated by Don Davis
Florida State Archives
NE007

101 ASHVILLE/RHODES STORE
Florida State Archives
PR05659

102 WAUKEENAH
Florida State Archives
RC11397

103 MILLER'S FERRY
Florida State Archives
PR13459

104 ELDORADO
Florida State Archives
N039173

105 LOTUS
Donated by Jud Laird
Florida State Archives
N045285

106 HINSON
Florida State Archives
RC07886

107 MOSS BLUFF
Florida State Archives
PR07195

108 MARYSVILLE
Florida State Archives
RC18310a

109 LLOYD/BAILEY'S MILLS/ STATION NUMBER TWO
Florida State Archives
RC03337

110 OWANITA
Florida State Archives
RC08179

111 ATHENA
Florida State Archives
N027889

112 ROMEO
Florida State Archives
N034655

113 MASON
Florida State Archives
RC05962

114 UPCOHALL
Florida State Archives
RC08171

115 HAMBURG
Donated by Lillian A. Balloon
Florida State Archives
MA0124

116 HILLIARDVILLE
Florida State Archives
N044407

117 DOWLING PARK
Florida State Archives
PR02825

118 OLGA
Wieboldt
Florida State Archives
FA0826b

119 PAXTON
Florida State Archives
N038706

120 ELLIOTT KEY/LEDBURY KEY/ISLANDIA
Florida State Archives
RC05481

121 KORESHAN/NEW JERUSALEM
Florida State Archives
PR10582

122 PLEASANT GROVE
Florida State Archives
RC05916

123 JUNIPER
Florida State Archives
RC07890

124 PIGEON KEY
Florida State Archives
PR09282

125 CONCORD
Florida State Archives
N048709

126 KINARD
Florida State Archives
PR06132

127 CROOM/FITZGERALD
Elias Howard Sellards
Florida State Archives
GE0026

128 NASH/BOLTON
Florida State Archives
N035686

129 ESTIFFANULGA
Florida State Archives
N048285

130 SPRAY
Florida State Archives
MA0846

131 OCHEESEE
Florida State Archives
RC04383

132 FENHOLLOWAY
Florida State Archives
RC16507

133 CAMP PERRY
Elias Howard Sellards
Florida State Archives
GE0155

134 FORT DRUM
Florida State Archives
N029024

135 ASHTON/ASHTON STATION
Florida State Archives
N027884

136 MAJETTE
Florida State Archives
PR12624

137 FLORIDATOWN
Charles Thomas Cottrell
Florida State Archives
RC06217

138 BERLIN
Florida State Archives
N028172

139 PALM VALLEY/DEIGO
Florida State Archives
N036666

140 GILLETTE/FROG CREEK
Florida State Archives
RC04195

141 CHARLOTTE HARBOR/ HICKORY BLUFFS
Florida State Archives
RC08140

142 MIDLAND
Florida State Archives
RC10132

143 LINDEN
Donated by Karen Newell Eitel
Florida State Archives
PR13878

144 RUNNYMEDE/WHARTON
Florida State Archives
N039121

145 LUANA
Florida State Archives
N046058

146 MABEL
Donated by Karen Newell Eitel
Florida State Archives
PR13876

147 ARRAN
Florida State Archives
N027880

148 HILDRETH
Florida State Archives
PR04289

149 INDIANOLA
Florida State Archives
RC02845

150 Oak Grove/Wiggins
Florida State Archives
RC13733

151 Newport
Donated by Venila Shores
Florida State Archives
RC00182

152 Smith Creek
Guinn Haskins
Florida State Archives
N041086

153 Hanson
Florida State Archives
N031451

154 Salem
Florida State Archives
RC07893

155 Harbeson City
Florida State Archives
C000298

156 Kreamer
Florida State Archives
SM0508

157 Lakeport
Florida State Archives
N048311

158 Crossley
Florida State Archives
GE1244

159 Juliette
Florida State Archives
GE1341

**160 Cherry Lake/
Overstreet's/
Townsend**
Donated by Marion L.
Anderson
Florida State Archives
MA0146

161 Lake Ashby
Florida State Archives
NO33715

162 Day
Florida State Archives
N029462

163 Jonesville
Donated by Don Davis
Florida State Archives
NE185

**164 Lamont/Lamont/
Perry/Lick Skillet/
McCains Store**
Florida State Archives
N033975

165 Hardaway
Florida State Archives
N031475

166 Fort Gates
Metro-Goldwyn-Mayer
Florida State Archives
PR25671

**167 Aucilla/Ocello/Stop
Four**
Florida State Archives
N027922

168 Eloise
Robert E. Dahlgren
Florida State Archives
FR0182

169 Hesperides
Florida State Archives
N033773

170 Hibernia
Florida State Archives
N031534

171 Irvine
Florida State Archives
C004700

172 Otter Creek
Robert Orion Vernon
Florida State Archives
GE1922

173 Bellville/Benton
Florida State Archives
N029672

174 Willow Oak
Florida State Archives
RC09933

175 Bethel
Florida State Archives
N028174

176 Baxter
Florida State Archives
C031986

178 Fort Brooke
Lithograph published by T. F.
Gray and James
Florida State Archives
RC03507

179 Fort Dallas
Florida State Archives
N046352

180 Fort Reed
Florida State Archives
PR03378

181 Fort Mason
Florida State Archives
RC09073

182 Arlington/Matthews
Florida State Archives
PR05274

183 Spring Garden
Florida State Archives
N041379

184 Mellonville
Florida State Archives
RC18323

185 Mohawk
Florida State Archives
RC18548

186 Seabreeze/Halifax
Florida State Archives
RC07627

187 Bailey's Bluff
Florida State Archives
RC20122

188 Lake Charm
Florida State Archives
RC02304

189 Medulla/Spring Hill
Florida State Archives
RC18320

190 Lemon City/Motto
Florida State Archives
N032441

191 West Fort Meade
Florida State Archives
FR0361

192 Oak
Florida State Archives
N039272

**193 Stetson/West
DeLand**
Florida State Archives
N042035

194 Sulphur Springs
Florida State Archives
N042042

195 Lucerne Park
Florida State Archives
FR0708

**196 Beulah/Reaves
Settlement**
Florida State Archives
PR13901

197 River Junction
Florida State Archives
N048475

198 Rattlesnake
Florida State Archives
PR02440

199 Beresford
Florida State Archives
N038569

200 Columbus
Florida State Archives
RC20533

201 Goulding
Grady W. Robarts
Florida State Archives
N039227

BIBLIOGRAPHY

Bloodworth, Bertha E. and Alton C. Morris. *Places in the Sun: The History and Romance of Florida Place-Names.* Gainesville, FL: University Press of Florida, 1978.

Bradbury, Alford G. and E. Story Hallock. *A Chronology of Florida Post Offices.* Vero Beach, FL: The Florida Federation of Stamp Clubs, 1962.

Hunt, Bruce. *Visiting Small-Town Florida.* Sarasota, FL: Pineapple Press, Inc., 2003.

Johnson, Anne M. *Country Towns of Florida.* Castine, ME: Country Roads Press, 1995.

Morris, Allen and Joan Perry Morris. *The Florida Handbook 2003-2004.* Tallahassee, FL: The Peninsular Publishing Company, 2003.

Morris, Allen and Joan Perry Morris. *Florida Place Names.* Sarasota, FL: Pineapple Press, Inc., 1995.

Norton, Charles Ledyard. *A Handbook of Florida.* New York, NY: Longmans, Green, 1891.

Pohlen, Jerome. *Oddball Florida: A Guide to Some Really Strange Places.* Chicago, IL: Chicago Review Press, 2004.

Read, William A. *Florida Place Names of Indian Origin and Seminole Personal Names.* Tuscaloosa, AL: University of Alabama Press, 2004.

Waitley, Douglas. *Roadside History of Florida.* Missoula, MT: Mountain Press Publishing Company, 1997.

Warnke, James R. *Ghost Town Locations in Florida: 350 Forgotten Sites Pinpointed by County.* Boynton Beach, FL: Warnke Publishing, 1992.